Nina Rapi
Maya Chowdhry
Editors

Acts of Passion: Sexuality, Gender and Performance

Acts of Passion: Sexuality, Gender and Performance has been co-published simultaneously as *Journal of Lesbian Studies,* Volume 2, Numbers 2/3 1998.

Pre-publication
REVIEWS,
COMMENTARIES,
EVALUATIONS . . .

"**A**cts of Passion is witty, well informed and intelligently partisan. Its clarity of purpose in charting the energy and vitality of current lesbian performance is played out in the text whose coherence lies in the commitment of the contributing practitioners, academics and practitioner-critics to speaking across the critical/practice divide. Critical practice informs cogent analysis; personal memoir and descriptive pieces by artists converse with theoretical issues. The whole mix is rich, focused and up to the moment. It's a lively, wide-ranging book, a credit to its editors. . . . I can imagine myself using it in teaching and for research to present the diversity and scope of lesbian performance today."

Claire MacDonald
Senior Lecturer and Research Fellow
De Montfort University, UK
and Co-Editor, Performance Research

"**A**cts of Passion is a passionate book in two senses. It is written, with feeling, by a number of women who live, 'act' and continually re-enact, embody and otherwise employ the personal and public politics about which they write. It also dares to tempt the tempestuous subjects of sexuality, gender and performance with a style which crosses over from academic to journalistic to performative and poetic, back to instructive and out to outrageous, finally looping back on itself to invite the reader to 'try this at home.'

The book is both transdisciplinary and nonhierarchical in focus and aim. . . . The book crosses generic borders by moving easily from theatre to music to dance, live art to multimedia installation and CD-ROM, comedy to club culture, all framed by a layer of critical self-analysis.

Rapi and Chowdhry's skill in selecting and editing the pieces is evident. The free rein they obviously gave to contributors lends the book an open-ended, slightly quirky and wonderfully readable feel. It is a delight to be informed by a book which evidently enjoys itself and a joy to be delighted by a book which provides a wealth of evidence to support the basic idea that lesbian theatrical representations have much to uncover and discover and recover for those who dare to look. The book is irreverent and funny at times, contentious in intent and effect, highly serious and well argued in part, and well worth a read overall."

Lizbeth Goodman
Lecturer in Literature
The Open University, UK

Acts of Passion: Sexuality, Gender and Performance

Acts of Passion: Sexuality, Gender and Performance has been co-published simultaneously as *Journal of Lesbian Studies*, Volume 2, Numbers 2/3 1998.

The *Journal of Lesbian Studies* Monographs/"Separates"

Classics in Lesbian Studies, edited by Esther Rothblum

Gateways to Improving Lesbian Health and Health Care: Opening Doors, edited by Christy M. Ponticelli

Acts of Passion: Sexuality, Gender and Performance, edited by Nina Rapi and Maya Chowdhry

These books were published simultaneously as special thematic issues of *Journal of Lesbian Studies* and are available bound separately. Visit Haworth's website at http://www.haworthpressinc.com to search our online catalog for complete tables of contents and ordering information for these and other publications. Or call 1-800-HAWORTH (outside US/Canada: 607-722-5857), Fax: 1-800-895-0582 (outside US/Canada: 607-771-0012), or e-mail: getinfo@haworthpressinc.com

Acts of Passion: Sexuality, Gender and Performance

Nina Rapi, MA
Maya Chowdhry, MA
Editors

The Haworth Press, Inc.
New York · London

Acts of Passion: Sexuality, Gender and Performance has been co-published simultaneously as *Journal of Lesbian Studies*™, Volume 2, Numbers 2/3 1998.

Cover photo: Helena Goldwater ("Scenes from the Outskirts," ObScene Women's Theatre)
Photographer: Jyll Bradley

Cover design by Thomas J. Mayshock Jr.

Library of Congress Cataloging-in-Publication Data

Acts of passion : sexuality, gender and performance / Nina Rapi, Maya Chowdhry editors.
 p. cm.
 Includes bibliographical references and index.
 ISBN 0-7890-0370-8 (alk. paper). – ISBN 1-56023-108-4
 1. Lesbians. 2. Lesbianism. 3. Women–Sexual behavior. 4. Gender identity. 5. Interpersonal relations. I. Rapi, Nina. II. Chowdhry, Maya.
HQ75.5.A26 1998
305.48'9664–dc21
 98-24201
 CIP

INDEXING & ABSTRACTING

Contributions to this publication are selectively indexed or abstracted in print, electronic, online, or CD-ROM version(s) of the reference tools and information services listed below. This list is current as of the copyright date of this publication. See the end of this section for additional notes.

- *Abstracts in Social Gerontology: Current Literature on Aging,* National Council on the Aging, Library, 409 Third Street SW, 2nd Floor, Washington, DC 20024

- *Contemporary Women's Issues,* Responsive Databases Services, 23611 Chagrin Boulevard, Suite 320, Beachwood, OH 44122

- *CNPIEC Reference Guide: Chinese National Directory of Foreign Periodicals*, P.O. Box 88, Beijing, People's Republic of China

- *Feminist Periodicals: A Current Listing of Contents,* Women's Studies Librarian-at-Large, 728 State Street, 430 Memorial Library, Madison, WI 53706.

- *Gay & Lesbian Abstracts,* National Information Services Corporation, 306 East Baltimore Pike, 2nd Floor, Media, PA 19063

- *HOMODOK/"Relevant" Bibliographic database, Documentation Centre for Gay & Lesbian Studies, University of Amsterdam (selective printed abstracts in "Homologie" and bibliographic computer databases covering cultural, historical, social and political aspects of gay & lesbian topics),* HOMODOK-ILGA Archive, O.Z. Achterburgwal 185, NL-1012 DK Amsterdam, The Netherlands

- *Index to Periodical Articles Related to Law,* University of Texas, 727 East 26th Street, Austin, TX 78705

(continued)

- *INTERNET ACCESS (& additional networks) Bulletin Board for Libraries ("BUBL") coverage of information resources on INTERNET, JANET, and other networks.*
 - <URL:http://bubl.ac.uk/>
 - The new locations will be found under <URL:http://bubl.ac.uk/link/>.
 - Any existing BUBL users who have problems finding information on the new service should contact the BUBL help line by sending e-mail to <bubl@bubl.ac.uk>.
 The Andersonian Library, Curran Building, 101 St. James Road, Glasgow G4 0NS, Scotland

- *Public Affairs Information Bulletin (PAIS),* Public Affairs Information Service, Inc., 521 West 43rd Street, New York, NY 10036-4396

- *Referativnyi Zhurnal (Abstracts Journal of the All-Russian Institute of Scientific and Technical Information),* 20 Usievich Street, Moscow 125219, Russia

- *Sociological Abstracts (SA),* Sociological Abstracts, Inc., P.O. Box 22206, San Diego, CA 92192-0206

- *Studies on Women Abstracts,* Carfax Publishing Company, P. O. Box 25, Abingdon, Oxon OX14 3UE United Kingdom

- *Women "R" CD/ROM. A new full text Windows Database on CD/ROM. Presents full depth coverage of the wide range of subjects that impact and reflect the lives of women. Can be reached at 1 (800) 524-7922, www.slinfo.com, or e-mail: hoch@slinfo.com,* Softline, Information, Inc., 20 Summer Street, Stamford, CT 06901

- *Women's Studies Index (indexed comprehensively),* G.K. Hall & Co., P. O. Box 159, Thorndike, ME 04986

(continued)

SPECIAL BIBLIOGRAPHIC NOTES

related to special journal issues (separates)
and indexing/abstracting

☐ indexing/abstracting services in this list will also cover material in any "separate" that is co-published simultaneously with Haworth's special thematic journal issue or DocuSerial. Indexing/abstracting usually covers material at the article/chapter level.

☐ monographic co-editions are intended for either non-subscribers or libraries which intend to purchase a second copy for their circulating collections.

☐ monographic co-editions are reported to all jobbers/wholesalers/approval plans. The source journal is listed as the "series" to assist the prevention of duplicate purchasing in the same manner utilized for books-in-series.

☐ to facilitate user/access services all indexing/abstracting services are encouraged to utilize the co-indexing entry note indicated at the bottom of the first page of each article/chapter/contribution.

☐ this is intended to assist a library user of any reference tool (whether print, electronic, online, or CD-ROM) to locate the monographic version if the library has purchased this version but not a subscription to the source journal.

☐ individual articles/chapters in any Haworth publication are also available through the Haworth Document Delivery Service (HDDS).

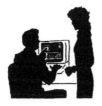

ABOUT THE EDITORS

Nina Rapi, MA, is a playwright, translator, and lecturer at CEMS, Birkbeck College, University of London. Her plays include *Dance of Guns* (London Tour, 1992), *Dreamhouse* (Oval House, 1991), and *Ithaka* (Riverside Studios, 1989; University of Reading, 1995). *Ithaka* was also published in *Seven Plays by Women* (Aurora Metro, 1991) which won the Raymond Williams Award. Ms. Rapi's monologues *Dangerous Oasis* and *Johnny Is Dead* were produced in London as part of two award-winning seasons (1991 and 1993). Formerly a writing, recording, and performing artist with Tapanda Re (1983-1987), she co-founded and edited the lesbian and gay theatre journal *GLINT* (1992-1995). Her critical writing on aesthetics and representations has been published in *The New Theatre Quarterly* (No. 34, Cambridge University Press, 1993), *Daring to Dissent* (Cassell, 1994), and other anthologies. Her new play, *Edgewise*, is currently awaiting production. In addition, the Arts Council of England has awarded Ms. Rapi a Writing Bursary for the production of her next play.

Maya Chowdhry, MA, is an award-winning playwright, poet, writer, and Live Artist. Her plays include: *Kaahini* (Birmingham Repertory Company, 1998, and Red Ladder Theater Company, National Tour 1997), *An Appetite for Living* (West Yorkshire Playhouse, 1997), and *Splinters* (Bradford Theatre in the Mill, 1997). She has written four plays for BBC Radio including *Monsoon* (1991). *Monsoon*, a winner in the 1991 BBC Young Playwrights Festival, was nominated for the 1993 BBC Newcomers award at the Prix Futura in Berlin and was published in *Six Plays by Black and Asian Women Writers* (Aurora Metro Publications, 1993). The author of "Shooting the Shots," a critical chapter published in *Talking Black: Lesbians of African and Asian Descent Speak Out* (Cassell, 1994), she has won much acclaim for her widely published poetry and fiction. Ms. Chowdhry, recipient of a Live Art commission from the Institute of Contemporary Arts, has performed and taught nationally and internationally. In 1994, she

was Resident Dramatist with Red Ladder Theatre Company, and from 1991 to 1994 she was a member of the editorial collective of Feminist Arts News. She was a guest tutor at the Manchester Writing Festival in 1994 and at "Words Without Borders," the International Lesbian and Gay Writers Festival in Vancouver in 1990. She has an MA in Scriptwriting for Film and Television and is a member of the Writers Guild and the Black Arts Alliance.

Acts of Passion:
Sexuality, Gender and Performance

CONTENTS

Illustrations

INTRODUCTIONS

Representing the 'Real'

Nina Rapi

Is 'the real' any more real than its representation? Real to whom? The writer, the performer, those represented, or the audience? Can fantasy be said to be more 'real' than reality, especially when it is repeatedly and ritualistically enacted in everyday situations as, for example, with the masquerade of femininity (the performance of everyday life), or on a more conscious level with drag kings? Is this theatre or life? What if that fantasy is structured into a staged performance (e.g., lesbian drag queens), presented in front of a paying audience? Is it still a fantasy or does it become 'real' on stage? And talking of 'real' who is a real lesbian anyway?

In other words, dear reader, in these post-modern days of fragmentation, un/reality, and non-fixity of self, identity and sexuality, you can easily lose count of what is what, not to mention of who you 'really' are. In this collection, we have worked towards some

Nina Rapi can be contacted via e-mail at ninarapi@compuserve.com.

[Haworth co-indexing entry note]: "Representing the 'Real.'" Rapi, Nina. Co-published simultaneously in *Journal of Lesbian Studies* (The Haworth Press, Inc.) Vol. 2, No. 2/3, 1998, pp. 1-8; and: *Acts of Passion: Sexuality, Gender and Performance* (ed: Nina Rapi, and Maya Chowdhry) The Haworth Press, Inc., 1998, pp. 1-8; and: *Acts of Passion: Sexuality, Gender and Performance* (ed: Nina Rapi, and Maya Chowdhry) Harrington Park Press, an imprint of The Haworth Press, Inc., 1998, pp. 1-8. Single or multiple copies of this article are available for a fee from The Haworth Document Delivery Service [1-800-342-9678, 9:00 a.m. - 5:00 p.m. (EST). E-mail address: getinfo@haworthpressinc.com].

1

kind of synthesis. Tricky word, I know, but what can a dyke do if she's had enough of either/or situations. Be that either theory or practice; essentialism or social constructionism; "authenticity" or deconstructionism; black or white; intellectual or experiential; Father's alienating *distance* or Mother's smothering *nearness,* etc. It seems that while contemporary theory struggles to deconstruct limiting binaries, it invariably re/constructs others in the process. Are 'binaries' inescapable or does theory divorced from everyday 'reality'/experience/practice inevitably get caught in the frame of reference it seeks to escape?

In this collection, therefore, you shall find both theoretical and practical contributions, experiential and deconstructionist, 'real' and 'hypereal.' What they all have in common is a desire to understand and communicate the ways in which sexuality, gender and performance are expressed and interconnected.

PERFORMATIVITY

A lot has been written recently about performativity and performance.[1] Philosophy, Sociology, Psychology and Performance Studies have inter-disciplined themselves to explore notions of 'life as theatre' and the 'realness of performance,' and the making of gender, sexual and racial identities through performative processes.

The concept of 'performativity' was first coined by the English philosopher J. L. Austin to identify the socio-cultural instances where saying something means doing something, where a speech becomes an act; e.g., "I take thee to be my lawful wife" is a speech that becomes an act, sanctioned by the performance of the marriage ceremony.

Further developed by philosophers Jacques Derrida and Judith Butler, the notion of performativity has facilitated an understanding of how identities are formed through a complex process of citational instances.[2] Heterosexuality, for example, is understood by Butler to be constructed as an identity through continuous repetitions of an imagined original.

Lesbians then, who are often criticized for copying heterosexuality, Butler argues, only copy a copy and never an original since an original never actually exists.[3]

Taking this further I would argue that we, lesbians in a western context, are engaged in a continuous de/re/construction of our sexual identities through a mix and match process, whereby lesbian becomes a combination of the cultural constructs 'man' and 'woman'; of the social reality 'dyke' as she has developed over the last fifty years; and any additional elements produced by the individual's imagination and influenced by the specific sub-cultures she might belong to. These could be either national sub-cultures, such as Jewish or Greek, Asian or Arab, Jamaican or Nigerian or British Black; and/or other socio-cultural groupings such as drug culture, ragga/goth/pop scene, anarcho-feminists, squatters, etc. Hence the infinite lesbian personae: *drag kings and transgender lesbians*; *butch* (baby butch, camp butch, dandy butch, stone butch, 'boy,' ragga dyke, papa, diesel dyke, Bulldagger, S & M dyke, daddy boy); *femme* (high femme, camp femme, baby femme, top femme, mama, S & M femme, Riot Grrrl, punky femme, goth femme, ragga girl, gay girl, rude girl, babe); *androgynous* (zami, khush, hermaph-rodyke, cyberdyke, cardigan lesbians, power lesbians).

How much of this diversity actually makes it to the stage? Not a lot, unfortunately. What is known as lesbian theatre or more recently as lesbian performance still largely remains a 'nice' white, Anglo-Saxon affair. We hope this collection makes a further difference in that it includes artists and writers who are stretching this narrow perimeter.

THE MARGIN AND THE CENTER

Lesbian Theatre as such, unlike gay theatre, has mostly survived on the fringe. This has had a double effect on its development. On the one hand, an assumed lesbian audience has enabled a certain freedom and experimentation with form and content unlikely in a straight environment. On the other hand, it has meant low production standards, non-critically assessed work and a certain complacency. Also, the experimentation has largely remained within rather fixed boundaries, often within those of pastiche.

Audience wise, a non-critical audience can have a stagnating effect on the artist. Further, pastiche relies a lot on the audience being able to read certain lesbian codes and conventions, on being

'in.' This of course is both inclusive and exclusive at once. And while any sub-culture inevitably has its own systems of signs, often incomprehensible to outsiders, lesbian theatre needs to 'decodify' itself, make itself accessible and visible in order to make any lasting difference. Besides, pastiche, which can rarely offer more than mere entertainment value, increasingly leaves lesbian spectators dissatisfied and disappointed, turning for something more challenging and meaningful to mainstream culture.

Very little 'serious' lesbian theatre has emerged, and by that I mean 'universal', i.e., theatre which may originate in a very specific angle/situation (e.g., lesbian) but manages to "shift the axis of categorization"[4] and make that specific situation part of the world's experience.[5] While a few individual playwrights have made it into the mainstream, despite controversial subject matter (Sarah Daniels, Sarah Kane), and/or experimental structures (Phyllis Nage), they haven't necessarily produced 'universal' theatre except, ironically, by carefully avoiding any lesbian subject matter, such as Sarah Kane in her ground-breaking "Blasted" and "Phaedra's Love."[6] Can lesbians then only break through to the mainstream by de-lesbianising their work? Or by denying they are 'lesbian' playwrights?[7]

Does making 'universal' theatre necessitate 'mainstreaming'? Can we not produce 'universal' theatre in the ghetto? We certainly can. But how wide will its audience be? Theatre cannot develop without an audience that challenges it, without critical assessment that questions as well as encourages it, without production standards that free rather than limit the imagination. Engaging with the mainstream on our terms seems imperative, if we are not to simply witness 'lesbianism' manufactured into 'chic.' Alternative representations need to emerge.

The question of course remains of how far is it possible to engage with the dominant culture as an individual artist or group of artists, without being appropriated. I suggest that rather than accept an omnipotent all-consuming power inherent in dominant structures, it is both more productive and transgressive to search for the gaps/in-between spaces/ways of breaking through those structures with your sanity and artistic integrity intact. No one anyhow can totally exist *outside* the dominant culture, so we might as well claim the

power to change it from within since it's already *inside* us, hence to a degree subject to our individual agency. I believe that it is necessary now in the late nineties to devise and develop ways that constructively and effectively bridge the margin with the center, the sub-cultural with the dom-cultural, the fringe with the West End.

THE RISE OF THE SOLO PERFORMER

An interesting recent development in lesbian theatre in Britain has been the rise of the solo performer, who somehow epitomizes that bridge between the margin and the center. One such example is the dance theatre artist Emilyn Claid, who smoothly shifts between the dominant dance establishment of Sadler's Wells and the fringe dominion of Gay Sweatshop, the oldest Lesbian and Gay theatre company in Britain, which *still* remains in the fringe after 25 years of existence! [Gay Sweatshop has lost its funding and no longer exists.] Likewise, performance poet Patience Agbabi glides between the Royal Albert Hall and an unknown performance space in the East End of London, while Scottish stand-up comedian Rhona Cameron hosts prime-time T.V. shows *and* small, lesbian nightclubs like CUM in South London.

Lesbian drag queens and particularly drag kings have generated a lot of interest in the mainstream media and have been featured in T.V. chat shows and national newspapers. Has this helped reshape and redefine gender as something culturally constructed and fluid? Has it produced a wider acceptability of the diversity of lesbians? It is hard to assess without detailed statistical evidence, but empirically many lesbians, myself included, have noted how much easier it has become in the urban centers, at least, to be openly a dyke. It attracts a lot less hostility; if anything hostility has been replaced by a strange mix of fascination and curiosity. But curiosity is never a bad thing. It leads to asking questions.

LESBIAN AESTHETICS

What of lesbian aesthetics then? Can one be said to exist? It appears that historically three strands of lesbian theatre—here simply

defined as theatre created by lesbians and foregrounding the lesbian experience–have emerged: lesbian theatre companies, individual playwrights, and solo performers. At the risk of generalizing, I'd venture asserting that the lesbian theatre companies of the seventies and eighties, and the playwrights closely associated with them (e.g., Siren and Tash Fairbanks; Bryony Lavery and Dramatrix; Holly Hughes and Split Britches), have predominantly produced pastiche, at times of a dark kind (e.g., Holly Hughes's dykenoir). The Butch and Femme dynamic runs through most of their productions and to a large degree is defining their aesthetic.[8] In the nineties, new theatre companies such as Spin/Stir and ObScene have become a lot more experimental in both form and content, combining a 'feminine aesthetic' with the theatre of the absurd.

Individual playwrights of the eighties and nineties such as Sarah Daniels, Penny Casdagli, Maya Chowdhry, Jackie Kay, Phyllis Nage, Nina Rapi and Jacqueline Rudet have employed a number of different forms, styles and structures: from realism to surrealism; from drama to tragi-comedy; from linear to elliptical to choreopoem.[9]

However, despite the apparent differences between the companies and the individual playwrights, certain common characteristics can be detected. In a paper I wrote a few years ago I identified the following elements for a lesbian theatre aesthetic: "the freedom-confinement dynamic, with or without role-playing but definitely with inter-subjective reciprocity; 'distancing' role from 'essential being,' and 'woman' and 'man,' the social constructs, from male and female, the biological entities, either through butch and femme or androgyny."[10] It was further added that the socio-cultural positioning of the playwright will further influence her aesthetic, such as Jackie Kay's choreopoem written in the tradition established by Ntozake Shange. Petra Kuppers identifies a possible lesbian aesthetic as "the embrace of disruption, the embrace of the Grotesque."[11] Bonnie Zimmerman asserts that "in general, lesbian critical reading proposes the blurring of boundaries between self and other, subject and object, lover and beloved, as the lesbian moment in any text."[12]

Artists who certainly seem to personify this blurring of self and other in their work, as Barbra Egervary points out, are solo perform-

ers like Helena Goldwater and Helen Paris. Their aesthetic appears to be that of 'The Monstrous Feminine,' as Egervary terms it.[13]

Drag queens such as Cathy P, Queenie aka Valerie Mason-John, and Amy Lame use mostly pastiche, even though Queenie is venturing into new territory with her new short show "Sweep under the Carpet," a biting satire.

Stand-up comedians like Rhona Cameron mentioned above, Donna McPhail, Lia Delaria and Maria Esposito, are fast establishing a dykerap form of comedy that certainly reveals gender to be an artificial construct, played around by dykes on stage, at will.

THE FUTURE

It used to be said in the seventies that the 'Future is Female.' It has been claimed by gay men in positions of power, no less,[14] that the future of theatre is lesbian. Is this true?

There is certainly an energy and vitality in current lesbian performance that is unprecedented. This, however, has mostly manifested itself in solo work. The new companies that have emerged in the nineties and the old ones that continue to exist (e.g., Split Britches) are yet to make any major inroads into arenas other than strictly lesbian. As such, their influence remains limited.

Individual playwrights are continuing to create work that crosses the boundaries between the lesbian sub-culture and a wider audience. But how far are they allowed to succeed? In the British context at least, "name" lesbians can comfortably be counted with the fingers of one hand. And even so, it appears that mainstream media and/or the dominant theatre can only really accommodate *one* name lesbian playwright at a time. Witness the demise of Sarah Daniels upon the rise of Phyllis Nage, and the demise of Phyllis Nage upon the rise of Sarah Kane. Other playwrights like Penny Casdagli, Maya Chowdhry, Jackie Kay, Nina Rapi and Jacqueline Rudet, widely produced and published, enjoy varying degrees of recognition but remain unknown by the wider public with the exception of Jackie Kay, who is mostly known for her poetry though. Bryony Lavery is another writer who has become accepted by the academic if not the critical establishment, while Tash Fairbanks has given up in disgusted anger at all the obstacles she has faced and still has to face.[15]

Overall, I would argue that the future of lesbian performance

looks rather promising. This optimism is largely based on the confidence evinced by lesbian practitioners, as well as the changes that have incurred in the past few years in the theatre world (in terms of venues, critical reception and production possibilities). Both are making the staging of lesbian work feasible in venues other than the traditional fringe 'black box.' It will be interesting to see the changes and developments in lesbian aesthetics as the venues, production standards, critical reception and audiences evolve. The result might very well be spectacular.

London, November 1996

NOTES AND REFERENCES

1. PERFORMATIVITY AND PERFORMANCE, Andrew Parker & Eve Kosofsky Sedgwick, eds. (Routledge 1995).

2. See BODIES THAT MATTER, Judith Butler (Routledge 1993).

3. See GENDER TROUBLE, Judith Butler (Routledge 1990), p. 31.

4. See "The Point of View: Universal or Particular," by Monique Wittig, *Feminist Issues*, Fall 1983, pp. 63-9.

5. This is an expression I read in James Baldwin's ANOTHER COUNTRY (Black Swan 1987), p. 116. It has somehow made a lasting impression on me.

6. BLASTED and PHAEDRA's LOVE, by Sarah Kane (Methuen 1997).

7. See "Drama Queens: Ruling with a Rod of Irony," by Joelle Taylor, in this collection.

8. See "Towards a Butch/Femme Aesthetic," by Sue-Ellen Case in MAKING A SPECTACLE: FEMINIST ESSAYS ON CONTEMPORARY WOMEN'S THEATRE, ed. Lynda Hart (Ann Arbor: University of Michigan Press, 1989), pp. 282-99.

9. See "That's why you are so Queer: The Representation of Lesbian Sexuality in Theatre," by Nina Rapi, in DARING TO DISSENT, ed. Liz Gibbs (Cassell, 1994), pp. 37-65.

10. See "Hide and Seek: The Search for a Lesbian Theatre Aesthetic," by Nina Rapi, in NEW THEATRE QUARTERLY, No. 34 (Cambridge University Press, May 1993), pp. 147-158.

11. See "Vanishing in your Face: Embodiment and Representation in Lesbian Dance Performance," by Petra Kuppers, in this collection.

12. "Lesbians like this and like that," by Bonnie Zimmerman, in NEW LESBIAN CRITICISM, ed. Sally Munt (Harvester Wheatsheaf, 1992), p. 110.

13. See "Another Con-Text," by Barbra Egervary, in this collection.

14. Neil Bartlett, Queer Up North, 1994.

15. See "From Stage to Screen and Back," by Jan Goulden in this collection; and interview of Tash Fairbanks in FEMINIST STAGES, ed. Lizbeth Goodman, Harwood Academic Publishers, 1996.

Living Performance

Maya Chowdhry

When lesbians move into the area of performing, the rules and assumptions which pull us towards society's bounded gender and sexual roles start to be challenged, either through performing characters alien to ourselves or through performing our own texts as lesbians. If and when we identify as a lesbian performer we move into another arena. Labelling our sexuality and gender brings them into being: they are creatures which haunt us, chide us and chastise us until we learn to live with or without them.

Performances ask questions, raise conflicts, move towards resolutions: as a lesbian performer my identities are continually challenged. I use my own life-stories as a basis for my text; as a lesbian and a Black[1] woman the conflicts which produce the most challenging material for me and my audiences are around my identity. As women we learn our relationship model from mothers and fathers, men and women; as performers we delve deep into all our relationships, performing our lives.

In this introduction I want to explore these areas through my own writing and performing experiences and link these to some of the work contained in this collection.

Address correspondence to Maya Chowdhry, 18 Vickers Road, Sheffield S5 6UZ, United Kingdom.

[Haworth co-indexing entry note]: "Living Performance." Chowdhry, Maya. Co-published simultaneously in *Journal of Lesbian Studies* (The Haworth Press, Inc.) Vol. 2, No. 2/3, 1998, pp. 9-20; and: *Acts of Passion: Sexuality, Gender and Performance* (ed: Nina Rapi, and Maya Chowdhry) The Haworth Press, Inc., 1998, pp. 9-20; and: *Acts of Passion: Sexuality, Gender and Performance* (ed: Nina Rapi, and Maya Chowdhry) Harrington Park Press, an imprint of The Haworth Press, Inc., 1998, pp. 9-20. Single or multiple copies of this article are available for a fee from The Haworth Document Delivery Service [1-800-342-9678, 9:00 a.m. - 5:00 p.m. (EST). E-mail address: getinfo@haworthpressinc.com].

NAMING

In my family I was labelled 'the shy one.' I was a thinker and I'd be wrenched out of my thoughts by my mum regularly chanting, "This is Maya, she's the shy one." To avoid the embarrassment from the poking and cooing which ensued I quickly learnt to transform–to concentrate on communicating with the outside world, whilst my heart longed to sing itself to sleep, dreaming of forests, caves, and girls in tree-houses: I learnt to perform.

I was/am mixed race/heritage/parentage. From an early age I learnt to perform my identity following the "Where are you from?" question. The performance text ranged from: "Scotland, where d'you think?" to "My dad's from the Punjab" to "My dad was born in the North West Frontier state of Pakistan and my mum's from Kent with Scottish and French ancestry, McLarens from near Aberdeen." Later, when I discovered there was a sexual identity to be had, I learnt to perform the ritual of "my girlfriend lives in Sheffield" in answer to the "Are you married?" question. Gender was more difficult to find a performance text for. I thought I was a girl: I played with Sindy's Supershow whilst my brother lowered her out of the Attic window on yellow wool; I climbed trees and lived in trousers; I was called a nice wee laddie when I had my hair short. But at school I went to the girl's loo and liked the Bay City Rollers–I probably was a girl! So I learnt to say "No, I don't like spiders," "Yes, I might marry a man," and "No sugar, I'm sweet enough."

I began writing to stay above water; I wrote to survive teenage years: crushes, exams, obsessional cooking–my poetry was a lifeline. When my poetry was published I was asked to read at the launch–to perform my life. It slipped easily off the tongue: I had had years of performing answers to society's questions about my identities; I had written about the questions, searching for my true identity. Readings became performances, multi-media shows, commissions. Suddenly my identity was captured, fractured, sliced and served to audiences and I was a 'live' challenge to myself. Did I now have the answers?

> There are rooms in Pakistan which avoid me, old stone houses carved from exile. At night the stone transforms

and women's voices cry, their smooth skin blends into sand-
stone tomb.

She wears red chillies in her hair,
walks 30 miles for water and returns
to find her children turned to dust.
The rain is a gift she has not received,
death finds places to talk to her, her mother's songs
are her grandmother's dreams, her daughter's nightmares.

There are flames and silence in these houses,
the sandstone women are married
to death. An old woman painted my hands
like a virgin bride while I searched in her eyes for a flicker of
belonging.

Three nights and two cultures I wandered in desert
lands, dreaming of sandstone women in village
houses, digging for roots, ginger and
religion. Her head is sprinkled with water,
cleansing she passes prasaed to her daughter,
two hands, blessing. In the mirrors
of her kameez she watches
the eyes of sandstone women narrow and close.

She remembers her mother never
cut her hair, she remembers
it coarse and grey, she remembers the eyes
of sandstone women, she remembers three cultures,
two nights, that roots make a difference. In
her first language
she learns to say mother, in her second home, she remembers
sandstone women, in her dreams
she goes home with them.

The boundaries of land shatter memory,
there is no map to lead my family
home. They travel to voices

and words become death. The colour of my roots
makes me shout. I am located in earth,
my feet have no voice,
I am located in sound, I walk into language.

There are marriage rooms
in this story. She has more language
than difference, she speaks root words,
looks for rivers in the desert,
knows places to die with sandstone women, closes her eyes.[2]

The words tear at my skin; I search through my wardrobe for a suitable 'costume' to perform in: Asian Lesbian, Indian woman, Black dyke–who do I want to be? What do I want to perform?

PERFORMING

If I consider my early performances, the most obvious identity presented to audiences is Black woman. Although sexuality was never a theme it was obvious from some parts of the text that I was a lesbian. Some of the experiences presented in the text could only happen to a Black woman or a lesbian. At the same time I became frustrated with these, sometimes narrow, definitions of my life and identities.[3]

The poetry of my readings demanded other formats to present their complex ideas–projected photographic images were used to highlight and question the text. This allowed my work to move away from the 'solo performer talking about her life' stance which (although fiction was integrated with autobiographical material) the audience seemed to believe was my life story. The new format allowed for more than one representation: I could present a wide range of images of people, objects and places meaning I needn't leave it to the audience to imagine and, sometimes narrowly, define the landscape of my life.

MONSOON

My work as a performer developed from the poetry of 'my life.' My first major international performance, *Monsoon*, took the par-

Maya Chowdhry

Photo by Jan Wells. Used by permission.

allels of menstruation and the monsoon as metaphor for the cycles of life. At the center of this theme is woman as life-giver. The piece wove poetic text and images around the theme of birth, life and death. It was performed with a chorus of three women.

> The birth of Maya
> the beginning of time
> I cannot see my growing
> the new moon in my eyes.
>
> Spring to summer
> I shout and scream
> can find no peace
> everything is too big and small
> all at once.
>
> The air is laden
> with the heat of summer
> and promises to the land
> that growth and change will come.
>
> From the darkness of this cave
> I wait noon to noon
> for the moon-dew
> under a lowering monsoon sky.
>
> The heaven's have opened
> first drops fall
> heavy and full
> absorbing the dry air.
>
> From a steady trickle
> to a torrent
> the roads are awash
> rivers cascading
> and overflowing
> the dust of the earth
> is reborn
> the water giving life.

The heaven's have opened
and my womb has shed her lining
and flows endlessly
for days.

The flesh of Durga
fighting for change
the hungry red earth heaving
and growing.

I cannot look at the sun,
or swim in the seas,
or speak,
or behold the altar fire
in the temple of Durga
my womb sanctuary.

I feel wet and heavy
I feel bloated
and weak
I sense gravity
claiming my ocean of blood,
stained sheets
menstrual madness
bringing me closer
to the earth
Moon blood in my eyes.

Winter comes
my womb begins again
to prepare me for birth
to create life
a fruit for each month.
I flow
with the seasons
create my own seasons
am surprised
when the rain stops.

The soul of Uma
flying free,
Himalaya, heaven and mountain.

Before death
Kali devouring time
and after.[4]

This performance was programmed in a woman's festival high-lighting the gender of the performers and the gendering of the themes. In this way I am identified not only as woman, but woman speaking about women, about their bodies and all that makes us the beings we are. This type of woman who admits that she bleeds and that the intensity of her cycle puts her in touch with her spirituality is the type of femininity 'conjured as monstrous.'[5]

In this performance and through the themes of this writing I'm searching for a style and type of performance which comes from and is in essence all woman.[6] I perform text in which 'we write ourselves.'[7]

THE SACRED HOUSE

My first major performance commission, *The Sacred House*,[8] used the houses of my astrological chart as both structure for the piece and theme. In terms of content the houses of my astrological chart are examined in relation to the houses I inhabit in my life. For example, in House One, which signifies 'the self' in the astrological chart, I contemplate how I can be connected to two continents whose histories are opposed to each other:

The sea travels from
Mandvi to Ganga Sagar knows
no cease-fire
line or the difference
between an European and an Indian
body except the sea
knows me my brown skin
travels from Mandvi

to Ganga Sagar unravelling
around the coasts of India
travelling from
the Arabian Sea to the Bay
of Bengal the sea travels across
oceans and does not know that one
country has ended and another began
that the spices in Sainsburys
travel
that the silk in Libertys travels
that people travel
except the sea
finds their bodies
on her ocean bed
and unpicks their flesh until
they are bones
and only the sea knows where
she has hidden them.[9]

As a structure the performance is cyclical, moving away from birth as a beginning and death as an end, as in a traditional narrative, and towards the 'feminine morphology'[10] through writing about female biological experience and the cyclical essence of woman. Thus the identity of the work becomes feminine by nature of its structure and its inherent cyclical content. Further, although some of the content is connected to the body, the form of this work does not collude "with the tradition of the feminine associated with the organic body and the masculine with the technological mind."[11] Instead, through the use of video images and other technologies, it questions the perceptions of what is masculine and feminine.

ANNANDAA: THE GODDESS OF FOOD

Annandaa: The Goddess of Food explores the obsessions and contradictions of women and food. Contrary to work where the text indicates the necessity of food, my presence on stage excluded it. Using text which explores the kitchen as a battle-ground, this performance follows the journey of a young Indian woman who wants

to cook to heal the wounds of her family whilst avoiding the war between her parents. Cultural aspects of food are explored alongside symbolic aspects of food in the family. Visuals, in the form of projected images, are used to translate the ideas and symbols and poetic text/monologue to tell the story. As in all my performances a poetic text is used to tell the story, drawing on my unconscious: and this combined with the content—where food is used as symbol of both physical and emotional survival—feminizes the performance.

> Her white hands
> burrow through atta, she calls brown flour,
> and he adds pani laughing and she
> says water, he says namak and adds the salt.
>
> Her gold thread sari border shines like
> her newly wedded laughter,
> he taught her recipes and words and threw
>
> Indian customs across oceans and floors, she
> learnt to bow her head
> and raise it only for Angrezi parties.
>
> Some of her children slipped from her, clotted
> blood sliding
> between her legs and
> girl children flowed like monsoon rain until a
> boychild she
> thought she'd delivered happiness but
> nothing changed.
>
> Her kheema learns to fly,
> she scrubs
> the stubborn haldi from the walls, it smiles
> yellow like
> the August sun on her wedding day.[12]

These performances deal with identity, with aspects of gender and sexuality. I made careful choices about what to include and how to present myself but I did not ask the following questions: If I am a

woman and a lesbian then how can I present my identity without including these aspects of it? How is my sexuality conveyed in this performance? How do we perceive a lesbian visually? Do I make my sexuality explicit? How do I? Do I want to? Can I disguise my gender? Do I want to?

DEFINITIONS

I have performed at women's festivals, in Black seasons, Live Art festivals and lesbian and gay festivals. I have chosen to appear in these and so have chosen to define my sexuality and gender in the broad classifications of woman, Black and lesbian. It is part of what I did in my ad lib self-definition performances on the streets of my growing up.

After performances about parts of my life which tear my heart out I search for a new identity. I decide I need to be tougher to perform on the Live Art circuit and begin a Joinery course. An Asian dyke rip-sawing, layers splinter, identities fragment, the smell of pine sap hits my nostrils; new lines of creativity are born.

I watch the heterosexual world of white-male Joiners and Carpenters go to work. I examine their designs. Scottish, Indian, Lesbian, my identity designs grow from 'Star-lights' to sculpted skirting. I wear steel-toe-capped boots and jeans when I go dancing and I don't fit into that stereotyped shy-Asian-femme-character I've been all my life.

NOTES

1. 'Black' as used here and capitalized denotes a political identity. As there is no definite consensus among artists and activists about the use of a lower or uppercase character for this word we have in this collection used both as chosen by individual writers to reflect this fact. Thus I use the term in a way which highlights my experience. Furthermore, in the United Kingdom, 'Black' is used to refer to people of color in general, not just to people of African descent.

2. From *The Sacred House*, Institute of Contemporary Arts, 1993.

3. See Hill, Atherton and Hensman in this collection for further discussion of the self in performance.

4. From *Monsoon*, performed at The Women's Festival, Highways Performance Space, Los Angeles, April 1993, 60 minutes.

5. Gilson-Ellis, "Get Your Feminism Off My Floppy: Seedy ROM's and Technical Tales," in this collection, discusses the association of femininity with un-bound flow.

6. See Helene Cixous, "The Laugh of the Medusa," *Signs* (summer 1976) for a perspective on woman writing from the body.

7. Taylor, "Drama Queens: Ruling with a Rod of Irony," in this collection.

8. First performed in a season of Black performances at the Institute of Contemporary Art, October 1993.

9. as [2].

10. See Taylor in this collection for a description of this.

11. as [5].

12. From *Annandaa: The Goddess of Food*, first performed at Spacex Gallery, Exeter, October 1994 in a programme of visual and performance work about women and food.

PART ONE:
THE MONSTROUS FEMININE:
LESBIAN AESTHETICS IN PROCESS

Another Con-Text

Barbra Egervary

SUMMARY. Increasingly, performance by women questions existing binary definitions of gender and sexuality by destabilizing familiar notions of the 'real' and creating new production values and aesthetics in the process. This paper explores three theatre companies (Spin/Stir; Amy Roadstone Productions; ObScene Productions) and two performing artists (Helena Goldwater and Helen Paris), all U.K.

Barbra Egervary is Artistic Director of ObScene Productions. Her previous work includes producing as Co-Artistic Director of the Pride Arts Festival '95 (a combined arts festival of contemporary queer arts) and Project Manager for Freedom Arts Festival (the successor to P.A.F. '95). She has written various articles and reviews on British and international art and is currently writing and translating for performance.

Address correspondence to Barbra Egervary, 88 Riverside Close, London, E5 9SS United Kingdom.

[Haworth co-indexing entry note]: "Another Con-Text." Egervary, Barbra. Co-published simultaneously in *Journal of Lesbian Studies* (The Haworth Press, Inc.) Vol. 2, No. 2/3, 1998, pp. 21-45; and: *Acts of Passion: Sexuality, Gender and Performance* (ed: Nina Rapi, and Maya Chowdhry) The Haworth Press, Inc., 1998, pp. 21-45; and: *Acts of Passion: Sexuality, Gender and Performance* (ed: Nina Rapi, and Maya Chowdhry) Harrington Park Press, an imprint of The Haworth Press, Inc., 1998, pp. 21-45. Single or multiple copies of this article are available for a fee from The Haworth Document Delivery Service [1-800-342-9678, 9:00 a.m. - 5:00 p.m. (EST). E-mail address: getinfo@haworthpressinc.com].

based and at the cutting edge of contemporary lesbian performance, who personify these developments. *[Article copies available for a fee from The Haworth Document Delivery Service: 1-800-342-9678. E-mail address: getinfo@haworthpressinc.com]*

The effort to 'cite' the performance that interests us even as it disappears is much like the effort to find the word to say what we mean. It can't be done, but the futile looking attaches us again to Hope. It's impossible to succeed, but writing's supplement traces the architecture of the ruin's Hope (endlessly to return, reconstruct, represent, remember).

<div align="right">

Peggy Phelan:
"Reciting the Citation of Others"[1]

</div>

My desire for creating a theatrical representation of a woman is neither scopophilic nor tactile per se but rather based on the pleasure of building a space, in this case a theatrical one, where 'self-representation' can occur.

<div align="right">

Nina Rapi:
"Speaking in Tongues but in Whose Language?
In Search of Female Aesthetics"[2]

</div>

Between the ruins and the building, between hope and desire, between thought and creation, lie the words which mark our endless efforts to recapture the performance which is absolute in the moment. Between the cunt and the text lies a moment of creativity in which we birth ourselves–as women, as individuals, as divine in our ability to re-vive ourselves and each other. When you perform your words, you touch the innermost part of me. This is how we look for and find each other–cunt, text, cunt. The spaces we build are of us, about us and for us. As unique as is the nature of desire to each woman, so the space which she builds; but she builds for us all. Something in me changes irrevocably when you touch me, and I return to your fingerprint, to the memory of that touch. So I return to performances that have changed me in the knowledge that my words can no more cite them than I can recapture your touch, but in the hope that by 'tracing the architecture' of the ruin–the memory–we can between us begin to recreate the magic of that touch.

The discrepancy which prevails between the volume and diversity of women's performance being produced and the critical writing which seeks to represent it is such that one can only begin by touching on as many areas of inquiry as possible, in the hope that threads will be picked up by others and woven into ropes of critical attention. In looking at some of the work produced by women which has most recently captivated me, I discover an abundance of interest which these words can only begin to explore. At every level of inquiry, there are examples of women's performance which lead us into uncharted territories; from questions of programming and producing to discussions regarding form, content and aesthetics, to documentation and modes and means of theorizing women's performance. Here, then, is a beginning–the bricks from the ruin which become the foundation of ever new spaces in which to represent ourselves.

FRAMING THE FEMALE

Feminist critical analysis has revealed the manner in which women are represented in the signifying system of a patriarchal society as absent. Within a signifying system which conflates the lack of a penis with the lack of that which the phallus signifies (in relation to power, choice, determinism, activity, agency), which represents the female as lack, as absence, comes a displacement of the female subject from the symbolic order. 'Woman,' on stage as in society, becomes an indeterminate force which accrues meaning and significance only by warrant of not being male; by opposition to that gender which does bear meaning within the order of the Father.

The theatrical frame is a forum where every sign, be it visual, spatial, temporal or linguistic, is assumed by the spectator to bear meaning. The spectator willfully searches for meaning in order to construct a narrative which renders the seen and heard a coherent whole; one which reflects and facilitates reflection upon, the stuff of her own life. As Elin Diamond, in her essay on Caryl Churchill's theatre, writes:

> The theatre wants us all to believe–or at least accept–its representations, and in doing so we ratify the power that authorises them.[3]

By placing the female body as metonym[4] center-stage, occupying the signifying space of the stage, women working in theatre challenge the notion of female absence and confound the processes of objectification by the spectator by extreme self-objectification. Increasingly, performance by women questions existing binary definitions of gender and sexuality which reflects on the 'real' in such a way that our perception of it is destabilized and questions arise as to the validity of discursive paradigms which place the female in the context of a binary opposition which marks it as lack, as absence, as ultimately inferior. By placing the self as woman at the intersections between definitions, the performer brings into question the currency of the definitions themselves, introducing an element of doubt which effects a dislocation from given categorizations. Thus the woman as performer finally occupies a nebulous, indefinable space which sets her outside the terms of discourse so completely that she cannot in any tangible way be 'consumed' by the spectator, but generates instead her own representational paradigms.

SPIN/STIR WOMEN'S PHYSICAL THEATRE COLLECTIVE: FEMININE MORPHOLOGY AS FEMINIST AESTHETIC

Spin/Stir is structured in the eighties feminist theatre tradition of women's collectives; drawing on a predominantly feminist audience, its work emphasizes the exploration of a 'feminist aesthetic.' The collective was established in early 1992 by Joelle Taylor and Vanessa Lee as a partnership which invites other members to join on a temporary basis. The members of the collective have a background in theatre and performance poetry, and are trained in rape crisis counselling. Their commitment is to a theatre which "focuses on the bitter edge of sexual politics and the experience of 'woman.' "[5] The collective has produced two plays to date—*Naming* and *Whorror Stories*—both written and co-directed by Joelle Taylor and premiered at the Oval House Theatre.

Naming was the culmination of a six-month research period into feminist theatre process as relevant to an exploration of issues surrounding child sexual abuse. The piece demonstrates Taylor's exposition of female experiences of abuse and the resultant self-

alienation through the use of the fractured languages of text and body. Short, episodic scenes, wild gesture and parodic characterization, the use of sound generated by movement, poetic and fragmented speech, voice-over and television footage all make up what Taylor describes as "feminine morphology as feminist aesthetic." Her characters are those of the self-lacerating child, the confused and controlling mother of the abused child, the abusive lover, the suicidal survivor. Her approach to the issues surrounding child sexual abuse–which she wants people to view as political issues–is to write "something that tells the truth, however dirty and nasty it is, about survival."[6]

Whorror Stories approaches the 'monstrous feminine' through the techniques of contemporary horror, feminist deconstruction and physical theatre. The four central characters in the piece are spiders, emblematic of the culturally endorsed fear of female sexuality; the Tarantula on stilts, the Black Widow, the Wolf Spider and the House Spider. Each spider is symbolic of a socio-cultural stereotype of "Woman." The spiders live in the basement of a house, weaving a web which is narrative and structure of the piece.

The threads of the web are stories of women's lives: the Child Star, trapped in a large, gilded bird cage, relating her story of child pornography; the victim of psychotherapy and psychic invasion; the woman returning to her father's house after his death and starving herself to become weightless enough to walk the web from her bed without alerting the spiders and escape; the child brought up for fourteen years as a dog who kills the members of her family, dresses in her mother's skin and lures men to an unsuspecting death. These are the nightmare characters of the 'monstrous feminine,' survivors of abuse who become executors of their abusers. The only male character is that of a serial-killer who imprisons pregnant women until they give birth, walls them up and sews the babies into dolls– killed in turn by the women he has walled up,

Harrowing and nightmarish, *Naming* and *Whorror Stories* present a theatre which does not shy away from some of the most difficult stories women have to tell, the fact and effect of abuse. These are not plays which look to communicate to a mainstream audience the experiences of women who have suffered abuse, but a means of validating women's worst experiences to themselves.

AMY ROADSTONE PRODUCTIONS:
WRITING SEXUALITY INTO AN ACCESSIBLE SYSTEM

Amy Roadstone is the context in which writer Jyll Bradley has produced her work in its various forms, from her plays (*On the Playing Fields of Her Rejection*, Institute of Contemporary Arts and Drill Hall, and *Irene Is Tied Up (With Concert Arrangements)* ICA—Institute for Contemporary Art) to poetry readings (*Breast Pocket*, ICA). Bradley describes the aims of Amy Roadstone as providing challenging, complex roles for women in theatre, inventing new written and visual languages for a women's theatre that innovates and entertains, exploring some indigenous theatre traditions (such as music hall, vaudeville and the 'pleasure garden') in order to do this. She looks to "create a theatre of female sexuality, not a theatre about female sexuality,"[7] "to work with humor, naughtiness to create a women's theatre which is as celebratory in its 'difficulty' as in its 'accessibility' to a wide audience."

In the context of Amy Roadstone, Bradley is able to oversee the production of her work by appointing her own female creative team for each production, allowing for a shared vision of the work but also to "ultimately have control over my own work and its representation." She considers one of the pitfalls of a collective theatre to be that the identity of individuals as artists and creators is subsumed to the collective, and endeavors to counteract this tendency by promoting individual artists within each production.

On the Playing Fields of Her Rejection places a female sexual agenda within the context of the tradition of absurdist theatre. It follows the initiation of four women into lesbian sex and sexuality, showing them as apprentice 'gardeners' to the object of their desire: Lady Jane. The character of Lady Jane is attended by her four sub-personalities, Jane Eyre, Jane Austen, Jane Seymour and Jane, Jane, Tall as a crane.

The play is "an evolving, theatrical pleasure garden, rather than a piece 'about' pleasure gardens." It is Bradley's approach to asserting the "power and diversity of sexuality in general and women's sexuality in particular by *writing sexuality* rather than *writing about* issues of sexuality, such as adultery, homosexuality, etc. This is done in my belief that the production of text, both in its writing,

reading and performing constitutes *an act of proposition or seduction* in itself and herein lies the power to effect."

Beyond theatre production, Amy Roadstone seeks to "inspire intellectual debate around female sexuality, its representation, and female humor." Incorporating as it does, the promotion of Bradley's writing in mainstream publication and lending its name to her own site-specific work, Amy Roadstone is evolving into a broad-ranging, multi-faceted production company, which is able to promote and produce work across the spectrum of site, art-form and audience.

With a view to "putting women's work into an accessible system where it may be debated," Bradley places her work in 'mainstream' contexts; she promotes her work in off-West End theatres, through larger publishing houses, and seeks funding not only from established arts funding organizations, but non-arts-specific sources, thus proposing expansion of policy in relation to women's work to potential funders, rather than merely responding to existing funding structures and policies.

In the course of producing and promoting her own work, Bradley is actively opening avenues for other female writers and artists to access a mainstream audience.

ObScene PRODUCTIONS: WHAT CONTEXT?

ObScene Productions was founded as a women's theatre company in 1994 in response to my own sense of a lack of support for female theatre practitioners. Its aim was initially to help create a forum in which it would be possible to investigate performance practice in order to generate increasingly supportive and appropriate contexts for women working in performance. The company's first production—an adaptation of two monologues originally performed by Franca Rame (*Coming Home* and *The Same Old Story*)—was transgressive in terms of fragmenting the space, structure and character coherence of the original text, in order to act as a dialogue around the universality of experience proposed by the definition of 'woman.' The process of eliding two monologues, performed by three actresses moving constantly between charac-

ters, foregrounded both the similarities and particularities of women's experiences.

During rehearsals and through production, the notion of a truly collaborative creative process came under unnecessary strain due to the context within which the work was being created. Preconceptions of individual artists' positions within a conventional theatrical creative process seemed to dictate roles and creative responsibilities. Once an actor/director relationship is established, roles set within that relation become difficult to secede from.

Consequently, whereas the form and content of the production was initiating a dialogue around issues of women's experience of power and powerlessness, the mode of production was exposing perhaps more pressing issues: how much creative input and control can a performer have within the context of a conventional theatrical production, informed as it is by the actor/director relationship?

Recognizing that increasing numbers of female artists were creating solo performances and that there are still only few venues, festivals and production companies in a position to support and produce these performances, I began to look at creating a context which could serve to focus attention on the wealth and quality of work being produced by lesbian performers, and the context in which it was currently being presented, if at all. The result was two seasons of work, one entitled *ObScenities* at the ICA (known for its ground-breaking programming of live and performance art) which included ten artists presenting their work in double-bills over five nights. The season included dance, poetry in performance, a book-reading and several performance artists from widely different backgrounds, both women and men. This was followed by *Scenes from the OutSkirts*, a tour of four of the artists presenting seven pieces in double bills at two fringe theatre venues.

By programming across boundaries of art-form, gender and venue, the seasons sought to make inroads into more fluid approaches to programming and producing, exploring ways in which artists in collaboration with programmers and producers can show pieces in situations which are more appropriate to the nature of their work. Live and performance art in particular (which tends not to be the length of a play made for theatre) is difficult to program and produce, as there are so few venues which have

created a context for it and it is still in the process of developing a substantial audience.

Performance art is proving to be one of the most dynamic forms in which women can create, control and produce their work without artistic constraint. Lesbian practitioners appear to be taking a lead in performance art, a practice which challenges structures and modes of representation on stage. At the forefront of contemporary live and performance art is a cross-section of lesbian practitioners for whom the scope to create and produce their own work in a context which is by its very nature breaking with both theatrical and fine art modes of representation is highly seductive.

HELENA GOLDWATER:
THE DIVINE CHILD PLAYING WITH FEMININITY

Helena Goldwater's performances, emanating from a fine art background, demonstrate the current trend in women's art from the static into the dramatic. Placing herself within her art, finding her voice, Goldwater disrupts the relations between physical, visual and narrative text. The expositional sequence of subject, verb, object is shattered into half sentences, jingles, word-associations, placing the subject always at the edge of discourse.

In *And the Hairs Began to Rise . . . ,* her first widely successful performance piece, Goldwater stands alone on stage in the red dress, wigs, false nails and false eyelashes that constitute her drag/ camp stage persona. In the course of the performance, she removes a golden bag from a dildo harness beneath her dress, removes one wig after another and attaches them around her waist, lip-synchs with a hair-clip to 'Woman in Love' by Barbra Streisand, hides the bag in her hair, rupturing a sachet of milk hidden inside it so that it floods down her face and body.

Hairs . . . transgresses the Freudian theory of the female's desire to transform her whole body–by means of beautification–into a phallic substitute, by transforming her body in the course of the performance into a representation of female genitalia, by reclaiming female ejaculation at the climax of the piece with milk pouring from her hair. Showing us the dildo harness hidden beneath her dress which holds not a penis-substitute, but an iconoclastic representa-

tion of the clitoris—the golden handbag containing "a past exploit, a broken fingernail"[8]—Goldwater disrupts an encultured coding of the female genitalia as absence.

Bringing into the spotlight female genitalia, Goldwater confounds the primary imperative of a gender economy. As Juliet Flower MacCannell defines it:

> What founds our *gender economy* (division of the sexes and their mutual evaluation) is the exclusion of *the mother*, more specifically her body, more precisely yet, her *genitals*. These cannot, must not be *seen*.[9]

Hear Me

Goldwater's language is that of the double-entendre, both as a Jewish woman whose self-expression is mediated by her appearance, and as lesbian performer. Neither her appearance as the glamorous cabaret artist, nor the ordinariness of her references to popular culture are what they appear, but act as referents to that which is off stage, that which is judged unfit to be represented; the female genitals, lesbian romance and Jewish cultural specificity.

Language is reconfigured by experience, both personal and cultural, by history and sexuality. The complex of factors which constitute the artist as individual are translated into signifying paradigms on stage. Goldwater's representation of herself linguistically, physically and visually is filtered entirely through her own experience; her language is at once poetic and popular, marked by her own sense of spirituality, divinity and the legacy of her position as Jewish woman and lesbian in a signifying system which obscures both.

The sense of not being heard in the world is counteracted by placing herself in the frame of reference. On stage, Goldwater feels she is heard because "the stage says so much more."[10] By creating a self-referential 'dream-state'[11] on stage, Goldwater creates a context in which her voice can be heard. In both *pucker* and *Secrets Galore*, she hangs objects mid-air. Suspended in the course of the performance, Goldwater's objects of desire are suspended not purely in terms of space, but also in time and significance.

Lesbian Drag

Goldwater's persona, with all the trappings of 'femininity,' assumes an agency which is at once a disruption of existing assumptions of the encodings at work in society and within the lesbian community. By seemingly embodying the stereotype of 'woman' in her dress, make-up and delicate accessories, only to shatter them within the context of her text (which has her acting as initiator of a lesbian encounter), she disrupts the spectator's reading of the persona, challenging the naturalness of all such readings. She brings into question the lesbian binary opposition of 'butch' and 'femme,' wearing the outward guise of a 'femme,' whilst showing the dildo harness which in lesbian parlance equates with the 'butch.' The result is a fluidity of definition, both of her sexuality and the expression of that sexuality. She represents a continuum of identification, from the appearance of a heterosexual woman to the 'appearance' of a lesbian; from the guise of a 'femme' to the action of a 'butch.'

For Goldwater, drag is related primarily to her Jewishness. In reclaiming the outward signs of femininity, she reclaims an affiliation with the female members of her family, and with what she might have been herself, had it not been for the fact that she is a lesbian. It is as much an expression of yearning for closeness with her sister, mother and aunts as a parody of them.

This is a "playing with femininity and how men do drag."[12] Goldwater's persona is not "the hysterical parody of femaleness"[13] of male drag artists, but a reclamation of the history of drag as originating from such women as Mae West and Marlene Dietrich and from her own female cultural heritage: "It is an issue for Jewish women how they look, particularly having long hair. It's a question of cultural placing."[14] Her performances are centered around the search for "das Heimliche," "reclaiming it in a very fundamental and profound way–existing in no place and a multitude of places at the same time."[15]

A Divine Act of Transformation

Secrets Galore is set in Goldwater's hallway, with a telephone seat, a kitsch fountain lamp sporting two mermaids, a record player

and microphone (necessary to be heard even in her own space). She moves constantly between the objects, pulling records from the telephone seat and playing them—everything from Barbra Streisand songs to Yiddish humor—on the record player as she talks. She takes Groucho masks from the back of the telephone seat, tossing them one at a time into a heap on the floor, picks each up and drops it behind her back into the drawer of the telephone seat. Later she takes them out, removes the gold-painted noses, and hangs them from hooks across the stage, elevating them to the monumental.

Goldwater's work foregrounds the process of transformation out of destruction; dousing her carefully made-up persona—wigs, dress, shoes and all—in milk in *Hairs . . .* , soaking both stage and props with melting ice in *pucker*, tearing the lining of a telephone seat to hide her 'secrets,' she poses the question of whether she is destroying or resurrecting both the objects and herself in the process. She expresses the need to transform in order to uncover a sense of self, to measure ourselves against others and transform ourselves, looking at whether these processes are anti-semitic and homophobic, or simply intrinsic to marginal cultures.

In "trying to understand who we are in the world,"[16] Goldwater invests objects with the significance of her own personal history; they come to reflect and represent her in ways which take the performer from the personal to the public. Through her intensive focus on the objects on stage as bearing meaning for her, the objects themselves "speak volumes."[17]

In *Secrets Galore*, objects give up their 'secrets' in a tangible way (Goldwater pulls shoes, records, a telephone and locks of hair from a telephone seat), as representation of Goldwater giving up her secrets. Are these truly secrets, or merely that which we cannot or will not hear, secrets by warrant of the processes of obscuration and obfuscation of Jewish cultural stereotyping and lesbian stereotyping?

Goldwater is facilitator and transformer of the objects on stage, she transforms them physically, but most significantly, she transforms our perception of them. They speak of her, illuminate her experience. By confounding our expectations of the objects on stage (we do not expect to find records, a telephone, shoes, locks of hair in a telephone seat, or milk and water to pour from handbags,

or a fountain to respond to having coins thrown in it or light up as if participating in a dialogue with the performer), she opens a space which she herself can fill with meaning.

She uses Groucho masks–objects of mirth–to show how ridicule enables us to stereotype, herd together, treat as collectively value-less–or marked with negative value–hide, obscure, and ultimately so dehumanize as to facilitate the destruction (genocide) of entire communities.

Goldwater describes her work as creating her "own system and trying to believe in it."[18] Her work is philosophical, spiritual, self-defining, based on her own experiences of being a Jewish lesbian. In her work she feels the "need to control, but also not to know, to have that spiritual side of things,"[19] to explore the definitions of her by others and by society in general, and her own sense of being a "divine child–special, but being persecuted for it."[20] Her choice of drag is a means of allowing herself as performer to find a persona which can express things in a way that she cannot.

Goldwater's is a representation of lesbian identity, sex and sexuality, of the lesbian body on stage which is elevated to an iconic representation of divinity and spirituality, maintaining a strong, if critical, relationship to her own personal, family and cultural history. Reworking rather than destroying, recreating something in her own image that is not a denial of her Jewish history, as well as reclaiming our history as lesbians, she exposes the self as lesbian as well as revealing the lesbian Other.

Her performance focuses on the self, but in representational form. There is an emphasis on Goldwater's name in her work, and how others have commented on it ("I would like some of that"),[21] on her name and those who name her. She comments: "At present I make my own"[22] (make myself, my name, my sexuality), and asks: "Am I a counterfeiter?"[23] Who knows me? Who can know the self? Do others know me better than I know myself? There is the sense of others having a greater insight, or is it that we give them the power of knowledge and disempower ourselves with it? Her conclusion is: "How can they have the gall to press on my bladder when they barely know me?"[24] How can they dare to seek to represent/re-present my name when they cannot know the ontological insecurity it produces in me? "I would rather press on my own

bladder".[25] I would rather squeeze out some representation of myself for myself, even though: "I have no answers."[26]

HELEN PARIS: I AM GETTING OFF ON MY SMELL– CAN YOU SMELL ME?

Helen Paris's solo performance work investigates the eroticism of the female performer, utilizing the sexual relationship between the performer and her audience and showing what she describes as the 'darker side' of female sexuality. Her work is confrontational in its challenge to every aspect of the performance event: what of the female is seen on stage, what in performance extends the boundaries of the art-form, what are the forms in which the 'monstrous feminine' can be interrogated, what modes of presentation can disrupt the 'safe' space for an audience, what are the expectations of the performer, what are the processes which ratify misogyny and who defines what it is to be 'queer'? Paris's performances juxtapose the everyday act with the metonymic effect, giving us new ways of viewing and representing experience.

Paris extends the range of languages at the performer's disposal. She incorporates film and video footage, projection, movement and choreography, smell and taste into her performances, using every means of communication at the performer's disposal to create an intimate and rawly personal piece. She performs material which is personal and vulnerable, but tells something hard-hitting, constantly asking questions of the audience and of herself as performer. She plays with the eroticism of the female performer on stage, setting it against scenes in which she masturbates in the 'dirt' and spits and bites herself, showing her experience of the 'darker side' of female sexuality and asking whether a woman can still be considered sexy in the full expression of her sexuality, colored as it is at times by things which we are conditioned to find ugly or repellent.

A Journey of Perversion and Etiquette

"Sniffing the Marigolds" is a "journey of perversion and etiquette";[27] a linguistically and physically choreographed piece

Helen Paris

Photo by Barbra Egervary. Used by permission.

which, by juxtaposing the familiar with extraordinary, reformulates our reception of everyday actions. This is a journey of the female performer's body on stage, a terrain mapped by experience, with the audience cast as voyeurs, at once compelled by the beauty of the figure and thrown from a 'safe' space from which to view her by the experiences she presents.

Paris takes us from one short, absurd situation to another, in turns horrifying, engaging and amusing us with fairy tales which become horror stories of self-abuse, to absurd pastiches, to images of confinement and correction. Perhaps most indicative of Paris's style of performance is an early scene where she shaves her legs, underarms and face, not with a razor, but with garden shears, to the Commodores' "You're once, twice, three times a lady." She takes something intimate and everyday and gives it an edge which makes us ask what effect such habits have on our psyches. Using the shears as a shaving-implement highlights the act as one of self-correction rather than beautification, the displacement of a woman's love for and acceptance of her own body into a fetishization of the tools with which women alter the natural state of their bodies according to social norms.

In one section, Paris reads from the side of a spray-can: "A nice smell for personal feminine use–nice, considerate, subtle, agreeable, especially for men . . . , especially for men . . . , especially for men . . . struation."[28] She sprays the marigolds at the front of the stage, exuding an artificial odor across the auditorium. Equating the words used to sell the product to women pressurized into covering up their own natural smell with the language used to define attributes considered socially acceptable in women, she explodes the myth that such acts of denial of the female body are for women themselves and not for men. These are the mechanisms at work in the cycle of conditioned self-loathing, denial of the female body and transformation of the self into a socially acceptable object of male desire.

Later in the piece, Paris takes Marigold gloves from a bucket, pulling them one after another over her left hand. She then removes them, making a flower of each, chops the blooms from the real flowers and replaces them with the gloves: it is not without destruc-

tion of the natural (female body) that replacement with the artificial can be achieved.

Paris recites the fairy tale of the sleeping princess, told in a child-like voice and rhythm which denote the age at which social conditioning is implemented (the first words the girl-child is encouraged to learn by rote are those which encase her in social norms). She taps out the rhythm of the rhyme first with two fingers on her hand, which escalates into a slapping of her face, chest and legs, leaving the mark of the rhythm inscribed on her body.

Another scene from childhood is also played out in rhythm—that of child sexual abuse. Paris turns her back on the audience as a projection of a photograph of her as a smiling child appears on the screen. We are charmed by the photograph of the child, reading joy in her smiling face. The two fingers still raised from the previous fairy tale scene become a forceful movement of her arm, to the words: "That's good, that's right . . . That's right. That's good. Let me just, let me just . . ."[29] over and over, with increasing force and volume.

Paris's performance draws us in with wit and humor, relating childhood experiences which are familiar to us all, making us feel at ease, and then turning that ease into discomfort by contextualizing familiar experiences within material which is uncomfortable for the viewer. Paris places an emphasis on childhood as the place that unites us through recognition. When, in "Sniffing the Marigolds," she talks about packed lunches, she puts the audience initially at ease. By then placing it in the context of the woman on stage, half-dressed, representing child abuse and masturbation, the effect is far more hard-hitting. Her use of autobiography is not insular, but a way of finding connections with the audience through shared experiences.

Text from *Alice in Wonderland* is used to foreground our reaction to what is seen as ugliness in women, our fear and repulsion of the 'monstrous feminine,' set against her personal experience of how children are conscripted to conform to fashion:

> The Duchess squeezed herself up closer to Alice's side as she spoke. Alice did not much like her keeping so close to her, because the Duchess was very ugly . . . Them shoes aren't

fashionable. The Duchess was very ugly. Them shoes aren't fashionable. Very ugly.[30]

Auto-eroticism is played out against a backdrop of fear and discomfort, materialized in the form of a claustrophobic lurch down an alleyway, realized in film footage on a screen on stage. Paris describes the alleyway as the site of "fears of being lost, loss of identity, sexual anxieties and fantasies."[31] Touching her own body becomes a frenzied activity, displaying at once the fascination and encultured repulsion of the woman for her own body.

Equating the body of the woman and her sexuality with that which is socially marked as 'dirty,' Paris plays out a scene in which she is lying face-down on stage, vocalizing an internal monologue which resists such social encodings:

> In the dirt, on the ground . . . in the dirt, on the ground . . . I can smell myself . . . in the dirt, on the ground . . . I can smell myself . . . I am getting off on my smell . . . can you smell me?[32]

The rhythm of the words is matched by the rhythm of her body, leaving us with no easy reading of whether this is the woman accepting her love of the 'dirt'—of herself as so encoded—or of another woman's body.

Inside Out and Outside In

C'est la Vie en Gai Paris (or, though this be madness, yet there be method acting in it) is a piece about "lobotomies, 'letting go' and lesbian sex."[33] In it, Paris intersperses her performance with video footage of a natural-history program in which a mother spider dies so that her offspring might eat her, two female lizards engage in what looks like simulated lesbian sex to stimulate the production of eggs, and female aphids endlessly reproduce themselves. Against a backdrop of close-up film footage of a conversation between two older women, she 'wanks' the bottom of a tea-cup. She uses anecdotes which are strange but familiar, such as leaving one's purchase behind in a shop, and kissing a woman so hard the string under her

tongue snaps, punctuated by video footage of blue sparks flashing from a train's electricity-cable (electric shock treatment). She tells of how her mother decorated her bedroom "inside out and outside in,"[34] sexualizes home baking, and relates "Six tips on supermarket shopping" and "Six tips on the ice-pick lobotomy."[35] At the close of the piece is a choreographed dance during which she spits into a cake holder and pours the spit back into her mouth, bites herself, leaving teeth marks and strings of saliva hanging from her flesh.

This again, is the distinctive Paris aesthetic; she draws us in with the eroticized and humorous baking scene, only to ask the question of whether her spitting into a cake holder is still sexy; whether a different representation of what of herself a woman puts into mundane tasks is palatable. Allowing for instant audience recognition with her use of the everyday, she displaces it, juxtaposing home baking with female genitalia, afternoon tea with masturbation, natural history programs with lesbian sex, creating a different space for the expression of women's experiences, a space in which assumptions regarding women's experiences of their own bodies, sexuality and history of correction can be questioned.

For Paris, "less is more–minimalism is very interesting. What is the truth of the performer–what is the importance of the performance? Where is the honesty of the performer on stage?"[36] Her work questions what performance is at the end of the twentieth century, with the inclusion of technology–"Where is the female performer amongst all of that? One can add it to work, not as an alienating element or it superseding the importance of the performer on stage, but making the use of different media within a performance intimate and personal."[37]

C'est la Vie en Gai Paris is a powerful and painful approach to the issue of the effect on the female collective unconscious of a history of medical invasion into the female mind, under the guise of correcting symptoms of madness and the underlying evaluation of expressions of female sexuality as signs of madness.

The marks on the body make visible the marks on the psyche–extending beyond the duration of the performance, accruing with the repetition of that performance–what is shown here is a moment, the time it takes to drop a bus-ticket–the marks made (and made visible) in a moment.

C'est la Vie . . . shows us the ways in which we repress our own fears of being defined as insane, our fear of and attraction to the Mother, the fear attendant on allowing ourselves to express that which lies in the recesses of our consciousnesses, and our fear of exposing the inside, both psychologically and physically. The same exposure of underlying sexual expression is reflected in language. Sexuality shows itself in the space between words, in the 'mm, mm' responsive caress of one woman's words by another.

C'est la Vie . . . is not the utopian transformation of "Sniffing the Marigolds," which ends with a slide projection reading "Queer, say it with Flowers," it is not an uncritical celebration of female sexuality, but a much more complex and truthful representation of experience, of the line between attraction and repulsion, the line between a desired intensity in relating to other women and obsessiveness. It stages the fear of 'letting go,' of losing control, of going mad, of wandering so far into the metaphysical that one cannot make the journey back.

Eat Me

Paris's take on women and madness is double-edged, showing both exterior evaluations of our personal and sexual behavior and the internal fear of that which we harbor inside us; are we insane after all, is that what we are keeping hidden, is that what we bake into cakes and decorate our homes with, is that what the obsessiveness in us is?

All this in a moment, present for us in each moment, and at the same time, potentially lost in the moment it takes to perform a lobotomy, to perform electroshock therapy. Time is a known structure, is reason, but these are experiences beyond the realm of reason. If we drop a bus-ticket, what else are we capable of dropping? Dropping our guard on ourselves, losing control, losing the ability of preventing what is inside us coming out. This is what it is like inside Paris. Questions about what goes in, about women and food, lesbians and eating, what we are consuming and what we are consumed by. How much agency do we really have–what of ourselves do we take in, what of ourselves do we really know, how can we really know, unless through ruthless honesty? What is really in the cake holder, in home baking, in the things we create as women, be

they decorations, baking or performance? What does the Mother, the female lover, the performer give us of herself to consume?

When she spits saliva into a cake holder and pours it back into her mouth, it is our *reaction* which reveals our own revulsion of ourselves, of our bodies to us. Paris's ability to transform such an act into an acknowledgement of the cost and beauty of surviving our own fears as women is testament to the power of her performance. She gives a sense of biting as expression of the need for a 'true real,' as an acknowledgement of pain, as an expression of need and desire, the desire to really feel, to feel that emotion is real.

Paris questions the nature of desire for the self–desire to know, to have knowledge of, to *have* the self, a sense of the self which is desirable to us, to see ourselves as desirable as lesbians.

There is a totality, a wholeness, a truth and honesty in Paris's work, an overarching representation of experience, of women, of lesbians, of Paris. She enacts the desire for a reciprocal gaze; she is seen, but the material also reveals our own fears and desires, our own 'darker side.' We are the seeing subjects *and* the subjects seen and represented by Paris's performance. Such wholeness is both painful and liberating in the moment of recognition. Such a reflection of ourselves shows us the marks we each carry–the marks on our psyches reflected and made real within the frame of reference in the marks on the performer's body.

Paris's performances display the woman, the female body, the performer speaking through the symptom, speaking through metaphor and symbol, speaking through the invisible, making visible the experience of 'woman,' lesbian, performer in the frame. She presents the return of the gaze as confirming identification or difference, both in terms of gender and sexuality, self and other, sameness and difference, easy and uneasy familiarity, showing the dis-ease that marks the disease.

TOUCHING ON THE POWER OF PERFORMANCE

These are just some of the examples of performance created, produced and performed by women. The difficulty encountered in attempting to document them is inherent in the art-form itself. The disruptive power of performance lies in its valorization of the pres-

ent, in its refusal to submit to reproduction or documentation. In its very nature a challenge to the seeing eye/I, performance hovers always at the periphery of what can be seen, perceived, captured, owned and exchanged. It exposes both the inability to own by seeing—to fully take into oneself through the senses—and the frustration and nostalgia bounded by memory.

If the desire to be seen is forever at the fulcrum of the act of seeing, performance at once seemingly gratifies and denies that desire. In the performer's body on stage, we see a reflection of ourselves—as women, as lesbians, as individuals desirous of occupying the frame of reference. In her movements and voice is the mirror of our own, whilst simultaneously heightening our awareness of the impossibility of capturing her (seeing and hearing the performing body does not quell our desire for her; we want to touch her, to taste her, to smell her also), and the inadequacy of memory to fix the object of that desire.

Performance exposes to us the fundamental fissure between seeing and being seen, the desire to identify with and be identified by the Other, the presence and absence of the Other (and the attendant absence therefore, of ourselves in relation to the Other). Solo performance enacts the tragedy at the heart of the desire for the Other; always elusive, always self-possessed, the performer's body becomes the site and focus of the failure to fully perceive the Other (as tangible as her presence appears), to confirm her presence, and with it our own. The desire to be seen is confounded at the very moment of its possible consummation—when the performer's eyes alight on us. Only as holders of the gaze do we have any agency in this exchange. In the economy of the signifying system, only as voyeurs do we occupy a position marked with meaning. As the performer wrests the gaze from us, we become once more the unmarked Other—imbued with meaning only at her whim, poised between death and inscription (being).

The performance event re-enacts the economy of lesbian desire itself—to see and be seen by, to love and be loved by, to have and be had by the female Other: to capture on the retina and on the body the indelible mark of the object of desire, to enclose her body within ourselves, to capture and retain her gaze.

The intensified emphasis on the solo performer on stage, the

sense of vulnerability to our gaze, the processes of identification and objectification are such that issues of female representation, visibility and signification become particularly focussed. The solo performance–most especially that of the solo female performer–becomes an enactment of desire. Onto her body we strive to project our fantasies of the perfect Other: Mother, muse, lover, confidante, she embodies our most passionate desires–her body the screen onto which we project our own need to be seen and heard, understood and forgiven, comforted and sexed.

Each solo performance undertaken by a woman, and most particularly by a lesbian, generates its own paradigm. In a signifying system which denies a place within the frame of reference for women which is not marked by absence, women (and women who desire women) continuously re-mark and reposition themselves within the frame of reference. When performance artist Helen Paris hits and bites herself on stage, leaving bruises, the marks stand in defiance of her given position within the signifying system–that of being marked (with meaning) only in relation to the male. She takes the power to mark her experience on her own body, at once reclaiming both and making visible the cost of that reclamation. When live artist Helena Goldwater leaves the frame, it is fundamentally altered, most affectively by our altered perception of it, mediated by her presence on stage and the impact of that presence in transforming the objects on stage in relation to herself. As she manipulates, hides, exposes, moves, and changes the objects on stage, they become infected with her perception of them, imbued with the significance she attributes to them, altered forever in our evaluation of them. Shifting and dissolving given paradigms of meaning and signification, such performances demand a different approach to reading representations of women in performance.

TOUCH ME

These are some of the performances that have touched me and inspired me to examine the mark they have left on my skin. The questions they give rise to concerning the relationships between experience and expression, sexuality and cultural placing, context and artistic control, representation, self-representation and space in

relation to performance by women continue to be addressed by practitioners at every level. As we explore more fully these relationships and the performances which inspire the desire in us to do so, we bring ourselves ever closer to each other; performers to writers, writers to wider audiences, producers and programmers to performers. By creating new contexts for performances by women, we enable female practitioners to create new spaces in which to explore representations of ourselves; new spaces in which to be touched by other women's expressions of themselves. The magic of your touch builds spaces out of ruins, transforms hope into desire.

NOTES

1. Peggy Phelan: "Reciting the Citation of Others," *Acting Out: Feminist Performances* (ed. Lynda Hart and Peggy Phelen) The University of Michigan Press, Ann Arbor 1993, p21.

2. Nina Rapi: "Speaking in Tongues but in Whose Language? In Search of Female Aesthetics," *Seven Plays by Women: Female Voices, Fighting Lives* (ed. Cheryl Robson), Aurora Metro Publications 1991, p32.

3. Elin Diamond: "(In)Visible Bodies in Churchill's Theatre" (*Theatre Journal*, "Feminist diVERSIONS" issue, May 1988) p275.

4. That is, the woman's body as the part which represents the whole; the entirety of her own experience as a woman and the significance of the woman's body on stage as representative of the spaces women occupy.

5. Spin/Stir publicity material.

6. Interview with Joelle Taylor for *GLINT: Gays and Lesbians In Theatre Journal*, Summer 1994.

7. All direct quotes taken from correspondence with Jyll Bradley.

8. *And the Hairs Began to Rise . . .*

9. Juliet Flower MacCannell: *Figuring Lacan: Criticism and the Cultural Unconscious*, Lincoln, NE: University of Nebraska Press, p106.

10-20. Interview with Helena Goldwater, 1996.

21-26. *pucker.*

27. *Sniffing the Marigolds* publicity material.

28-30. *Sniffing the Marigolds.*

31. *Sniffing the Marigolds* promotional material.

32. *Sniffing the Marigolds.*

33. *C'est la Vie en Gai Paris* publicity material.

34-35. *C'est la Vie en Gai Paris.*

36-37. Interview with Helen Paris, 1996.

BIBLIOGRAPHY

Diamond, Elin: "(In)Visible Bodies in Churchill's Theatre" (*Theatre Journal*, "Feminist diVERSIONS" issue, May 1988).

Flower MacCannell, Juliet: *Figuring Lacan: Criticism and the Cultural Unconscious*, Lincoln, Nebr.: University of Nebraska Press.

Phelan, Peggy: "Reciting the Citation of Others," *Acting Out: Feminist Performances* (ed. Lynda Hart & Peggy Phelan) The University of Michigan Press, Ann Arbor 1993.

Rapi, Nina: "Speaking in Tongues but in Whose Language? In Search of Female Aesthetics," *Seven Plays by Women: Female Voices, Fighting Lives* (ed. Cheryl Robson), Aurora Metro Publications 1991.

Vanishing in Your Face:
Embodiment and Representation
in Lesbian Dance Performance

Petra Kuppers

SUMMARY. Lesbian dance performance has to come to terms with the cultural invisibility of the lesbian body, and the dichotomy of traditional gender representation. This paper charts strategies for the play with the invisible, the grotesque and the liminal in the dance performance of three UK-based choreographers: Emilyn Claid, Yael Flexer and Kate Lawrence. Their performances create tension between the role and the body, between the public and the private, and it is this tension that points towards alternative representational strategies. *[Article copies available for a fee from The Haworth Document Delivery Service: 1-800-342-9678. E-mail address: getinfo@haworthpressinc.com]*

Lesbian dance is still an undertheorized area of study, lagging behind the volumes of work devoted to gay performance aesthetics. A range of socio-historic reasons have been identified for this persistent invisibility, ranging from the assumed unreadability of a

Petra Kuppers was born in a tiny village in Germany and now lives in a tiny village in Wales with her cats and her blue wheelchair. She works as a researcher, physical theatre director, lecturer and journalist.

Address correspondence to Petra Kuppers, Freya Cwmysg, Trecastle, Brecon LD3 8YF, United Kingdom.

[Haworth co-indexing entry note]: "Vanishing in Your Face: Embodiment and Representation in Lesbian Dance Performance." Kuppers, Petra. Co-published simultaneously in *Journal of Lesbian Studies* (The Haworth Press, Inc.) Vol. 2, No. 2/3, 1998, pp. 47-63; and: *Acts of Passion: Sexuality, Gender and Performance* (ed: Nina Rapi, and Maya Chowdhry) The Haworth Press, Inc., 1998, pp. 47-63; and: *Acts of Passion: Sexuality, Gender and Performance* (ed: Nina Rapi, and Maya Chowdhry) Harrington Park Press, an imprint of The Haworth Press, Inc., 1998, pp. 47-63. Single or multiple copies of this article are available for a fee from The Haworth Document Delivery Service [1-800-342-9678, 9:00 a.m. - 5:00 p.m. (EST). E-mail address: getinfo@haworthpressinc.com].

47

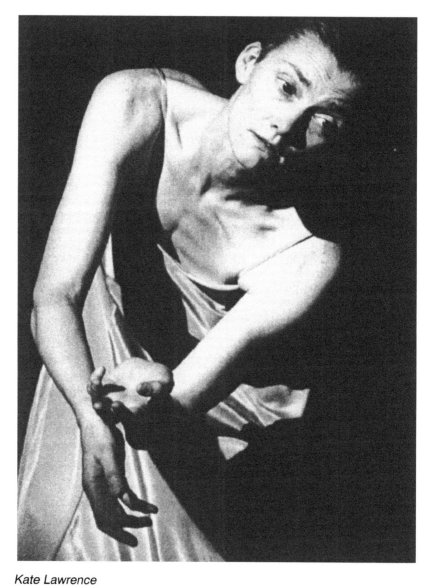

Kate Lawrence

Photo by Eleni Leoussi. Used by permission.

lesbian behavioral code to the display mechanisms of traditional ballet, which does not offer a space for alternative desires. Of course, male gay dancers have been associated with dance for a long while, but even this form of queer visibility has more to do with what dance means in western culture–displaying oneself, being consumed as a body by the audience, being the weak object of desire to the strong gaze of the audience–than with progressive politics and spaces for alternative desire. Women (and men who risk being seen as effeminate unless they display their strength by lifting ballerinas through the air) are the objects of traditional dance, not desiring subjects.

During my research for this article I put up notices in lesbian Internet communities, asked dancers, inquired in dance archives. Only a handful of names were my reward. Lesbian dancers? Dancers that explicitly engage in what they term lesbian aesthetics? Many shrugged, and some acknowledged that dance "isn't political in that way." Given the realities of mainstream dance today, this claim, as unreal as it must sound to scholars and lovers of contemporary dance forms, is an understandable one. Dance has covered its tracks during its long history. Gender has quietly found a place as the natural, the bodily. Female fragility and spectacle have been firmly inscribed in the public imagination by the dominant images of romantic ballet.

But my search for lesbian dance performers who actively portray female-female desire on stage wasn't fruitless. I located and will analyze the performance strategies of three UK-based dancers/choreographers, Emilyn Claid, Yael Flexer and Kate Lawrence, whose work I read as addressing issues of lesbian visibility.

There are a range of theoretical issues that I will address during this investigation. All three choreographers use liminal spaces like the grotesque body or the play with the invisible as part of their performance strategy. How can this ambiguous power of the grotesque body and the vanishing image become workable, liberating, usable for lesbian performance? Is there a possibility for dance to perform rupture by going beyond the role-play, the move from one mask to the other, which has dominated lesbian theatre? How can embodiment and radical representational strategies work together?

In order to address these questions concerned with embodiment

and representation, I will chart a brief history of imagery associated with the lesbian body, and highlight the problems associated with this representation. I will then use textual analysis of three performances to read the politics of visibility in them, and to identify strategies of rupture. My analysis will conclude with pointers towards a representational strategy which embraces disruption and the spaces between the visible and the invisible of performance.

'THE' VISIBLE LESBIAN

How can the lesbian be represented? In order to approach this question, I will trace a brief genealogy of lesbian imagery. 'The' visible lesbian has appeared in a range of spaces in the popular imagination. One of these spaces is a 1920s ballroom where a rich, mannish, dark-suited baroness stares longingly at some frilly young girl. Another one is the far outback, where a butch, dangerous to know, coarse-skinned woman with arms like barrels stands next to a pick-up truck. Stiff schoolmistresses, repressed tweed-clad lemons or butch prison wardens–these are the visible lesbians.

These stereotypical images create specific places for this woman with her different desire, spaces firmly elsewhere from the bourgeois or heterosexual norm. Her 'otherness' means that she is always lonely, longing, unfulfilled. The issue of deviance defines all of these stereotypical representations. These women have no rounded character, no story beyond their deviant desire. Their difference from the norm (usually represented in the form of the 'healthy' or untroubled girl) is their stake in the narrative.

As Andrea Weiss sums it up in her study of cinematic images of lesbians:

> Each lesbian image that has managed to surface–the lesbian vampire, the sadistic or neurotic repressed woman, the pre-Oedipal "mother/daughter" lesbian relationship, the lesbian as sexual challenge or titillation to men–has helped determine the boundaries of possible representation, and has insured the invisibility of many other kinds of lesbian images.[1]

Attempts to create alternative presentations run up against the problem of minority representation: every image enters the politics of

representation and stands for the minority group it depicts. The fact that few images of that minority are available puts an even greater burden on any of its representations. Questions of purity, 'authenticity' and self-definition further complicate the field of representation.[2]

A naked lesbian doesn't look like a lesbian. She automatically enters the dominant discourse, as heterosexual woman. Her desire isn't inscribed on her body. It needs to be added, in acting, and in other signs. The non-representability of the lesbian as bodily sign was recouped through excessive extra signs: the tweed, the thick glasses, the melodramatic/repressive body language. The subtle remains out of reach, the body of the lesbian is either over-inscribed or invisible. Terry Castle sums up this tragic position between marginalization and absence:

> The lesbian is never with us, it seems, but always somewhere else: in the shadows, in the margins, hidden from history, out of sight, out of mind, a wanderer in the dusk, a lost soul, a tragic mistake, a pale denizen of the night.[3]

Discussions focusing on butch-femme aesthetics have similarly highlighted the problems with 'performing' femme–an image available only in context, in dialogue, but invisible in a non-lesbian environment.

BEYOND REALISM

But not all representational politics need to work within the confines of realism with its demand of authenticity, to 'genuinely,' even if misogynistically, represent the source of difference of the lesbian. There is another space open to the lesbian body, a space to dance out of the repressive regimes. The body can acquire the power to disrupt the conventional, to mark a difference without entering the space of the other. This space is not definable through a vocabulary of iconographical signs. The best place to look for the pure form of this place is not in the visual and performance arts, but in literature, which has to rely solely on words to create its images. Here, the power of the disruptive lesbian comes out clearly, but so does the injury that this place does to the represented woman.

This space and its specific mode of representation are approached in an apparition that one of Britain's central poets tried in vain to capture:

> Beneath the lamp the lady bowed,
> And slowly rolled her eyes around;
> Then drawing in her breath aloud
> Like one that shuddered, she unbound
> the cincture from beneath her breast;
> Her silken robe, and inner vest
> Dropt to her feet, and in full view,
> Behold! her bosom and half her side—
> And lean and old and foul of hue.
> Oh shield her! shield sweet Christabel![4]

Grammar breaks down into chaos, vision becomes blurred, and hysterical alliteration forms itself into a shriek. The lesbian woman is the horrific woman. This vision is no longer pathetic or merely sinister, easily contained in the politics of representation. This vision is the space of the breakdown of categories. Something is foul, some part, usually hidden, is diseased and contagious. But the horror only comes out at night, in special performances. This space is dangerous—the represented might lose her substance—but it is a space that can haunt the conventional. In a heterosexual context, Dracula holds the popular imagination a lot firmer than the poor, bloodless guy who gets his wife kidnapped, never mind who survives. Even given a certain amount of 'alternative reading strategies' on my part, this horrific lady is the more interesting figure of Coleridge's poem, the place of enigma. Like Hollywood's femme fatale, her narrative position makes her politically incorrect, but she is a lot more fascinating than the good girls. The sight of her overwhelms the narrative, not just in the stationary spectacle that Laura Mulvey describes,[5] but as a presence that can shape the view of the whole. We might not get a lesbian image to live by, but we get a nearly invisible lesbian who is more interesting than prisonwardens and schoolmistresses.

The problem with this ghostly lesbian that breaks through representational categories is that she is strongest when she is not visible, but only hinted at, as she was in the poem. As soon as the Grotesque

becomes clearly visible, it loses its power and becomes the mere other, the monster. The Grotesque has been seen as a political tool that is implicated in that which it attacks:

> The meaning of the grotesque is constituted by the norm which it contradicts: the order it destroys, the values it upsets, the authority and morality it derides, the religion it ridicules, the harmony it breaks up, the heaven it brings down to earth, the position of classes, races, and sexes it reverses, the beauty and goodness it questions. The word 'grotesque' makes sense only if one knows what the 'norm' represents–in art and in life.[6]

But the power of the horror can be greater than just 'otherness.' This power becomes dangerous, contagious, when it is not 'bracketed,' that is, set in clear opposition. Coleridge's poem doesn't spell out the point of the Grotesque, and this is what makes Christabel so horribly endangered. In the presence of the unspeakable, Christabel's own presence in language is problematic. The heterosexual world has to take note of this different desire that doesn't fit into traditional binaries.

How can this strategy of the Grotesque be made to work for dance? Isn't the visual Grotesque always already too much 'othered' to retain its ghostly power? Are there modes of grotesquerie which go beyond making the dancer into a mere stereotype, such as the phallic mother, or the madwoman? How can a dancer trying to attain this disruptive space avoid being cast as the easily containable 'other' to the cozy heterosexual norm?

BEYOND CAMP

Sue Ellen Case, Judith Butler and others point towards the breakdown of categories as the pleasure principle of lesbian performance. The moment where language breaks down, because language is broken through by something that defies categorization, is a well-established radical space for queer scholars. They point towards the performance of roles in lesbian theatre, roles that defy a 'truth' for female desire, roles that constantly change the face of the lesbian.

For Butler's notion of performativity, lesbian is to straight "not as copy is to original, but, rather, as copy is to copy":[7] the traditional binary of language is disrupted. The role with no referent to the 'real' upsets the universality of the 'real.'

But the stating of the lesbian in dance is the problem. All 'roles' and masquerades in dance are problematic, if only because the physical body is the carrier of meaning (if we disregard the music). Within dance, we have a strong tradition of stable, clearly defined, never to be transgressed roles for 'the female.' Where she isn't 'just a modernist body,' supposedly empty of gender, class, race or other signs, she carries the burden of representation, she becomes 'woman.' Airy, light, on tiptoes, swathed in cloudy gauze, flying up through strong, male arms: these are the attributes of the romantic ballet dancer. In modern dance 'femininity' was allowed somewhat more scope though the reconnection with the earthy, the flower, the swaying, growing, maternal body–all images still firmly fixed in one version of heterosexual myth.

Dance works within the categories of the 'natural'–the body of the dancer provides the authenticity of live performance. The ensuing naturalization of a binary gender pair constitutes a problem for the representations of other identities. No clearly visible sign of its desire marks the surface of the lesbian body. Available images have to dress up the leotarded body, adding on bits to create cumbersome, restrictive images.

Movement in the relationships between dancers on stage rather than in the specific body-language of the dancers themselves can equally create unproductive images which are not able to escape the dominant aesthetic: heterosexual desire reads to its own ends, making soft porn out of lesbian sexual assertions. As Christy Adair put it: "How can women present themselves on stage when woman equals sexuality?"[8] How much more complicated, indeed, when the 'themselves' encompasses a difference to (hetero)sexuality.

Lesbian dance performers need to find a representational strategy that allows them to break away from the dichotomies of traditional dance representation, where the binary along which desire is constructed is between the female and the male. If they want to mark their desire, to dance their private identity, they also have to move away from formalism and assert their desiring bodies.

One way in which this move is danced by lesbian dancers is through the embrace of disruption, the embrace of the Grotesque, of moments that confound expectation and disturb the viewer. The play with the Grotesque, the freakish, the difference that isn't just safe 'other' but too close for comfort is what I want to trace in the aesthetic strategies of a specific lesbian performance possibility. The Grotesque isn't camp. The Grotesque doesn't just

> playfully (inhabit) the camp space of irony and wit, free from biological determinism, elitist essentialism, and the heterosexual cleavage of sexual difference.[9]

The airy, camp play with representations is broken through by the horror of the body. Performance is not just the interplay of representation, but dance keeps a troubling, problematic presence underneath all its gay ribbons. Death, stasis, refusal, violence and futility problematize the lesbian performance strategies I will explore. It is here that the Grotesque in dance becomes more than just the other to the norm. The body on stage is living, breathing, 'there.'

QUESTIONING REPRESENTATION

In the following I will create narratives of three different performances: my readings of the aesthetic strategies of three choreographers that perform the problem of finding a lesbian image. Their performances celebrate the inability to grasp romantic notions of essence, through powerful dance which questions any representation. Heidi Gilpin posits unrepresentability at the heart of performance, as the very nature of it:

> Performance, through its embodiment of absence, in its enactment of disappearance, can only leave traces for us to search between, among, beyond.[10]

What that means for dance critics, if not for dance aesthetics themselves, is the awareness of narrativity, the fact that everything I say about a dance can never be more than a representation of it, a construct, shaped in between my reading and the work itself. This

statement is a commonplace in our critical environment and its awareness of the structuring effects of language, but the warning cuts across into the very heart of what performance means: this unrepresentability lies in the play of the live event with absence, the instant vanishing of the moment, of the lived body in time and space. For me, the lesbian dance performances which I can't capture but try to analyze here, work with the ideas of absence and unrepresentability. This play with the unrepresentable is what makes their dances disturbing, powerful, just like the vision of the ghostly lesbian who disrupts language. They use the elements of performance, such as stereotypical imagery and the performer-audience relationship, to create moments of non-truth, or standstill, or distance coupled with a new form of intimacy, to make political dance.

EMILYN CLAID: CHANGING ROLES

On a dark stage, held in the only light, a woman is stripped of her wig, her dress, her voice, and emerges as a pathetic creature in a loose shift, with shaven head and pleading, gesticulating hands. From opera-singer to tragedy on legs, Emilyn Claid takes her audience through a parade of femininity, throwing bodies and images at us. Nina Rapi called lesbian identity politics the 'performance of being':

> Being in flux, continuously shedding skins, roles, costumes, and trying new ones.[11]

It is this strategy of living that which is not 'embodied,' that marks this performance.

But more than analytical distance or comical effect is created in the spectacle of changing roles. Towards the end of *Virginia Minx at Play*, we are faced with a small, white, cringing person mimicking her story on stage in a weird pantomime. First she is a child, half spastic, uncontrolled, awkward. The staged body moves from exhausted embryo on the floor to a chewing and spitting teenager, trying hard to project her unused sexiness. We have to watch. The neurotic performance questions our position as voyeur, and the

performer's position as exhibitionist. The boundaries of privacy and cultural stereotyping merge in this mangled, sweating, suffering body on stage, a body that just moments before was the site of power. The emotionally disturbing piece moves from make-believe kisses to the image of penetrative sex, complete with pelvis thrusting hard. Overeating, vomiting, rape, pregnancy, drinking and the senile shivers of an old hag: we get it all, performed for us with a shy, awkward smile. Femininity is reduced to neurosis and disgust. The female grotesque is played out in this mimicked life cycle.

These images of abjected womanhood have a particular currency in the context of dance: the anorexic/bulimic dancer has been a staple of feminist critiques of ballet. Cynthia Novak charts the complex and contradictory attitudes that female dancers have to adopt in order to place themselves into this canon of thin, ethereal ballerinas. She quotes the autobiography of Toni Bentley, a professional dancer:

> The anorexic has absorbed a great knowledge. She has control—some control—over her destiny and has taken responsibility for that destiny.[12]

This quote stands for a range of shifting political attitudes towards the fabricated body[13] which complicates any easy condemnation of women shaping their bodies as submissive, other-directed subjects of male domination.

Emilyn Claid's performance acknowledges these political struggles over agencies of female bodies. The formal structure of many of her pieces with their 'numbers' of identities, often created and unmade on stage, questions notions of embodiment, the reduction of the female principle to the body principle. It destabilizes any singular reading, any notion of 'nature,' 'purity' and 'the real self,' through this presentation of numbers, all of which are portrayed with intensity and emotional appeal. Every image is firmly located in a framework of theatricality. This is signalled through costume changes on stage and abrupt turnabouts, moving from one image to the next.

This Brechtian strategy is complicated, though: Claid's intense performance disrupts the distancing mechanism of the number structure through highly emotive, risqué or painful images. The boundaries of the personal and the performed are destabilized, but

still, pinpointing the dancer as an essence is impossible. Claid's anorexic is not only a quote from the cultural canon of ballet, not only an image created through a certain play with light, a white, clingy shift and a specific body language. The image is embodied: this is a real body, this body, with its bones sticking out. The questions of agency, control and power that surface in the Bentley quote above are forced into the viewer's perception. Just like the lesbian horror of Christabel, the play with the horrific and abject in Claid's performance breaks into the unrepresentable.

YAEL FLEXER:
CONFOUNDING TRADITIONAL DANCE EXPECTATIONS

The Israeli choreographer and dancer Yael Flexer's performance strategy in *Yes? Yes! Yes.* explores similar issues to Claid's pieces. The personal and the performative create the two poles that question "identity" and "representability" in her choreography. The voyeurism of the stage situation is once again brought to the foreground, making strange the relationships danced. The choreography moves from a solo piece over a duet to a group dance. Interactions—between space and body, bodyparts amongst themselves, two dancers, dancer and audience—and group dynamics make up the vocabulary of the three dances. Desire is danced through the halts and starts of narrational drives—when the spectator sees a storyline emerging, the action shifts ground, deferring the reading of the viewer. The spectator becomes implicated in this scenario, giving an air of intimacy to the explorations, always grounding abstract movement in physical bodies and actual women's bodies.

At the end of the first two movements, the explorations enacted in the body of the pieces are brought together, the dancer on stage gestures off-stage for music and light. Suddenly, the alienating halts are excluded, and a smooth, sustained, flowing movement creates an illusion of bodily integrity and traditional dance aesthetics—the 'real performance.' But the 'pleasure' of the 'normal' dance is broken up by the intimacy presented through the halting, meditating, 'private' explorations that went on before—traditional dance aesthetics and appreciation become unstable in the spectator. The last piece, the group choreography, ends in a 'narrational' moment

of a dancer opening up a repeated position by displaying her palms to the audience—'releasing' pent-up energy. But the overall address of the dance evening makes this kind of reading problematic—the difference between main part and ending of the previous two pieces makes the spectator sensitive to the discrepancies. The most pervasive image, the one that stayed with me long after the show, is of a contained body, energy directed inwards, defensive, with balled fists resting on hips. This grotesque moment of halting the flow of expectation, of refusing to show, to give in, of being private, is at the heart of the power of this dance.

Both narrational reading and traditional dance expectations are confounded by Yael Flexer's choreography, leaving the enigma of the dancer, her body and her desire behind. But this dancer is never remote, unrecognizable—she implicates the audience in her own dance, making them part of the desire machine. She caters for their need for reading, but always refuses in the end to show herself fully. Like in Claid's strategy, the marginal is not spelled out, but the center is destabilized through the ravishing power of the 'other' aesthetic, the insistence on the private.

KATE LAWRENCE: THE UNOBTAINABLE TRUTH

Another refusal of imagery is enacted by Kate Lawrence, choreographer for Nomad dance group. A multitude of detailed, small but fixating body actions, gestures full of meaning, "the way she carries herself" are collated, strictly formatted, meticulously performed. Nomad explored female imagery through the narrative device of a journey into the other, the colonial past, in *Voyage to the Forgotten Temple*, with the subtitle *A 'fly on the wall' view of Victorian women during the British Raj in India in 9 sections*. Movement patterns, ticks and constellations, all recognizable stereotypes of repressed Victorian womanhood, are explored and then shed: skirts and corsets fly off and four women dream in white underwear. The end of the journey, a dance sequence entitled *The Forgotten Temple*, hailed "a Pandora's Box of female sexuality: inviting, impossible to resist, terrifying and illuminating" (program notes): the four have now changed into the costume of Edward Said's Orient, with smooth silks and glorious colors, and dance the dream of female sexuality

through sensuous curves and Eastern music. Here, woman becomes the Orient: "inviting, impossible to resist, terrifying and illuminating," but the spectator is still nowhere near the performers, or women. The center hasn't been reached–we end on another stereotype, the other side of the Victorian schoolteachers, but the essence, the desire, the naked bodies of the dancers remain hidden.

What the spectator takes away from both performances are the undercurrents of violence. The restricted, tight costumes of the English ladies, their refusal to interact, the constant halting of their journey towards each other–these marks of coercion and social control are all the more visible in interplay with the 'freed' bodies of the harem dance. Again, that which looks different, weird, is too close to home, condemning gender roles.

But equally, the racist stereotypes of colonial Britain intrude on any 'innocent' reading of the dance–this is a dance both too reminiscent of female display for the male eye and the patronizing view of Westerners into the Orient. The four dancers never show themselves, but far from just playfully acting out role after role, their refusal takes on a more critical project. As in Claid's use of the narrational Grotesque and Flexer's aesthetic of the private, Nomad goes beyond the camp by complicating representation with the bodily, signalling that the 'truth' of these women's desire, their dreams and their interaction is there, but not obtainable to the audience which is trapped and implicated in cultural images that cloud the view of this 'other' desire.

THE LESBIAN BODY IN PERFORMANCE: REFUSING TO CONFORM

Dead bodies, stripped of the paraphernalia of cultural gender to the genital 'realities'; bodies whose physical, muscular presence throws the audience off any easy meaning-making processes; overstated bodies, hidden behind veils of demeanor and circumstance, whose social determination breaks through a formal appreciation: all manner of evasive strategies are employed by the choreographers I discussed. All of them use mechanisms to confound traditional audience expectations of romantic narratives, abstract spaces or formalist creations, through the constant 'tainting' with other

discourses, be they social, cultural or personal. Something always stands in the way, complicates things, and makes the categories and conventions of stage work visible through its refusal to conform. Flexer looks out at us, putting the stage back into what looked like an exploration of the formal elements of bodies. Lawrence mixes discourses associated with patriarchal or colonial power, making the 'nice' formal aspects of her dance hard to swallow. Claid questions any relationship between represented and 'real' through her use of the grotesque body which is not reducible to a mere image. The lesbian remains in the sidelights—Claid embraces her singer between numbers, in the dim half light, or during a marathon of violence, overshadowed by quotations. Flexer dances with a female partner a narrative of a relationship, but here desire remains mute compared to the passions of display and performance. Lawrence shows us an orgy of liberated girls, but remains firmly embedded in stereotypical images weaned from dominant discourse.

At the beginning of this journey through lesbian dance spaces, I asked how radical representational strategies and embodiment could work together. Given the overdetermined nature of the lesbian body in popular discourse (if it isn't merely invisible), what other marks than role-play can lesbian desire find for itself? Given the 'natural' bodies of dance, with this natural always already the 'natural' of heterosexual discourse, how can it question the 'natural' binary of bodies? The ghost of the Grotesque has provided ways to work through these problems. The bodily presence of dance becomes a complicating factor, marking the unrepresentable, the invisible, the private. The bodies act out more than representation can divulge. This gap, the moment of invisibility, troubles attempts to read these dances for conventional narratives. The audience has to face the physical nature of the dancing bodies, even though they contradict or refuse the meanings that are generated on another representational level. There is something there, between the numbers in Claid's show, in the private moments of Flexer, underneath the harem stereotype in Lawrence, that escapes the gaze but is affirmed through the lesbian bodies that act. The lesbian is still not clearly visible (and therefore not containable in easy dichotomies), but its traces upset the heterosexual norm. The 'other' desire has won a space of both privacy *and* disruption.

NOTES

1. Andrea Weiss: *Vampires and Violets. Lesbians in the Cinema*. London: Jonathan Cape, 1992, p. 1.

2. One of these problems can be traced in the critical treatment given to the heterosexual member of Split Britches, Deborah Margolin.

3. Terry Castle: *The Apparitional Lesbian. Female Homosexuality and Modern Culture*. New York: Columbia University Press, 1993, p. 2.

4. This early version of the poem is quoted out of Polidori: *The Diary of John William Polidori*. ed. W.M. Rossetti, London: Elkin Mathews, p. 128, by Nigel Leask in "Shelley's 'Magnetic Ladies': Romantic Mesmerism and the Politics of the Body." *Beyond Romanticism. New Approaches to Texts and Contexts 1780-1832*. Eds. Stephen Copley and John Whale, London and New York: Routledge, 1992, pp. 53-78, p. 56/57.

5. Mulvey writes about the woman: "her visual presence tends to work against the development of a story-line, to freeze the flow of action in moments of erotic contemplation. This alien presence then has to be integrated into cohesion with the narrative." The grotesque woman can't be completely narrationally contained by the male, she implicates the whole storyline with her interrogation of norms. She isn't alien enough to be successfully dominated. "Visual Pleasure and Narrative Cinema" in *Contemporary Film Theory*. Ed. Anthony Easthope, London and New York, Longman, 1993, pp. 111-124, p. 116).

6. This elegant non-definition of the grotesque is one of many that have been designed and elaborated by cultural and literary scholars, here discussed in relation to Aubrey Beardsley by Ewa Kuryluk, in *Salome and Judas in the Cave of Sex: The Grotesque: Origins, Iconography, Techniques*. Evanston, Illinois: Northwestern University Press, 1987, p. 11.

7. Judith Butler, *Gender Trouble*. London and New York: Routledge, 1990, p. 31.

8. Christy Adair, *Woman and Dance. Sylphs and Sirens*. Houndsmill, Basingstoke: Macmillan, 1992, p. 199.

9. Sue Ellen Case: "Towards a Butch-Femme Aesthetic." in: *The Lesbian and Gay Studies Reader*. ed. Henry Abelove, Michele Aina Barale, David M. Haperin, London, New York: Routledge, 1993, pp. 294-306, p. 305.

10. Heidi Gilpin: "Lifelessness in movement, or how do the dead move? Tracing displacement and disappearance for movement performance." in Susan Leigh Forster (ed.): *Corporealities. Dancing Knowledge, Culture and Power*. London, New York: Routledge, 1996, pp. 106-128, p.106.

11. Nina Rapi: "Hide and Seek: the Search for a Lesbian Theatre Aesthetic." in *New Theatre Quarterly*, Vol. XI, No. 34, May 1993, p. 147-158, p. 148. Cambridge University Press.

12. Toni Bentley: *Winterseason*. New York: Vintage Books, 1982, p. 56 quoted and discussed by Cynthia J. Novak: "Ballet, Gender and Cultural Power." in: *Dance Gender and Culture*. ed. Helen Thomas, Houndsmills, Basingstoke: Macmillan, 1993, pp. 34-48, p. 40.

13. Kathy Davis: *Reshaping the Female Body. The Dilemma of Cosmetic Surgery*. London and New York: Routledge, 1995.

REFERENCES

Adair, Christy (1992) *Woman and Dance. Sylphs and Sirens.* Houndsmill, Basingstoke: Macmillan.

Butler, Judith (1990) *Gender Trouble.* London and New York: Routledge.

Case, Sue Ellen (1993) "Towards a Butch-Femme Aesthetic." in: *The Lesbian and Gay Studies Reader.* ed. Henry Abelove, Michele Alna Barale, David M. Haperin, London, New York: Routledge, pp. 294-306.

Castle, Terry (1993) *The Apparitional Lesbian. Female Homosexuality and Modern Culture.* New York: Columbia University Press.

Davis, Kathy (1995) *Reshaping the Female Body. The Dilemma of Cosmetic Surgery.* London and New York: Routledge.

Gilpin, Heidi (1996) "Lifelessness in movement, or how do the dead move? Tracing displacement and disappearance for movement performance." in: *Corporealities. Dancing Knowledge, Culture and Power*, ed. Susan Leigh Forster, London, New York: Routledge, pp. 106-128.

Kuryluk, Ewa (1987) *Salome and Judas in the Cave of Sex: the Grotesque: Origins, Iconography, Techniques.* Evanston, Illinois: Northwestern University Press.

Leask, Nigel (1992) "Shelley's 'Magnetic Ladies': Romantic Mesmerism and the Politics of the Body." in: *Beyond Romanticism. New Approaches to Texts and Contexts 1780-1832.* Eds. A, Stephen Copley and John Whale, London and New York: Routledge, pp. 53-78.

Mulvey, Laura (1993) "Visual Pleasure and Narrative Cinema." in: *Contemporary Film Theory*, Ed. Anthony Easthope, London and New York: Longman, pp. 111-124.

Novak, Cynthia, J. (1993) "Ballet, Gender and Cultural Powers." in: *Dance Gender and Culture*, ed. Helen Thomas, Houndsmill, Basingstoke: Macmillan, pp. 34-48.

Rapi, Nina (1993) "Hide and Seek: the Search for a Lesbian Theatre Aesthetic." in: *New Theatre Quarterly*, Vol. XI, No. 34, pp. 147-158. Cambridge University Press.

Weiss, Andrea (1992) *Vampire and Violets. Lesbians in the Cinema.* London: Jonathan Cape.

Shall We Dance?
Identification
Through Linguistic Tropes
and Performance

Anita Naoko-Pilgrim

SUMMARY. This paper looks at the way in which linguistics has been used in the analysis of identity and suggests that we might now be able to go beyond linguistics and do a wider analysis of identity using performance.

I look at race and sex/gender in the context of sexuality and, as a part of my argument, I suggest that processes of identification should not be analyzed as separable but rather as interlocking elements, making up the complete human being.

Anita Naoko-Pilgrim was educated at Whitstone Comprehensive School, Strode Technical College and King's College, Cambridge, where she gained a BA honours degree in English Literature and Social Anthropology. After working in development aid overseas, an antiquarian book shop, architecture, publishing and as a writer, she is now doing her doctorate: an ethnographic study of British black and gay women and men, focusing on performance in the community. Besides articles and reviews in the popular gay press, she has published a chapter on British black lesbian literature in *Talking Black* (ed. Valerie Mason-John, 1995, Cassell: London).

Address correspondence to Anita Naoko-Pilgrim, c/o Department of Sociology, Goldsmith's College, University of London, New Cross, London, SE14 6NW, England (e-mail: sop01anp@gold.ac.uk).

[Haworth co-indexing entry note]: "Shall We Dance? Identification Through Linguistic Tropes and Performance." Naoko-Pilgrim, Anita. Co-published simultaneously in *Journal of Lesbian Studies* (The Haworth Press, Inc.) Vol. 2, No. 2/3, 1998, pp. 65-77; and: *Acts of Passion: Sexuality, Gender and Performance* (ed: Nina Rapi, and Maya Chowdhry) The Haworth Press, Inc., 1998, pp. 65-77; and: *Acts of Passion: Sexuality, Gender and Performance* (ed: Nina Rapi, and Maya Chowdhry) Harrington Park Press, an imprint of The Haworth Press, Inc., 1998, pp. 65-77. Single or multiple copies of this article are available for a fee from The Haworth Document Delivery Service [1-800-342-9678, 9:00 a.m. - 5:00 p.m. (EST). E-mail address: getinfo@haworthpressinc.com].

At the end of this mainly theoretical piece, I begin to apply my theory, looking at the work of two of my doctoral research project participants, Patience Agbabi and Zahid Dar, performers of pieces which raise a number of questions about sexuality, performance and identification processes. *[Article copies available for a fee from The Haworth Document Delivery Service: 1-800-342-9678. E-mail address: getinfo@haworthpressinc.com]*

INTRODUCTION

The work of the philosopher Judith Butler has had a major impact on lesbian studies. Apart from her work about and addressed to the gay community, any analysis of sex/gender has obvious implications for a community defined by same-sex desire. It can also be argued that analysis of a process of identification such as gender has a potential analogic implication for the analysis of other processes of identification such as sexuality or ethnicity. More than this, Butler's work shows that no process of identification can be seen to act in isolation from another and that sex/gender in particular operates in a 'heterosexual matrix.'

In this paper, I will discuss Butler's concept of "gender as a performative in the heterosexual matrix." I will also look at another linguistic trope,[1] /race/[2] as a floating signifier (from the work of Stuart Hall and of Kobena Mercer). This means I will be moving towards a conceptual framework that configures people as complex subjects rather than one that focuses on one area of identification to the exclusion of others. I will then examine the two areas of identification: race and sex/gender, and will begin to ask whether performance offers a useful arena for the analysis of identification. I will examine the relationship between 'the performative' and 'performance,' showing that it is where they don't fit which offers interesting food for thought.

I will look (briefly) at some performed material: Patience Agbabi's poem "The Black, The White and The Blue" and the solo piece "PakiBoy," written by Tenebris Light for Zahid Dar.[3]

In order to situate my arguments for those readers who aren't familiar with recent academic work on identification, I have had to compress some difficult theoretical work into simplistic explanations. This means I may be representing the thinking I need to

reference in a partial manner which doesn't properly convey the whole of the work. I hope this will be forgiven as a necessary evil.

DEFINITIONS

The two linguistic tropes I am analyzing come from the following: 'signifier' is from the grand old father of linguistics, Ferdinand de Saussure, who showed that the relationship between a thing–the 'signified,' and the word we use to designate it–the 'signifier' is arbitrary (de Saussure, 1915). 'Performative' comes from the work of J.L. Austin, who pointed out that some statements are, or are part of, the doing of an action rather than being purely descriptive of the action. His most famous example is "I do take this woman to be my lawful wedded wife" (Austin, 1955).

/RACE/ AS A FLOATING SIGNIFIER

In the Sage Anniversary lecture (Hall, 1996b), Stuart Hall set out the concept of /race/ as a floating signifier verbally against Anthony Appiah's position in his essay on Du Bois (Appiah, 1986). (Stuart Hall hasn't yet given a written account of this concept.) Appiah argues that however scientifically unreal the concept of race may be, we have to work with an axis of black/white in current society, some of us bearing "not insult but the *badge* of insult" (Appiah's emphasis) of "skin and hair and bone" (Du Bois' phrase). Appiah refers to a "Saussurian hegemony," where in our analysis of race relations in terms of metaphor and metonymy we have wandered away from "reality": "What we miss through our obsession with the structure of relations of concepts is, simply, reality" (Appiah, 1986, p. 36). Hall returns us to the Saussurian trope of /race/ as a signifier. He argues that we should understand that "skin and hair and bone" are being "read' as "text." These physiognomic details are attached as signifiers to a hierarchical system of difference with which they have no real relationship. Kobena Mercer, in an unpublished PhD thesis (Mercer, 1990), shows how this formulation can be manipulated in politics. Because /race/ is an empty (or floating)

signifier; because it is completely empty of meaning (unattached to any reality), /race/ can be filled with all kinds of political rubbish. Mercer shows in particular how the M.P. Enoch Powell was able to manipulate negative meanings into the signifier /race/. He discusses the way /race/ terminology can be turned, as when 'black' was manipulated into a positive political term–this also shows the empty or floating nature of the signifier /race/; we can attach 'black' to 'beautiful' as well as to 'inferior and frightening.'[4]

GENDER AS A PERFORMATIVE

Judith Butler's work on gender as a performative has raised quite a storm in academia. One troubling aspect of her work to parts of the academy is that she does not separate 'sex' as biological or natural from 'gender' as a cultural construction (see in particular Butler, 1993, pp. 4-12). This argument is based in a Foucauldian critique of the subject and of matter; a rejection of arguments that the subject is constructed, whether by the self or by external social forces. Butler proposes:

> a process of materialization that stabilizes over time to pro-
> duce the effect of boundary, fixity, and surface we call matter.
> (Butler, 1993, p. 9)

She argues for a subject continually materializing in time, reiterating itself within matrices of power. The particular matrix on which Butler focuses is heterosexuality: the gendered subject is produced within a heterosexual matrix (of power). The theory 'gender as a performative' fits with Foucault's theory of society as discourse: gender is like one of Austin's speech acts, something achieved by being reiterated[5] in the discourse of social life.

THE COMPLEX SUBJECT

After much slow hard work to gain recognition of women, and then of lesbian women, black women, black lesbian women, we

have reached a point where we must discuss the gendered subject in ways which also recognize h/er as racialized, sexualized, of a particular class or generation, as (dis)abled: in other words, as a complex person. In *Bodies That Matter* (esp. pp. 18-19), Judith Butler provides a useful account of some of the problematics we face in tackling analysis of identity which takes on such complexities rather than go the old simplistic route of trying to analyze the different identities which make up one person in isolation.

As the regulation of sex/gender is a domain of power for Butler, so is "the social regulation of race." However, she warns against treating racism, homophobia and misogyny as parallel or analogous. She also points out the dilemma of the writer or thinker working in these areas:

> On the one hand, any analysis which foregrounds one vector of power over another will doubtless become vulnerable to criticisms that it not only ignores or devalues the others, but that its own constructions depend on the exclusion of the others in order to proceed. On the other hand, any analysis which pretends to be able to encompass every vector of power runs the risk of a certain epistemological imperialism which consists in the presupposition that any given writer might fully stand for and explain the complexities of contemporary power. (Butler, 1993, p. 19)

Perhaps I can examine this dilemma in relation to Butler's own work. Butler has made clear how inextricably sex/gender and heterosexuality are involved. She includes in *Bodies That Matter* not only an analysis of Nella Larsen's *Passing* in which she examines the interweavings of racism and the erotic, but also a discussion of the ways in which race, class and gender operate in the person of Venus Xtravaganza, "a Latino/preoperative transsexual, cross-dresser, prostitute" (see Butler, 1993, especially p. 130). Her inclusion of more than one "vector of power" in her analysis is not imperialist. The occupation of the whole area of her discourse by one issue alone might be imperialist: to leave race aside doesn't produce a clean analysis of sex/gender but a white one; a discourse

colonized by white sex/gender, while black sex/gender lurks silently as the necessary but unnamed other in the story.

RACE AND SEX/GENDER:
"TOGETHER WE CAN MAKE IT WORK."

Both race and sex/gender are being analyzed in terms of a particular and rather curious figure of speech. /Race/ is not spoken of *as if* it were a floating signifier but *as* a floating signifier. Gender does not *work* as if it were a performative but *is* as a performative. There is a slippage in these figures of speech between metaphor and simile; it would be wrong to say /race/ *is* a floating signifier (metaphor) and not quite right to say /race/ is *like* a floating signifier (simile). /Race/ is [to be spoken of] as a floating signifier. This lends the image the appearance of a literal statement: /race/ seems to *be* a floating signifier while we talk of it, when what we really have is only a figure of speech, /race/ only *seems* so.

Furthermore, both race and sex/gender are being analyzed in terms of linguistics. This raises a question about how appropriate linguistics may be for the analysis of a corporeal identification: a process of identity which is enacted through the body, such as race or sex/gender (also (dis)ability and generation). This in turn raises thorny questions about reality and language. I don't wish to engage here with whether or not there is a reality to which language refers as a transparent medium, whether insubstantial language is appropriate to a solidly real/concrete corporeal identification, but rather to ask how appropriate analysis referring to words, speech, writing is for the whole body, including hearing and the voice but also other senses and parts.

The examination of race and sex/gender through the use of linguistics has been enormously fruitful. Rather than repeat Butler's, Hall's and Mercer's work to show this, I will briefly look at what we might gain when we talk of race as a performative or /gender/ as a floating signifier.

In a footnote to her analysis of Nella Larsen's *Passing* (footnote 4 on p. 275, Butler, 1993), Butler suggests that race might be construed as performative. The character Bellew, the white racist husband of Clare, one of the two passing women in the story, is

shown to be continually reiterating his whiteness as an anxious disavowal of blackness. This trope shows up the need to constitute blackness in order to constitute whiteness. We become aware of race as an identity constructed in a temporal matrix through reiteration and exclusion. What we lose, which we have when we use the trope /race/ as a floating signifier, is a sense of the ways in which the racial identity being constructed can be freely manipulated into spurious political positions. Speaking of /gender/ as a floating signifier suggests that the concept of attachment of gender to a truly sexed body is imaginary but it breaks cultural gender apart from physical sex and does not allow us the concept of a temporal process of generating the sexed material body through the heterosexual matrix. In both cases of the exchange, then, we lose the sense of a dynamic identification operating in complex social situations and gain only a somewhat static and more subjective perspective on identity.

What this suggests to me is that although race and sex/gender are processes of identification linked to the 'physical,' the ways in which they are manipulated to make politico-social life are not analogous (I'm following Butler's argument). Both can be analyzed in terms of linguistic tropes but what we look for in the analysis of race, or rather of racism and other race relations, is different from what we look for in the analysis of sex/gender. Nevertheless (Butler's suggestion that Bellew's production of sexual barriers is part of his reiteration of whiteness supports my argument), we can only achieve a partial perspective on any identification process if we look at race or sex/gender as separable elements.

PERFORMANCE AS AN ARENA FOR ANALYSIS

I suggest that one area where race and sex/gender can be examined together is performance. This is an area where neither would dominate the other in the imperialism Butler warns us about, where the physical is very present but the historical, social and political may also be articulated.

It's interesting that two famous texts in psychoanalysis should be entitled *Womanliness as Masquerade* (Rivière, 1929) and *Black Skin, White Masks* (Fanon, 1986). Also that both race and sex/gen-

der are subject to parodic imitation of the 'oppressed' by the 'oppressor': blackface minstrelsy and female impersonation. Butler's analysis of gender as a performative offers a thought-provoking study of 'drag' but I want to argue that drag is radically different from blackface minstrelsy and to compare blackface minstrelsy instead to the Pantomime Dame. Like blackface minstrels, Pantomime Dames are public performers whereas drag usually extends into private life even if the drag queen is also a stage performer. (One of the differences between drag queens and blackface minstrels is that the latter are never found secretly covering their faces in burnt cork as a personal act of identification.)

There is a functional aspect to the Pantomime Dame's role: to reinforce the concept of dual sex roles by showing that even in a dress and a wig, a man is still a man. The Pantomime Dame is given a good sporting chance, we endow 'her' with a generous range of womanly qualities: a full figure, which 'she' may maladroitly mishandle (pulling falsies back into place for our amusement); maternity, 'she' is often the Principal Boy's mother; proven marriageability, 'she' is usually a widow, i.e., 'she' has been married, but 'she' is also available to male suitors, which within the heterosexual matrix proves 'her' femininity. But all to no avail. We can see that the poor thing is a Man.[6]

One possible (though contentious) line of argument suggests that blackface minstrelsy is constructed in a similar way to prove that a white man is utterly different from a black man.[7] Eric Lott says of blackface minstrelsy that it

> arose from a white obsession with black (male) bodies which underlies white racial dread to our own day. (Lott, 1993, p. 3)

Sex/gender gets a cameo appearance here. In his study of bluegrass music, Robert Cantwell gives an even more intriguing account of the entanglement of race and sex/gender in blackface minstrelsy:

> Men such as George Christy and Francis Leon became famous in minstrelsy not as buffoons but as female impersonators, crossing both racial and sexual lines to become exotic creoles and 'yaller girls' upon whom men could lavish the sexual fantasies respectable women did not inspire. That contempo-

rary observers noted a natural effeminacy in these men lends credence, I think, to the idea that racial imitation, too, may have been based upon a natural affinity, and that minstrelsy offered a place in society to men with some renegade element in their natures, sexual or cultural, which on the minstrel stage might receive full and free expression. (Cantwell, 1992, p. 269)

I'm not sure I want to follow all the implications of Cantwell's thinking but it's fascinating to consider that these performers may have diverted potentially violent attention from their 'effeminacy' by imitating blackness so as to prove whiteness.

PERFORMANCE AND PERFORMATIVITY

Before I offer my own analysis of 'live' material, I should clarify my position on performance and the performative. I will argue that the most useful area of their relationship is where they don't fit; against Timothy Gould and Eve Kosofsky Sedgwick (see Parker and Sedgwick, eds., 1995). Performance is a word covering a wide range of public and private enactions of identity, and a concept which seems to incorporate the emotional, physical and rational together rather than subscribing to any Cartesian mind/body split. The performative is a linguistic term, as I outlined above. Gould's paper, "The Unhappy Performative," discusses the operation of the performative in a dramatic performance: Sophocles' *Antigone*. He remarks:

> I note that my project requires that I begin by decoupling the term 'performative' from the constellation of 'performance' and 'performativity.' (Gould, 1995, p. 19)

I think Gould's 'unhappiness' (see Gould, 1995, p. 23 on how J.L. Austin used happy/unhappy rather than true/false in writing about the performative) with the coupling of performative, performance and performativity, his need to uncouple them in order to conduct his project of examining them together, is important. I think the public arena of 'performance' and the artistic creation of a performance, in public or in private life, is quite different from the work-

ings of identity as a performative. Working with these two together usefully highlights the differences not only between them as tools of analysis but between areas of social life which they may be used to refer to.

ANALYSIS

I present here a few thoughts relating to material with which I am currently working. As I'm at a very early stage in my research, I beg leave to defer a fuller analysis for the time being.

In the poem "The Black, The White and The Blue," the performance poet Patience Agbabi enacts a white racist policeman:

> He's an East End Lad East End Ed
> East End born East End bred

> (Agbabi, 1995)

In performance, she enacts this persona not only using words to describe him, his racist actions and his racist and homophobic upbringing but also a Cockney accent, a wide-legged 'masculine' stance and aggressively bunched fists. Agbabi's use of the personal pronoun in the third and not the first person clearly indicates that although her body language generates a presence in the performance, "He" is not to be confused with her own person. More than this, however, because she is directly before us, we can 'read' alongside the white male subject of the poem, Patience Agbabi herself as a black woman. I prefer to call the enaction of the white man here 'performance' and to distinguish this from 'acting' because to act the white man seems to me to concentrate on the success of enacting him, whereas what is intriguing here is also the failure to do so. Underneath the surface narrative of the poem: a story correlating racism and homophobia, the floating signifier /race/ seems to be twisted into some unexpected shape (like the long thin balloons people turn into little dogs) while the difference between the performance of masculinity and the performative of femininity is displayed for us: written by the body. Agbabi's body becomes a site for discourse on identification. This raises a number of questions which I hope to address in my research: What is the

audience receiving in this performance (in addition to the surface narrative)? Is the performance working like that of the Pantomime Dame and Principal Boy to reassure us of an essential blackness, an essential woman? Or is something more sophisticated being engaged in? What does the layering of race and gender onto race and sex/gender suggest about any 'authentic' identity which Agbabi might lay claim to?

PakiBoy (Light, 1996) is another example of the layering of performance and performativity, floating signifiers drifting about the stage. Zahid Dar, "a second generation East African Pakistani" performs the character of "a glam, dancing, Pakistani queen from Birmingham" created for him by Tenebris Light "brought up in Birmingham in a Scots/Welsh/Catholic/Jewish family intermarried with Pakistanis" (quotes from program of first performances). As an audience, our perception of any true identity in terms of race or sexuality is punctured by confusion between Dar and the unnamed central character: so similar that we can't tell whether Light has given us (his version of) Zahid's 'real life' story or a completely fictional kathak dancer. Dar's body becomes a site for discourse about identification and authenticity.

Gloria Anzalduà (1987) refers to her intermingling of all the languages of her heritage in her writing as "a forked tongue." This is also of course the infamous phrase ascribed by Hollywood to Native Americans who accuse white men of creativity with the truth. In performance it seems that body language may speak with forked tongue–and exercise a marvelous creativity with any idea we had about 'true' facts of the body.

ACKNOWLEDGMENTS

The author would like to acknowledge the invaluable support of the following people, none of whom are of course responsible for any errors in her article: Prof. Paul Gilroy, Dr. Vikki Bell and Dr. Les Back. While writing this article the author had the help of a Career Development Loan from the Co-operative Bank plc and a scholarship from the Economic and Social Research Council–the author is profoundly grateful to both these organizations. The author is also grateful to Dr. Kobena Mercer for permission to quote from his unpublished PhD thesis and to Professor Stuart Hall for his encouragement. The author would like to thank the Department of Sociology at Goldsmith's, where she is still waiting to experience

that awful isolation everyone told her was part of doing a PhD; Anne-Marie Singh for being a friend indeed; Nina Rapi and Maya Chowdhry for their support during the editing of this piece; and Valerie Mason-John, who commissioned the author's first piece of writing in this area and started her thinking about doing research in the black and gay community.

NOTES

1. A trope can be roughly defined as a figure of speech, e.g., metaphor, simile, synecdoche, metonymy.

2. Kobena Mercer (Mercer, 1990) writes /race/ when he discusses it as a signifier rather than problematizing 'race' between speech marks. The putting of (a section of) a word between two slashes is a common practice in phonetics to mark off phonemes, although Mercer doesn't seem to be using the slashes in exactly this way.

3. Some people may wonder if it is appropriate for a gay man's work to be given space in this volume. As my article is more a theoretical piece than a review of lesbian performance, I decided to refer to Light and Dar on the same terms as Hall and Mercer–so far as they assist my argument.

4. The turning of 'black' and also the term 'queer,' rather than coining new terms, means they carry the history of denigration and hatred suffered by the people who have worked them into badges of pride.

5. Reiterate from the Latin: itero, -are, to repeat but particularly to repeat words.

6. It throws an interesting light on the way this potentially subversive cross-dressing actually works to underpin the heterosexual matrix, that in spite of the popularity of the panto in Britain, no woman has yet come forward to say she first realized she was lesbian when she fell for the Principal Boy.

7. There are very few accounts of female blackface minstrels.

SELECT BIBLIOGRAPHY

Agbabi, Patience, 1995. *R.A.W.*, Gecko Press: London.

Anzaldùa, Gloria, 1987. *Borderlands/La Frontera: the New Mestiza*, Spinsters/ Aunt Lute Press: San Francisco.

Appiah, Anthony, 1986. "The Uncompleted Argument: Du Bois and the Illusion of Race," pp. 21-37 in Gates Jr., Henry Louis, ed. *"Race," Writing and Difference*, University of Chicago Press: Chicago.

Austin, J.L., (ed. J.O. Urmson and Marina Sbisa), 1955, published in 1976. *How to do things with Words: The William James Lectures delivered at Harvard University in 1955, Second Edition*, Oxford University Press: Oxford.

Burgin, Victor, Donald, James and Kaplan, Cora (eds.), 1989, *Formations of Fantasy*, Routledge: London.

Butler, Judith, 1993. *Bodies That Matter: on the discursive limits of "sex,"* Routledge: New York.

Butler, Judith, 1990. *Gender Trouble: Feminism and the Subversion of Identity,* Routledge: New York.

Cantwell, Robert, 1992. *Bluegrass Breakdown: the Making of the Old Southern Sound,* Da Capo Press: New York.

Fanon, Franz, 1986. *Black Skin, White Masks* (trans. Charles Lam Markmann), Pluto Press: London.

Gould, Timothy, 1995. "The Unhappy Performative" in Parker and Sedgwick, (eds.), 1995, *Performativity and Performance.*

Hall, Stuart, 1996. "Who Needs 'Identity'?" in Hall, Stuart and Du Gay, Paul, (eds.), 1996. *Questions of Cultural Identity,* Sage Publications: London.

Hall, Stuart, 1996b. "'Race' as a Floating Signifier," The Sage Anniversary Lecture delivered at Goldsmith's College in 1996.

Hall, Stuart, 1995. "Fantasy, Identity, Politics" in E. Carter, J. Donald and J. Squires (eds.), 1995. *Cultural Remix: Theories of Politics and the Popular.* Lawrence & Wishart: London.

Hall, Stuart, 1988. "New Ethnicities" in ICA Documents no 7: Black Film, Black Cinema.

Hall, Stuart, 1978. "Racism and Reaction" in *Five Views of Multi-Racial Britain,* CRE Publishers: London.

Heath, Stephen, 1986. "Joan Rivière and the Masquerade" in Burgin, Victor, Donald, James and Kaplan, Cora (eds.), 1989, *Formations of Fantasy.*

Light, Tenebris, 1996. *PakiBoy,* performed at Oval House Theatre, London in March, 1996.

Lott, Eric, 1993. *Love & Theft: Blackface Minstrelsy and the American Working Class,* Oxford University Press, New York.

Mercer, Kobena, 1990. *Powellism: Race, Politics & Discourse.* Unpublished PhD Dissertation, Goldsmith's College, University of London: London.

Parker, Andrew and Sedgwick, Eve Kosofsky (eds.), 1995. *Performativity and Performance,* Routledge: New York.

Rivière, Joan, 1929. "Womanliness as Masquerade" in Burgin, Victor, Donald, James and Kaplan, Cora (eds.), 1989, *Formations of Fantasy.*

de Saussure, Ferdinand, 1915, published in 1983. (ed. Tullio de Mauro). *Cours de linguistique generale,* Payot: Paris.

PART TWO:
THE LESBIAN BODY IN PERFORMANCE

Performing the Lesbian Body–
The New Wave

Julia Brosnan

SUMMARY. In recent years a crop of fine, exhilarating new talent has burst onto the lesbian performance scene. It has thrown up a range of unique dyke representations–from big hair, high drag, postmodern stripping and reformed fan dancing through to irony and pigtails. In the past the famous dyke double negative–of being both

Julia Brosnan did research into nuclear weapons and ethics (it was a short study–nuclear weapons are wrong) before working as a BBC radio producer for several years. She co-produced the BBC's first national lesbian and gay radio program, then moved into print journalism. Her work has been published in *The Independent*, *The Guardian*, *The Pink Paper*, *Diva*, *The New Statesman* and *Red Pepper*, and her short book *Lesbians Talk: Detonating the Nuclear Family* was published by Scarlet Press in 1996. Her fiction has appeared in *Writing Women*, *Pulp Faction*, *The Big Issue*, *Queer Words* and *Panurge*.

[Haworth co-indexing entry note]: "Performing the Lesbian Body–The New Wave." Brosnan, Julia. Co-published simultaneously in *Journal of Lesbian Studies* (The Haworth Press, Inc.) Vol. 2, No. 2/3, 1998, pp. 79-94; and: *Acts of Passion: Sexuality, Gender and Performance* (ed: Nina Rapi, and Maya Chowdhry) The Haworth Press, Inc., 1998, pp. 79-94; and: *Acts of Passion: Sexuality, Gender and Performance* (ed: Nina Rapi, and Maya Chowdhry) Harrington Park Press, an imprint of The Haworth Press, Inc., 1998, pp. 79-94. Single or multiple copies of this article are available for a fee from The Haworth Document Delivery Service [1-800-342-9678, 9:00 a.m. - 5:00 p.m. (EST). E-mail address: getinfo@haworthpressinc.com].

79

female and 'homosexual'–has shadowed lesbian performance to
such an extent that there have been few positive, out representations.
The work of feminist/political performers which challenged this was
often reactive and thus tended to narrow down, rather than open out,
the range of 'acceptable' lesbian representation. But things are
changing. In this chapter, six 'new wave' performers talk about creat-
ing work, getting seen, showing flesh, doing politics and making
money. Although they affirm that presenting publicly as an out dyke
is still hard, they have also discovered a richness and freedom that is
essentially and uniquely lesbian. Given the grotesque stereotypes
and stinking closets so many lesbian performers have endured in the
past–this represents something of a genuine and much-needed break-
through. *[Article copies available for a fee from The Haworth Document
Delivery Service: 1-800-342-9678. E-mail address: getinfo@haworthpressinc.
com]*

In cultural terms the lesbian body in performance presents itself
as an arena of great tension. 'The lesbian' arrives on stage with a
mass of cultural baggage. Before she even moves or speaks much is
read into the single fact of her public presentation. This operates on
two deep levels, for she is viewed both as a woman and as a
'homosexual.' In the past this has largely been seen as negative and
has kept female performers as a whole in a subordinate position. It
has also forced the overwhelming majority of lesbians to remain in
the closet. Thus the real history of lesbian performance, like many
other lesbian histories, is impoverished by the universal dyke trade-
mark of invisibility.

But things are changing. In recent years a variety of factors have
fused together to create rich and fertile conditions for lesbian per-
formance. A number of different trends gelled and suddenly a range
of new freedoms and opportunities opened up. The main features
which propelled these changes are increased lesbian visibility in
society as a whole; a surge in the popularity of all kinds of live
performance; and the influence of queer/gender fuck thought and
practice.

Although the impact of this has been limited, and while it is often
still harder to present as a lesbian than as anything else (i.e., than as
a straight or gay man or as a straight or bisexual woman), it is also
true to say that the current new wave of dyke performers are not
simply presenting as out dykes (although that would be an achieve-

ment in itself), they are also discovering strengths and freedoms which are specifically lesbian. There is a genuine sense in which the lesbian double negative (of being both female and queer) is being seen to make a positive. Given our history, this represents a real step forward.

THE LESBIAN BODY–THE BAGGAGE

The fact that the lesbian body in performance is a highly contested area gives rise to the critical question of ownership–of who this body belongs to. A large part of this is to do with sex and power. In Western society the idealized female form is an icon of sexual submissiveness, and in this way female artistes have historically been objectified for male consumption.

"Women have always had a tough time on stage" says lesbian performer and club promoter Amy Lame.[1] "Fifty to sixty years ago just the fact of going out and performing meant that you were considered a whore." This identification between public presentation and sexual availability is a filter through which women have often been seen.

"When a woman's body is presented it's hard to see it as anything other than stereotype," says queer performer Alison Cocks. "We are so familiar with women looking a particular way for male titillation that this tends to prevent us from ever seeing beyond it." Thus once a woman is anything other than fully clothed there is a sense in which her image is suspect. It seems to automatically point towards the dark arena of male domination and exploitation. In this way there has been a tension between some feminist analysis and sexualized/eroticized female representations.

In the '70s a number of lesbian/gay/feminist theatre companies devised and performed agit prop/issue-based work which was largely concerned with being serious, non-sexual and with challenging old stereotypes. While this bought many critical insights it also tended to narrow down the sort of lesbian images that were portrayed.[2] However, challenging the stereotypes the straight world threw up was very important for lesbians who have often been represented as the antithesis of 'real' women.[3] Like witches, they have been demonized as psychopathic man-hating child eaters. Or

they have been presented as grotesque butches as in the film *The Killing of Sister George.*

"I was so upset when I first saw the film of Beryl Reid as Sister George," says lesbian performer Cathy P. "I was about 14 and it was probably one of the only lesbian images I'd ever seen—but it was so grim it made me want to cry."

Apart from this sort of depressing representation, lesbian images were largely absent from the public stage. But this didn't mean that lesbians themselves were absent. It has long been an open secret that a relatively high percentage of women working in the soft/performance end of the sex industry are and have been lesbian and bisexual. Andrea Stuart's recent book *Showgirls* chronicles the hyper-glamourous and physically sexual female performers from the latter part of the last century and beyond.[4] In examining the sexual relationships some of them had with other women, Stuart argues that the connection between high glamour and lesbianism has historically been very strong, but that this sort of glamour has since been appropriated by heterosexuality. Thus another lesbian image was lost.

The additional complicating factor here is that any sort of out physical/sexy representation of lesbians feeds directly into straight male fantasy. As any top-shelf magazine will confirm, lesbian sex is a major heterosexual male turn on and so lesbians have often been wary of presenting themselves physically/sexually as it may encourage male voyeurism. Thus until very recently the public lesbian image was very restricted.

At the heart of this is another driving force behind the public lesbian presentation—and that is that there is no definitive way for a lesbian to look. Professor Judith Butler has pointed out—the one thing that lesbians are consistently accused of is being derivative.[5] Whatever they wear and however they act they face this accusation because there is no established way 'to be' a lesbian. Thus butches are accused of aping men; femmes are accused of aping straight women; to present anything other than fully clothed is to reinforce the dominant cultural images; and to present as sexual is to encourage male voyeurism. These accusations come from the straight world, and in a slightly different form they have also come from within the lesbian community. Fears and insecurities borne out of

years of bitter experience have led to a certain amount of internal lesbian policing.

THE LESBIAN BODY-THE FREEDOM

Given all the projections, preconceptions, expectations and general baggage that have attached themselves to the performing lesbian body, it is understandable that the approach which enabled a real shift to take place came at its target from an entirely different direction. Instead of taking its cue from societal images or from the standpoint of working through the twists and turns of political understanding—new wave performers have come to their work from essentially two new perspectives: their own experience and an exploration of past performance styles they admire.

The notion of working from personal experience may appear obvious but it in fact marks a considerable break from what went before. In the past there was a tendency for lesbians to present themselves either as reborn dykes, cut adrift from their pre-out past, or to look at that past with the eyes of a victim. There was a big push to emphasize the watershed/better life aspect of coming out and to reinterpret/interpret past and present experience in the light of it.

While this struck a chord with many lesbians it wasn't the whole story. Many dykes have mixed feelings about their past—fond memories of girl magazines and tea round the fire as well as the alienation of growing up in a straight environment. The work of performance artist Helena Goldwater illustrates this well. Often billed as a "raving kosher campster," her trade mark is a sparkly red evening dress with accompanying big hair, nails and lashes. She is a lesbian drag queen and her starting point is not gender-political, it is rather about mining a rich and important seam of her personal history. Goldwater says:

> For me doing drag is really connected to being Jewish. It's how my family, particularly my aunties are. It's not such a parody for me—it's about getting in touch with who I am and where I come from—about celebrating the legacy of glamour I've grown up with. It's reclaiming that and putting it in a feminist context through my work.

Goldwater readily identifies as a feminist and has a strong political element to her thought and work, yet she also grew up in a straight Jewish family with whom she feels a deep connection. She appears to be confident enough in her politics not to let them negate these other feelings, and this is very much something which has come out of the 1990s second wave of lesbian feminism. It is a different way of combining image and message into performance. Amy Lame is another example. When she started out in 1993 one of her major themes was the affinity she felt with gay men. This was something that would have been very difficult to express in the past. What has changed is that there is also now a place for this to be done, and by a performer who is (like Lame) also very woman/lesbian identified.

Picking up on admired past performance styles is also something which appears to be an obvious source for artistes making their own work, but again this wasn't always the case. Although there were companies which used particular performance styles (for example circus skills), the push was very much to reclaim them in an overt feminist/political context, and some performance/theatrical traditions were considered too dubious to touch. Areas of variety, drag and burlesque for instance, often looked hopelessly misogynistic and straight, but these are now aspects that artistes feel free to examine. Lesbian performer Cathy P has done a range of work in this field:

> I really love variety. I love that whole thing of entertainment and direct contact with the audience. I've looked into the history of it and have done a show based on the historical representation of women in variety. I've also worked on the history of drag and how gay men have represented women.

Like Goldwater, Cathy P is quick to identify as a feminist. She has a strong sense of women's performance history, and like Goldwater and Lame, she celebrates the things that simply delight her—glitter, wigs, audience participation—wherever they come from and whatever their cultural readings.

Queer performer Marisa Carr also bases a good proportion of her work on past women performers. She is very interested in vaudeville and music hall, which she describes as

very anarchic and left wing. Early music hall produced many powerful, sexual women. People like Colette and Marie Lloyd who were very subversive and sexual. A number of them also campaigned for social reform, particularly in the area of prostitution . . . they knew how desperate many women's lives were.

Like other artistes Carr has discovered a number of radical trends in unlikely performance histories.

When questioned about this use of personal and performance histories, all the women interviewed here expressed a similar sentiment: why should straight men, straight women and gay men have all these sources of material and all these images for themselves? They don't own them, and it's time to not simply reclaim them (in the sense of rinsing them clean and presenting a politicized version) but to actually *appropriate* them.

The danger here–which the early feminists knew very well–is that what went on in the bad old days may simply be repeated. Is drag/variety performed by the new wave really that different? Alison Cocks thinks so: "It's about agency. If women are forced to do something or if they don't have any say in what they're doing it's quite different from work which is conceived and performed by a woman." This is indeed critical, and the single thing, perhaps above all else, that marks this new range of work is that in form, content and representation it is self-directed. By building on a diverse cultural, political and theatrical past they are making personal creations which mark out new territory.

THE CLIMATE

As often happens with such movements and trends, a few key people pick up on zeitgeist undercurrents, they meet up, the elements fuse together and they find ways to help each other disseminate their work. In this case there was one particular moment.

"It was the summer of 1994," says Helena Goldwater. "I was in Jyll Bradley's play *On the Playing Fields of Her Rejection* and I met Helen Paris. Around then we also met Marisa Carr and Amy Lame. We'd all been working separately on our own pieces so when we met up it was very exciting."

One striking feature about the women who came together at this time is their disparate backgrounds in terms of training and interests. Helena Goldwater was working in live/visual arts; Helen Paris had worked in experimental theatre; Amy Lame came to England from New Jersey in the USA with no theatrical background; Cathy P had been doing street theatre and clowning in the Highlands; and both Marisa Carr and Alison Cocks have worked at the performance end of the straight sex industry. They didn't come from a particular 'school,' although in another sense they had a good deal in common. Although they weren't all originally from London they were all living there, they were all in their early-mid 20s and they are all white. In this sense they correspond to the visible end of many similar movements which later (hopefully) filter out to a wider selection of people.

However, the distinctive feature here is the fact that it's about lesbians. That this was possible (as pointed up in the Introduction) was due to three main conditions. The first was the increased lesbian visibility in society as a whole, which made it easier for dykes to be out and public.[6] Secondly, the late 1980s/early 1990s saw an upsurge of interest in live performance generally. This led to a wide increase in venues and a chipping away at the genre delineations which were so prevalent. Before the field opened up, the opportunities for individual performers were limited. They ranged from rarefied art houses, where as Amy Lame says ". . . performance artists played to other performance artists"; to traditional song and dance cabaret venues; through to comedy/drinking clubs largely centered around standups delivering punch lines. These categories were notoriously difficult for a large section of female performers, let alone out lesbians who wanted to explore their lives and loves. Thus the opening up of more and more loosely defined venues, coupled with the fact that some performers like Lame turned club promoters themselves, gave them a tremendous boost. If nothing else performers do need somewhere to perform.

Finally the new generation of queer thinkers and practitioners was particularly important for performers. The theoretical queer ideas about gender as something that is essentially performed,[7] along with the whole gender-jumping scene, meant that in the clubs, in the glossy magazines and on the street, the theatricality of sexual-

ity was being celebrated in grand style.[8] The performers took it on stage.

"I don't think it could've happened without the queer impetus," says Helena Goldwater. "It's given us a freedom. If I was straight I could never be a drag queen—no way. Wearing an evening dress and high heels has an entirely different meaning if you're involved with men. Being a dyke I was able to bypass all that—and do what I liked."

Goldwater's observation provides an interesting counterbalance to what went before. Only a few years previously being a dyke generally meant having a lot *less* freedom over presentation. How things changed. This particular fusion of people, trends and events was particularly good for lesbian performers and enabled them to discover some of the treasures that were unique to them.

IDENTITY

The question of how these performers present themselves and what image they portray has been touched on briefly. Here the focus is on how two performers present in key shows, which have been chosen for the general issues and trends they represent.

The first is Cathy P's "Plush . . . an intimate review" which she created with her performance partner Chris Green in 1995.

"It's about the history of variety" says Cathy. "The impact of TV was important because variety had been the most popular form of entertainment and it suddenly had to compete with TV. It had to pull in a new audience and relied on women taking more and more clothes off—so it got seedier and seedier."

This is something Cathy represents on stage. The male compere makes derogatory remarks and her character is clearly not comfortable with stripping in that environment. This makes a point about the exploitation of women (the set-up, her treatment) rather than the fact of stripping itself. Later on Cathy does a strip to a gynecological text, which demystifies the process by reducing it (in one sense) to biology. Helen Paris does a similar thing in her "Sniffing the Marigolds." At one point she stands in her underwear in front of a film of an alleyway while the measurements/details (of herself? of the alleyway?) are read out. Paris describes it in this way: "When

you put a woman on stage there is an immediate objectification and that's what I'm playing with." Like Cathy P, she is exploring this head on.

The agency referred to previously is crucial here. Alison Cocks who has worked as a stripper in the straight sex industry explains:

> There's a law in Westminster which says you can't talk and strip at the same time and I think that's very significant. If you can't speak you can't express yourself and you lose control . . . you are an object and it's an entirely negative representation. But when I'm doing my own performance I do talk. I take possession of my identity and I express my own pleasure.

An example of this is a strip Cocks devised herself which she does to a commentary about witch burning. This removes the act of stripping from its usually perceived context and opens out a different perspective.

In "Plush" Cathy P also revives various burlesque styles like nude fan dancing, something which Marisa Carr also focuses on in her work. "Plush" looks at the way drag has developed as well, but not simply on the usual level of assuming the opposite gender. Cathy says:

> Because I love dressing up and doing loud characters I think a lot of what I do is drag. There are many great woman characters and really glamorous ones that I love–and I want that image. It's been taken over by men but I think it's fabulous to reclaim it. To be a woman doing female drag and to really celebrate it.

The lesbian drag queen is a new departure and is becoming increasingly popular. Interestingly a number of performers have come to it on their own, Cathy P through her love of popular theatre, Helena Goldwater through her Jewish background, and Amy Lame through her identification with gay men and her love of femme.

Lame explored this in her first show "Gay Man Trapped in a Lesbian Body," a one-woman piece which came out in 1993. It is autobiographically based and includes the search for the ideal

woman, notions of body size, perceptions of beauty, being a lesbian and Lame's own journey. She says:

> I read all these books and when I came out I thought there would be this big community waiting to accept me with open arms, but I discovered it wasn't like that. Instead there was a certain way you had to look.

Looks became a starting point for Lame. She describes herself as "a chubby girl in a frock with spectacles" and her first show was a celebration of femininity. "It was before lipstick lesbians," she says. "A lot of dykes were very suspicious of me. They didn't like to see a lesbian in a skirt or a dress, especially if she wasn't wearing them in relation to a butch partner. There wasn't a concept of a femme in her own right. Others thought the show was disgusting and asked why I didn't have a sex change . . . but I wasn't trying to be a parody of a lesbian or to be a gay man in drag, I was just being myself." There has been an undercurrent in lesbian culture which has seen femmes as 'less lesbian' than butches. The way femmes can 'lesbianize' themselves is through their butches. The very femme Lois Weaver of the theatre company "Split Britches," for instance, has most often performed with her butch partner Peggy Shaw, although she has recently done more solo work. For Lame to present as an out strong femme in her own right was a new departure.

Interestingly Lame's performance, which was essentially about herself, confronted the issues of gender, drag, sexuality and presentation directly. The fact that she did not, in the eyes of some other lesbians, "look like a lesbian" enhanced the feelings and preconceptions she was playing with. She describes the centerpiece of the show: "I came on stage in pink fluffy slippers with flowers on, a satin basque and slip and using the audience as my mirror, I put my makeup on and transformed myself—with big hair, frock, jewelry and high heels and did a piece of text on fat issues." Lesbians have often taken fat as part of the butching up, rather than femming up process. Putting fat in a feminine (rather than a butch or a feminist) context also shed new light on the shape of the lesbian body and its possibilities.

In terms of doing lesbian drag Lame says: "I was having a joke

with the idea that male drag queens actually dress up to look like *real* women. That's a joke because they don't look anything like them and I was also having a joke on lesbian fashion. In fact I was really just dressing as I do everyday–very feminine in lots of frills, but it was read as if I'd appropriated drag because lesbians don't dress like that." In this way Lame both undercut some of the prevailing presumptions and simply did what she felt like. It must have struck a chord as it wasn't long before a good proportion of the criticism wound down and other lesbian performers started doing their own versions of drag and dressing/presenting in ever more divergent styles.

The other interesting development is that rather than looking inwards for pure lesbian images, the new wave are more up front about doing what artists and performers have always done–borrowing from outside. This is where the gay male identification fits into Lame's frame:

> It's about that lovely three letter word–fun. There's a hedonism that gay men have. They know how to have fun, they know how to live life to the full. At that time I felt a lot of lesbians I knew weren't living life to the full, but that's changed now.

SEX

In the popular imagination the performing lesbian body is most likely to engender ideas of sex. After all lesbians are generally defined by their sexuality–so what else could they perform? Although this is a crude idea it does hold some truth. Most of the new women's queer performance art does have a sexual element. Here we concentrate on two artistes who use it specifically–Marisa Carr and Alison Cocks.

Carr's work moves between live art and erotic performance. In 1995 she was in Robert Pacitti's show "GEEK" which was banned because the performance involved her pulling a string of union jack flags out of her vagina. During the critical summer of 1994 she organized the London Smut Fest which starred Karen Greenleigh, the only avowed female necrophile in the world. Carr certainly puts

herself on the edge. She revels in rude, bawdy images and has a reputation for presenting herself as raw, raunchy and sexualized.

However, although the character and content of her performance appears to be very contemporary and "in yer face," Carr in fact spends a great deal of time doing historical research. She says: "My recent show 'Lady Muck' was based on the lives of five cross-, dressing bisexual performers who played in Music Hall." For Carr the spirit of queer which she embraces with enthusiasm is not new: "Looking back it's possible to read all sorts of female performers–like Mae West for example–as queer. She was a polygamous sexual adventurer who ran things her own way. She was working class and worked for years in the burlesque houses, then she moved into the mainstream by doing two shows: 'Sex,' about prostitution and social conditions, and 'Drag,' about drag queens."

Carr has been involved in the anarchist movement and is committed to the positive representation of women: "Feminism and liberation are so connected to the way that women use their bodies . . . and I want to move it out of the realm that sex and the body are usually stuck in. A lot of women like Colette who worked with sex were also intellectual–she was a literary figure as well. They mixed low and high culture which is something I try and do." While it is certainly true that work with sex/the body is often seen to negate any high/political/intellectual content–bridging the gap with integrity is an extremely fine balancing act.

Cocks also mixes sexually charged work with historical research and politics. Her work often refers to crimes against women and the drab domestic/low pay prospects that still constitute the future for many. Although bisexual, Cocks says: "I would never represent the heterosexual aspect of my desire on stage because of its relation to the dominant culture." However, she recently did an autobiographical piece which charted some of her early experiences with men, but says: "I did it to show the contrast between that–which was largely about the man seeking his pleasure, and my experiences with women which were much more free and equal."

Within the women's movement the question often asked of women who profess politics and also use their bodies is: Why attempt the balancing act, why not just do the politics? Cocks says: "I think the female body is potentially very revolutionary. Ideas

about it tend to be so narrow and fixed that when you subvert that
you can have a big impact. In my work my movements often go
from being very feminine to very masculine. I'll move or act in a
very different way and that can be both challenging and empower-
ing." Helen Paris agrees: "Sometimes I undress on stage and I'm
standing there in my underwear and then I'll do something really
unexpected–like bite into my arm or spit out some orange that's in
my mouth. I subvert people's expectations." Carr also talks about
using nudity in this way: "The bodies you see are not what are
traditionally considered to be sexy–they are pierced, tattooed and
shaved in the wrong places."

But is this really revolutionary? Or is the work of the more
sexually explicit performers like Cocks and Carr–simulating sex
and pulling props out of their genitals–too close to the antifemin-
ist objectification and exploitation of the straight sex industry?
Cocks and Carr are both quite close in the sense that, like some
female performers of the past that they admire (e.g., Edith Piaf,
Mae West), they have worked in the commercial sex industry
both at the 'softer' end of stripping and peep shows. Neither is in
the growing tradition of sex worker turned performance artist,
the most famous example being American lesbian Annie
Sprinkle. Instead Carr and Cocks both started their stripping
when they took up studying, and the bottom line was that it was
mainly for the cash. "I can earn £1,500 in two weeks doing peep
shows," says Cocks. "This enabled me to study and perform.
Otherwise I'd be earning £4 an hour as a waitress and I'd still get
sexually harassed . . . at least with this work you know where the
boundaries are."

However money wasn't the only factor. Carr says that when she
started she was "fascinated" by the work and both she and Cocks
feel that the straight sex and their queer performance work inform
each other. But this enthusiasm doesn't last forever. Says Carr: "It's
less fascinating now because it's exploitative, not because of the
stripping because that's your personal choice but because there are
no unions, no lunch hours and no showers . . . And there are terrible
things in the sex industry as a whole . . . junkies in Thailand forced
into prostitution." This disillusionment has a familiar ring. It is
echoed by many who started out starry eyed, particularly by those who

(unlike Carr and Cocks) moved into the harder end. One hundred fifty porn films and 5,000 blow jobs later Annie Sprinkle is now sounding jaded by her experiences.[9] The sex business is a dangerous game and while it may for some add excitement and glamour to performance work, there is a chance that some of the darker aspects will also rub off.

Meanwhile Cathy P is enthusiastic about some sex scenes she recently filmed for Channel 4's Dyke TV season. "It was a lesbian film in a lesbian context and it was very affirming for me personally." What about the possibility of straight men using it to get off on? "Well they could use anything. What they do isn't my responsibility. What's important to me is the reason I made it and I made it for other women not for them."

There is clearly a long way to go before explicit sexual lesbian images are taken as they are meant. Yet the issue of how to present the lesbian body will not be taken forward without engaging in areas that interest, excite and challenge all of us–this is what performance is about.

A BALANCING ACT

The past few years have certainly seen an upsurge in out lesbian performance, and it has produced work which has forged into new areas. A broad span of performance which includes drag, flesh, high femme and variety as well as feminism and politics has attempted to fuse together the many aspects of lesbian life and experience. After all we all live in the straight world at least some of the time–most of us have families, fantasies and contradictory desires. For a number of very good (and not so good) reasons in the past, these expressions have not been so possible, but things have changed. The new wave performers are working through their own balancing act of possibilities, and the decision a number of them are currently facing is–where to go now? After several years on the fringe and playing to largely lesbian and gay audiences many of them are wondering about going more mainstream and are asking what impact this would have on their work. It is an issue which faces many artistes who experience a degree of success–but for lesbians the question is

more difficult than for most. As Helena Goldwater says: "Whatever you say and whatever's happened culturally–it's still hard, probably hardest, to present as a lesbian." Things have undoubtedly got better–but there's still a long way to go.

NOTES AND REFERENCES

1. All quotes from the artistes are taken from interviews with the author during the summer of 1996.

2. The writings of lesbian feminists like Sheila Jeffreys are important here. In her book *Anticlimax–A Feminist Perspective on The Sexual Revolution* (The Women's Press, 1990, London) for instance, Jeffreys equates the eroticization of difference with heterosexuality and the heterosexual power imbalance. This sort of analysis has gone on to be interpreted so broadly in some quarters, as to disallow virtually all erotic/differently styled (whatever they may be) lesbian representations.

3. Chapter on "Lesbian Evil" in *Surpassing The Love Of Men* by Lillian Faderman, published by William Morrow and Company, 1981, New York (The Women's Press, 1985, England).

4. *Showgirls* by Andrea Stuart, Jonathan Cape, 1996, London.

5. "Imitation and Gender Insubordination" by Professor Judith Butler from *The Lesbian and Gay Studies Reader* edited by Abelove, Barale and Halperin, Routledge, 1993, New York.

6. The cultural impact of 1990s lesbian visibility is discussed in *Daring To Dissent: Lesbian Culture from Margin to Mainstream* edited by Liz Gibbs, Cassell, 1994, London.

7. As discussed throughout *Performativity and Performance* edited by Andrew Parker and Eve Kosofsky Sedgwick, Routledge, 1995, New York/London.

8. The impact of queer thought and practice is discussed in *Lesbians Talk Queer Notions* by Cherry Smyth, Scarlet Press, 1992, London.

9. Interview by Andrea Stuart, *Diva* Magazine, pp. 38-41, Feb-March 1996, London.

Get Your Feminism Off My Floppy: Seedy ROMs and Technical Tales

Jools Gilson-Ellis

SUMMARY. This paper is located at the collisions of femininities, technologies and performance, and in the CD-ROM format in particular. The paper begins by asking what it means to be located as Other to an insurgent technology, and develops this analysis in relation to the association of femininity with un-bound flow. It goes on to call for the marking of technology with the feminine. The latter part of the paper analyses specific examples of performative practice on CD-ROM. These are Gilson-Ellis/Povall's *mouthplace*, Adriene Jenik's *Mauve Desert* and Laurie Anderson's *Puppet Motel*. *[Article copies available for a fee from The Haworth Document Delivery Service: 1-800-342-9678. E-mail address: getinfo@haworthpressinc.com]*

Using computers to store recipes is one of the oldest jokes in the personal computer business–in the early days, that's what

Jools Gilson-Ellis is a feminist writer, performer and choreographer whose recent art work includes collaborations with director/film-maker Johannes Birringer, and composer/programmer Richard Povall. The artist's CD-ROM *mouthplace*, the result of the collaboration with Povall, was published in 1997 (*mouthplace*, New Hampshire, Frog Peak Music, 1997). Recent performances include *Difficult Joys* at Dartington Arts Gallery, January 1996, *Lively Bodies, Lively Machines*, Split Screen Festival, Chichester, July 1996, and *mouthplace Live* at Steim, Amsterdam, September 1996. Jools Gilson-Ellis is Lecturer in English (Drama) at University College Cork, Ireland.

Address correspondence to Jools Gilson-Ellis, The Lodge, Knockanemore, Ovens, County Cork, Ireland.

[Haworth co-indexing entry note]: "Get Your Feminism Off My Floppy: Seedy ROMs and Technical Tales." Gilson-Ellis, Jools. Co-published simultaneously in *Journal of Lesbian Studies* (The Haworth Press, Inc.) Vol. 2, No. 2/3, 1998, pp. 95-109; and: *Acts of Passion: Sexuality, Gender and Performance* (ed: Nina Rapi, and Maya Chowdhry) The Haworth Press, Inc., 1998, pp. 95-109; and: *Acts of Passion: Sexuality, Gender and Performance* (ed: Nina Rapi, and Maya Chowdhry) Harrington Park Press, an imprint of The Haworth Press, Inc., 1998, pp. 95-109. Single or multiple copies of this article are available for a fee from The Haworth Document Delivery Service [1-800-342-9678, 9:00 a.m. - 5:00 p.m. (EST). E-mail address: getinfo@haworthpressinc.com].

95

all marketing executives thought women would do with them. The obvious drawback is that cookie dough, pasta sauce, and other goo-based substances will get all over the keys when you try to retrieve a recipe file. A speech interface is the obvious solution, but it would seem that the marketing executives haven't thought of that one yet.

Brenda Laurel
Computers as Theatre
(Reading, Massachusetts: Addison-Wesley. 1993)
footnote p. 174

I want to suggest in this piece that the matrix of meanings which emerge from Laurel's footnote continue to underpin women's relationship to technology, and to the personal computer in particular. The women Laurel describes as looming up to their PCs dripping with sauces and cookie dough is not a wholly laughable image. Women's bodies are always constituted (literally and figuratively) as messy: they leak liquid, cry too much, gorge infants with milk. How could it be possible for such a grotesque notion of the feminine to seriously engage with new technology? And what is it about CD-ROM as a format that has relevance for a performative feminist politics?

GIRL MEETS COMPUTER

Feminine corporeality is frequently characterized as blurring the bodily boundary of where she is and where she is not.[1] It is as if her body is somehow culturally unbounded, liable to seepage and therefore dangerous to electronics. Mary Douglas's early work on structurations of pollution and taboo in *Purity and Danger*[2] analyzed the ways in which rituals of cleanliness articulate deep-rooted fears and ways of understanding the world within cultures. Douglas described dirt as disorder, as matter out of place, a cultural sign rather than absolute filth. These are important points for a politics of re-inscription, since the female body is popularly categorized as a site of disorder. Elizabeth Grosz develops Douglas's analysis in her book *Volatile Bodies*,[3] and asks, "Can it be that in the West, in our time,

the female body has been constructed not only as lack or absence but with more complexity, as a leaking, uncontrollable, seeping liquid; as formless flow; as viscosity. . . ."[4] Grosz does not suggest this is how women *are*, but that "women's corporeality is inscribed as a mode of seepage."[5] If we return to the opening quote, this is certainly the case. The woman conjured by Laurel seeps 'goo' onto her keyboard; her body just hasn't got any edges. Laurel's response to the "oldest joke in the personal computer business" is not to deconstruct the image of the woman with her hands covered in cookie dough looking plaintively at her computer, but to suggest a speech interface as a solution to her dilemma. If this woman can operate her PC without actually touching it, then there is less likelihood perhaps of the technology being engulfed by her terrible femininity. By having her speak to her PC she remains connected to orality and passivation and separated from the technology.[6]

In this piece I am interested in a radical re-working of the relationship between the feminine and technology. I write this without interest in prescription, but as a call to forge new ways of marking the technology, of turning it to our needs; in the words of Donna Haraway to wrought a feminine cyborg practice by "seizing the tools to mark the world that marked (us) as other."[7] Such a practice would be located at the collisions of femininities, technologies and performance. What does it mean to be located as Other to an insurgent technology? What kind of interactive technologies are being developed out of this curious clash? How might sexuality be inscribed in such a medium? What are the implications of these questions for a performative feminist politics? I want to argue that such a collision is likely to be/should be irreverent, provisional, contingent; greedy for skills, and out for what it can get.

Furthermore, moreover and also, I want to argue for revelling in the worst fears of a femininity conjured as monstrous, for taking such images for the fakes they are, in *pleasure*; to argue that we were never *that*, that we were somehow culturally misrepresented, and at the same time hinting that we might just be far far more terrible than has yet been possible to signify. That she should absolutely bring the pasta sauce to the keyboard, design a wipe-down terminal, make work out of the ordinary and the fantastic, become the marketing executive as well as the hacker. Her perspective is

desperately lacking in the programming, design, and content of digital media; I miss the audacity of the excluded, I miss the things it wouldn't occur to me to write here.

I want to argue for a way of thinking that refuses to see bodies and technology as antithetical. Haraway is there before me: "By the late twentieth century, our time, a mythic time, we are all chimeras, theorized and fabricated hybrids of machine and organism: in short we are cyborgs. The cyborg is our ontology; it gives us our politics."[8] I would suggest that Haraway intends in this comment not to call for vision implants or bionic limbs, but rather to articulate the complex matrix of our relation to technology, such that this relation is a flickering economy of exchange. We mark and are marked by technology. Point-and-click, for example, revolutionizes the way we approach retrieving information, we find such a gesture already in commercial advertisements, I find it in my dreams.

The dynamics of using a computer screen/keyboard/mouse are importantly different from the ways in which we 'use' or view film and television. We lounge *in front of* the telly, but sit *at* a computer screen. The grammar of location is utterly different; a difference made in flesh. We rarely sit at a computer with anyone else. This small screen and our solitariness result in the possibility of an intimate viewing ("chimeras, theorized and fabricated hybrids of machine and organism"). Because we touch this technology, press language out of rows of lettered keys, send arrows roving over our screen, the binary of organic body/machine is affronted. I want to suggest in this paper that this 'touch' of the physical body and the computer can participate in an inscription of sexuality. Such touches are gendered of course, with the tradition of the feminine associated with the organic body and the masculine with the technological mind. All the more reason then to re-work such touches to our own ends.

> Most women don't have a damn thing to put in their CD-ROM drives.[9]
>
> Adriene Jenik

Adriene Jenik's aphorism articulately summarizes many women's irritation with/sense of exclusion from contemporary digital media. For CD-ROM this is an aesthetic arising largely from computer

games and informational databases. Such environments are characterized by glossy visuals and search-and-destroy hectic clicking or by the calmer point-and-click demeanor of informational CD-ROMs. As a location for artwork, the format is relatively new. The distinctiveness of CD-ROM is that it is PC-based, can function as a matrix of connecting image, sound, interactivity events, can, I would argue, evoke little worlds that are at once expansive and oddly connected. With imagination, the CD-ROM demands you learn how to navigate anew each time you view a work. I want to call for a fracturing of the dominant aesthetics in this medium, for women artists to make work through and about this medium, to ask for themselves what it is that this has got to do with them. This medium needs artists, and it needs that half of the world so often represented here as ingénue or amazon, most especially.

The latter part of this piece will analyze specific examples of performative practice on CD-ROM. These will be Adriene Jenik's *Mauve Desert*, Laurie Anderson's *Puppet Motel* and my own collaboration with Richard Povall—*mouthplace*.

MOUTHPLACE—*JOOLS GILSON-ELLIS/RICHARD POVALL*

mouthplace is an artist's CD-ROM which takes the female mouth as its poetic focus, examining through visual, written and uttered texts the ways in which the female mouth is a site of contested and contestable meanings. This project is the result of a collaboration with composer/programmer Richard Povall. We approached our collaboration with a desire to make a work which conjured traceries of the body and of the feminine body in particular. One strategy for achieving this was by refusing an aesthetic of computer-generated slickness, and working instead with painted text, hand animation, hand-writing, laughter, poetic text and the spoken and sung voice. When I sit and show *mouthplace* to someone, I find myself tapping the screen with my orange fingernails and chatting away, pointing to this place and that icon. The opening page of *mouthplace*, a place you must always return to, is a treated video still of me licking the inside of the screen. My saliva rests in little pools and bubbles. Such thematic and practical attraction to the liminal, to the separation of my body and its fluids from technology, led us to revel in such admixtures.

In a section of the CD-ROM linked specifically to sexuality, there is a site where a video loop runs of a woman's face under running water. This is an attempt to inscribe female sexual pleasure, an inscription particularly fraught in the field of the visual, and one especially so when using the image of the female face. The loop does not attempt to realistically represent such pleasure, rather it tries to blur the distinction between whose pleasure is being evoked, the woman in the frame or your own. She blinks under the flow of water, closes her eyes, but also returns your gaze. Beside this loop and far smaller is a still of a gazing eye from the same face. An eye that looks; if you click on this image, the computer selects a spoken text from a group of writings related to sexuality. Since this is a random choice, if you keep clicking you will eventually hear all the texts, but they will also repeat.

In another fork of the same section, there is a short piece that is simply a black screen with a hand-written 'HA HA HA' in its center. The recorded voice is of a woman telling a dirty joke and losing it. This was not a staged descent into hysterical laughter, but one of those times in the studio where the joke and Richard's collapse into giggles at the mixing desk was just too much. I love the way this section marks the medium with the raucous female body. I love the sound of my laughter, and the odd understatement of the words 'HA HA HA' staring pertly back at you.

In "recipe," a site located within the motherhood section of the CD-ROM, there are two given elements: parallel video loops and a vocal composition. The third element is the user's control of the video loops. The vocal piece is composed by Richard Povall, but the material is an accidental recording of my mother over the phone telling me how to make moussaka. My mum always knows the recipe, and here she grabs what is to hand (the microwave book) and translates for my imminent dinner guests. Her words are not staged for my CD-ROM, and they have the mark of the everyday about them; the mark of an ordinary act of love. The images which accompany this heard text do not illustrate my mother's words, rather they connect with it oddly. One of the loops is of my friend Kate Cameron, oiling her big pregnant belly. The other shows Kate's daughter Beth touching the same belly. Whilst the vocal composition runs on in this section, the video loops do not loop

unless the mouse is moved. Once you have the knack, you can make this pregnant woman caress her own belly, or her daughter do the same. As I move my mouse to let these video loops move, my actions are not parallel to running a tape and then re-winding it; there is no button to press for play/stop or rewind, no place to start, go-on and then watch again, rather my hand on this mouse must move in circles to bring Kate's hand into its own swirl. And I want to ask what is the nature of this touch; my fingers resting on plastic/ Kate's hand following the contours of her roundness? This woman rubs her own belly, oblivious of me; she doesn't look at me looking. I am not interested in arresting agency from her. What I want is for the circular movements you must make on your mouse-pad to reso- nate physically in you. You can only watch this action, if you also make some trace of this action yourself.

It is this repetition of the action on the screen that alters the relationship between the one who sits hand-on-mouse, and the image of the woman before her. It is an odd image. I had never seen a woman do such a thing before I saw Kate do it. I find it an extraordinary and beautiful gesture. Her action is assertive and vigorous, like the kneading of dough, or like a thing done many times. And all the while, it is my mother who speaks–telling me how to layer vegetables, and sweat aubergine. In the other loop, we see Beth's small thumb-sucked hand touching the side of her moth- er's belly. It is an oddly tentative gesture beside Kate's own encom- passing palm. The digital context for this artwork means that we can make a work where touches engender touches. The meanings and resonances of mothers and daughters/cooking and feeding are here woven out of the structures of this medium.

MAUVE DESERT–*ADRIENE JENIK*

Mauve Desert is a CD-ROM adaptation of the experimental novel *Le Desert Mauve* by Quebeçois author Nicole Brossard. In the origi- nal novel by Brossard, Laure Angstelle has written a book about fifteen-year-old Mélanie who takes the Arizona desert by storm in her mother's white Meteor. Driving through the desert Mélanie escapes her mother, her mother's lover Lorna and the Mauve Motel. This 'book within the book' is found by Maude Laures, and trans-

lated by her into a version "coloured by danger and sensuality."[10] Jenik takes this translated novel about translation and translates it into a CD-ROM format. Jenik's own acts of translation participate in the exchange of genres and languages that make up the shifts between novel, CD-ROM, and lived experience.

When you first go into *Mauve Desert*, your first destination after the intro. screen is a short video clip which captures Mélanie leaving the Mauve Motel. This sequence becomes emblematic of Mélanie's regular departures from the motel. Interestingly, Mélanie is largely out of shot, heard but hardly seen, and though she is almost-absent visually, the exchange focuses on her. Mélanie grabs the car keys from the counter, blurs past the camera and leaves. As her mother calls after her we shift into the Meteor for the first time or the first time this visit. In lush frosted spiral-dripping mauve we sit in the back seat as Mélanie drives. We can't see her face because she's driving, and we're behind. Three languages resonate out of synch. Three voices. My French and Spanish are not good enough to hear their meaning in the layering of languages. I have a friend who speaks five languages and listened to the intermingling of languages during Jenik's presentation at Chichester (July 1996),[11] and said how they were saying the same things differently. I imagine this as the shifting of understanding ("What drives you to understanding?" Jenik asks us). The voices are woven, out of synch, and they say the same things differently. I hear them as textures; the deep voice of the woman who speaks Spanish, with its cicada roll and spring and the fluid curvature of the French. And then the English Mélanie, invoking the desert in her girl-voice. Jenik uses the uttered language here as a way of driving understanding. The three women's voices are more than translated alternatives of the same thing; they are plural body marks. They comprise a gesture of difference. I hear in these voice/tongue minglings the articulation of a feminine aesthetic, here wrought in women's mouths, and composed like a planned haunting.

Mélanie's drives into the desert produce a structure of journeying. Jenik inscribes the very instructions of navigation with a haunting poetic hint that our journey is driven by Mélanie's and our own obsessions. When I was researching this article, I was obsessed with trying to 'get it all.' I would try and be thorough–return repeatedly

to the bar at the Red Arrow Motel to get the 'whole picture' from the fractured video clips that make up the story of Mélanie's encounter with Angela Parkins. When there is the sound of gunfire, and the sudden cessation of dance music, Angela drops to the dance floor, which shifts into the swirl of desert dunes, as Mélanie crouches beside her lover. And then suddenly we are in the car with Mélanie. The density of three women speaking three languages rushes over me, and then we get closed up; the credits roll, and the sounds of the shots grip me like a half-heard story. What? What? These particular series of video clips comprise a narrative sequence. If you were less obsessional than I, you could cruise here briefly, listen to a young woman in a bar talking about the clientele—"a whole lot of accents"[12]—and leave. What is particular about the CD-ROM format is the possibility of designing a space of tentative viewing, it isn't that you don't watch the end of the movie, it's that you journey at various levels. (It is, consequently, a rich and evocative genre for adapting experimental novels.) Since this work operates as a poetic, resonant text, this structure allows the various texts and textures (printed, hand-written, filmed, scanned, painted, vocalized and musical) to be enabled by this structure. My experience of viewing this CD-ROM is of a gradual unfolding, of a gathering of connections. The two women (Mélanie and Angela) leave to "get some air" mid-seduction at the Red Arrow Motel. With the apparent conventionality of the structure of this seduction scene, one imagines that the women are off outside to face the brewing passion, and perhaps they are. But Jenik undoes the expectation of this scenario by locating a series of starlit, evocative conversations as Mélanie's memories at the end of a couple of her drives (you click her eyes in the rear view mirror to access them). These conversations are charged poetic exchanges. The sexuality that resonates between the two women is inscribed in this language; it conjures the pang between them. The tone of these duets is contemplative; quite unlike the abandon of grooving on the dance floor inside the Red Arrow Motel. Their difference in tonal setting is also a difference in location and meaning. To get the Red Arrow Motel story of Mélanie and Angela, one goes to the Red Arrow Motel and clicks on bar or dance floor, and keeps returning until Angela is apparently shot, crumples to the dance floor, and we are made to leave. Finding

these quiet conversations is a surprise; no narrative sequence drives you to expect to find them where they are.

Jenik inscribes sexuality here as a process of translation; as a shift and slippage between texts. In the CD-ROM the narrative and poetic texts are largely uttered by the actress Lora Moran/Mélanie. It is her voice which evokes the scenes, but she does so as an act of translation from text to text, from novel to uttered speech, from the text of a young actress to the text of a young runaway (Lora Moran– see later). Texts uttered and written produce a matrix of connections which begin with Brossard's text; itself producing a writer and a translator (Laure Angstelle and Maude Laures). Mélanie as a character and Lora Moran as a real young woman both write journals that appear in *Mauve Desert*. Jenik's acts of translation are marked in her Maker Map.[13] I mark my own acts of translation here in this paper–I lay another text between the many that shift before me.

Each of Mélanie's journeys into the desert begins as a collage dominated by a scan of the open page of Brossard's novel from which the text of the drive is taken. This is not only Brossard's text, it is also Jenik's text, scribbles of notes, underlinings and outlinings of the novel; her notes for adaptation/shifting themes/shots. (It also recalls Maude Laures' making notes for translation on the Laure Angstelle book.) Jenik places another textual layer over and between Brossard's text.[14] This text can function as backdrop/texture in the lust for finding something to click and bring about change. I certainly related to it in this way until I realized that these were not random selections of text, but the precise pages from which Mélanie spoke as she drove into the desert. Then I began to read the text before driving off with Mélanie, and to get frustrated at the bits that were obscured by the rectangle of car interior placed screen center. I get into the car with Mélanie, listen to her speaking and watch her world through the windscreen.

In the Yucca Mountain drive, a text of haunting poetry is spoken by Mélanie, as she takes the Meteor through a landscape of trees filmed in black and white. Her memory at the end of this journey, is formed in film-script. You can click on her eyes reflected in the rear-view to get red script. In this un-performed performance text, Mélanie returns to the Mauve Motel, flops on her bed and masturbates, a voice-over, which we do not hear, but see written, has

Mélanie say "The fingers that gripped the pencil so tightly need an ending. Right there and there . . . " as if her practice of writing were also a practice of sexuality, as it is here, as she has sex with herself in script.

In the glove compartment of the Meteor Mélanie steals each night to drive into the desert, there are various maps, a revolver and a notebook. At the end of both versions of Mélanie's narrative in Brossard's text, she finally departs saying "I cannot get close to any of you." In 'real life' the 14-year-old actress who played Mélanie (Lora Moran) also ran away after the end of shooting. This was complicated by the fact that the actress who played Mélanie's mother in *Mauve Desert* (Kathy) was Lora Moran's real mother. The notebook here in the glove compartment is no work of fiction, but the real journal of Lora Moran kept during this time, and used here with her permission. What all this evokes is a profound affront to borders of fiction/non-fiction and genre. Moran's name (*Lora*) is oddly the same as the other two major forgers of fiction in this scenario–*Laure* Angstelle (the fictional writer of the book about Mélanie) and Maude *Laures* (the fictional translator). For Lora Moran, forging corporeal fiction by playing Mélanie pre-figures her own departure. Such a taking of leave appears like another translation, one of quite practical pain and distress. By including Moran's story in the CD-ROM Jenik suggests powerfully that the material and psychological processes of making this work are, in fact, also its content. A page of Moran's journal says simply "I HATE COMPUTERS."

In one of the starlit conversations between Mélanie and Angela, Angela asks about her tattoo. Mélanie says "I find it strengthening. It makes me feel looked over." In the Maker Map you can find some documentary footage of the film-making process, and there is a shot of Adrienne, just having finished drawing the tattoo on Lora Moran's arm. Jenik asks her what she thinks, and Moran, pensive, looks curiously at it, and sticks her tongue in her cheek. These layers of meaning complement an art work about translation. Moran's quiet intake of the tattoo on her arm is haunting in its quietness. Mélanie is full of language–she writes and speaks in poetry, like the child-woman wrought in fiction that she is.

PUPPET MOTEL–*LAURIE ANDERSON*

Finally, I wanted briefly to mention Anderson's work in relation to the other two works analyzed here. Laurie Anderson's CD-ROM *Puppet Motel* is visually a big contrast to either *mouthplace* or *Mauve Desert*, both of which are collagic and marked by the processes of crafting them from video, scans, and manipulated imagery. Anderson's world in *Puppet Motel* is more digital in origin, since much of its visual geography is entirely generated by computer. This aesthetic is largely the result of Anderson's collaboration with whiz-kid programmer Hsin-Chien Huang. Many of these spaces are stunningly beautiful. Sites range from the specific detail of virtual rooms, to more abstract spaces where shapes and bodies float. Anderson's characteristic of contrasting high-tech with her haunting, understated texts is reproduced here. Like *mouthplace* and *Mauve Desert*, the female speaking voice is a constant refrain. In *Puppet Motel*, Anderson's voice is framed by another refrain of digital voices–recorded phone messages, computer warnings, which make more stark the contrast between the corporeal and the electronic. Many of the rooms in *Puppet Motel* are shadowy places of half-light. In one of these rooms a tape spins in the darkness, and a computer-generated voice repeats in litany "love me, love me, love me, now." Time passes oddly, the light from a high window sweeps the room like the passing of cars in the night, or like days rushing by. This place suggests a melancholy sexuality wrested from bodies; the mannequin (the puppet of the title) lies in the half-light stuck between romantic phrases and a lost body. If you go into the mirror, Anderson tells a story of seeing lipstick kisses accumulate on the mirror in the office of a psychiatrist she visited. Her doctor can't see the kisses from where he sits, and it turns out that his twelve-year-old daughter has been coming in and kissing the glass. Anderson traces here an adolescent sexuality inscribed in tricks of light and mirrors.

Puppet Motel is peopled with odd bodies–ventriloquist dolls, little computer-generated puppets, shadows across windows, a woman's sudden breath. The sexuality inscribed here seems fragmented or absent, as if the digital invokes a closing-off, a separation between lived lives and their electronic representation. This is often

Anderson's theme, in a way that is quite different from the Mauve Desert and mouthplace.

In more than twenty years of performance art practice, Anderson has often used the individual's alienation from technology as a zeitgeist. Her irony has always been that she uses technology itself to describe this relationship. In *Puppet Motel*, the rooms are almost always empty; in our mouse-shifting we constitute their only inhabitants. There is something about the particular impact of rendered images which makes it unsurprising that there are no bodies here. Cubes, spheres and other surfaces are perfect. They are very unlike the messy feminine I began this piece describing. It is as if in retaining a computer-generated aesthetic, Anderson makes room for no body. She and Huang craft a haunted house, in which the auditory rather than the visual is the primary mode of 'marking' with the female body. And it is here, between the grain of Anderson's voice and the imagery it haunts that a critique opens up in dialogic play between the feminine and digital. This exchange is interesting in part because it is a constantly shifting relation. And one characterized by a sense of loss; I hear her but rarely see more than a glimpse of her, or more than an iconic representation of her–a female sign, the imprint of lips. This melancholy sexuality, this breathlessness in the dark, suggests the underside of the digital, or its failure. It disrupts the clarity of digital self-sufficiency; a tripping-up between Anderson's utterance and its incorporation into the space before me. I half-hear this to half-tell you.

* * *

I press buttons here, in orders I have learnt especially for you to understand. Dennis O'Sullivan at the Computer Center watches me push my luck as I sit down once again on the only Apple Macintosh I can find to view these CD-ROMs. Every time I visit these days, he tells me, a little reluctantly, that he should already have returned the machine to some locked space in The Maltings. I write of an intimate solitary viewing, but for myself, I take the lift up to the top floor of the science building, sit in a busy office near the door, get cold as the wind rises once again through these high windows, and peer. Getting access to computers with CD-ROM drives and enough memory to run these works is more than a little hindrance to view-

ing them. I know this. But I know equally of the importance of pursuing this work. I spend hours wandering and wondering in Jenik's gorgeous and inspiring work. I leave messages for Laurie in *Puppet Motel*–and find her smiling in dark rooms. All this whilst I trawl *mouthplace* for bugs, note them in detail, re-record texts, suggest differences in rhythm, and send them in long lists to Richard in Ohio. I speak to Adriene through the electronic ether; the story of Mélanie and Angela haunts me, not least because these are the names of my two sisters. What kind of secrets are there? And what kind of secret is a digital secret, and how will I tell you?

NOTES

1. This is particularly true during pregnancy and adolescence, where the presence of two bodies within one body in the former, and the on-set of menstruation in the latter, confuse the clarity of the discrete body.

2. Douglas, Mary. *Purity and Danger. An Analysis of the Concepts of Pollution and Taboo* (London: Routledge & Kegan Paul. 1966).

3. Grosz, Elizabeth. *Volatile Bodies: Towards a Corporeal Feminism.* (Bloomington and Indianapolis: Indiana University Press. 1994).

4. Ibid. p. 203.

5. Ibid.

6. I do not intend to suggest here that the association of orality and femininity is a wholly negative connection, rather that in this context, having the woman operate her PC by verbal command reifies the prominent binary of woman/body/organic and man/mind/technology, rather than engaging with the concerns of real women.

7. Haraway, Donna J. *Simians, Cyborgs and Women. The Reinvention of Nature* (London: Free Association Books. 1991) p. 175.

8. Ibid. p. 150.

9. Jenik quoted by Mike van Niekerk ("Cinema of Another Kind" *The Age*, 30 Jul 96, p. D2) from her presentation of *Mauve Desert* at the Melbourne International Film Festival, 1996.

10. This synopsis is adapted from Jenik's intro. screen in *Mauve Desert*.

11. Split Screen Festival, Chichester Institute, England, July 1996.

12. From Mélanie's text spoken in the Red Arrow Motel, and referring to the clientele.

13. Jenik's *Maker Map* is a site in *Mauve Desert* which traces Jenik's own processes of coming to make this CD-ROM. It includes video clips of Jenik working at her computer, questions she asked herself during the making of the work, and a photograph of the artist reading Brossard's novel.

14. Nicole Brossard's original French novel is used here in English translation; the English translator is Susanne de Lotbinière-Harwood. The Spanish translator is Monica Mansour.

BIBLIOGRAPHY

Douglas, Mary. *Purity and Danger. An Analysis of the Concepts of Pollution and Taboo* (London: Routledge & Kegan Paul. 1966).

Grosz, Elizabeth. *Volatile Bodies: Towards a Corporeal Feminism* (Bloomington and Indianapolis: Indiana University Press. 1994).

Haraway, Donna J. *Simians, Cyborgs and Women. The Reinvention of Nature* (London: Free Association Books. 1991).

Laurel, Brenda. *Computers as Theatre* (Reading, Massachusetts: Addison-Wesley. 1993).

van Niekerk, Mike. "Cinema of Another Kind" *The Age*, 30 Jul 1996, p. D2.

DISCOGRAPHY

Anderson, Laurie with Hsin-Chien Huang. *Puppet Motel* (New York: Voyager. 1995).

Gilson-Ellis, Jools and Richard Povall. *mouthplace* (New York: Frog Peak Music. 1997).

Jenik, Adriene. *Mauve Desert. Mauve Desert: A CD-ROM Translation* is available by purchase by direct order to individuals for $39.95 CD-ROM only, or bundled with the English translation of Brossard's own novel, also titled *Mauve Desert* (translated by Susanne de Lotniniere-Harwood), for $49.95. The institutional price, which includes rights to public and/or multiple screenings, is $79.95/$89.95 with book. To order *Mauve Desert* contact: A. Jenik, 216 North Commonwealth Avenue, Apartment A, Los Angeles, CA 90004 (e-mail: depop@earthlink.net).

Fleshing it Out

Leslie Hill

SUMMARY. From the raw physicality of *Aunt Bill* to the radio mike performance of *Push the Boat Out* to the collaboration of *Strange Relations*, and finally to hypertext narrative work, live artist Leslie Hill traces the currents of her experimentation with form and content and explores the links between lived experience and issues of sexuality and gender in her performance work. *[Article copies available for a fee from The Haworth Document Delivery Service: 1-800-342-9678. E-mail address: getinfo@haworthpressinc.com]*

When I was first approached about writing this piece I was told that the title of the collection was to be *Acts of Passion: Sexuality, Gender and Performance*, and I was asked if I would do something on . . . technology. This provoked an acute sexual anxiety crisis, on my part. *God, I must be unsexy,* I thought. Immediately I declined to write about technology and began a nervous review of my performance work, desperately seeking traces of Passion, Sexuality and Gender. In a panic, I concluded that there weren't any. That, of course, was absurd because no artist inhabiting a living, breathing, sweating, pulsing body can get up in front of a live audience devoid

Leslie Hill is a text-based live artist working in solo and collaborative performance, installation, video, hypertext narrative and Web site creation and development.

Address correspondence to Leslie Hill, 7009 E. Acoma Drive #2089, Scottsdale, AZ 85254 USA.

[Haworth co-indexing entry note]: "Fleshing It Out." Hill, Leslie. Co-published simultaneously in *Journal of Lesbian Studies* (The Haworth Press, Inc.) Vol. 2, No. 2/3, 1998, pp. 111-124; and: *Acts of Passion: Sexuality, Gender and Performance* (ed: Nina Rapi, and Maya Chowdhry) The Haworth Press, Inc., 1998, pp. 111-124; and: *Acts of Passion: Sexuality, Gender and Performance* (ed: Nina Rapi, and Maya Chowdhry) Harrington Park Press, an imprint of The Haworth Press, Inc., 1998, pp. 111-124. Single or multiple copies of this article are available for a fee from The Haworth Document Delivery Service [1-800-342-9678, 9:00 a.m. - 5:00 p.m. (EST). E-mail address: getinfo@haworthpressinc.com].

111

Leslie Hill

Photo by Alan Crumlish. Used by permission.

of sexuality and gender, whether they get their kit off or not. Anyway, it got me thinking about sexuality and gender in performance and why clothes just seem to fly at the mere whisper of 'live art,' and how keeping my kit on in this crowd makes me feel a bit like the pervert in a bathing suit at the nudist beach. In fact, as a writer, the whole thing made me stop and question my desire to step off the page in the first place. Why, I asked myself, do I feel compelled to appear in the (albeit fully clothed) flesh? Even without my glasses, a few things became clear right from the beginning of my self-examination: (1) I am fascinated by relationships between voice and body, between text and context in a live performance space; (2) I drew away from explicitly sexual form and content quite early on; (3) working with other performers has resulted in more overtly sexual work than I normally make on my own; (4) actually, I do find that there is a certain *frisson* in writing for hypertext, Web publishing and CD-ROM development. (I will address this last point at the end of the article, having specially taken my kit off to do so.) Though this article is not by any means meant to be a full retrospective of my work, I will start with my first solo piece and trace some of the currents of experimentation with form and content in the work from then to the present.

BODY AND VOICE

My first solo piece, *Aunt Bill*, took the name of a great aunt of mine I never knew. In and amongst Oma Edna, Ethel Irene, Violet Ester, Agnes Bula, May Irona, Lena Bell, Eva Jo and Dortha Lou, the name "Bill" led me to suspect that this aunt had been a lesbian and the fact that her husband had her shot three times in the head by a hit man while she was out in her tool shed, and buried in an unmarked grave only added to this sneaking suspicion. The project of *Aunt Bill* was to excavate as much of her story as possible and accordingly to reconstruct my own automythography in the hinterlands somewhere between the celebrated family histories and the histories which were rotting in unmarked graves. This piece was developed in residency at the Centre for Contemporary Arts (CCA), Glasgow, as part of the 1994 *Bad Girls* season, in collaboration with conceptual artist Jason Bowman. During the residency, in which we

had access to two adjacent performance spaces, a separation evolved between body and voice; between physicality and text; and between access to presence and access to narrative.

The first space the audience entered was a room with a black wooden floor and a row of large windows looking out onto the city. I had painted five generations of my family tree onto the furthest white wall. The black swing door leading into the theatre was just to the right of the tree. There were no names on the tree, only small black lines, but a set of glass shelves held objects which marked certain aspects of the family: potatoes for the (celebrated) Irish ancestors; fragile animal skulls for the (buried) Cherokee ancestors; glass jars of pecans for the living. Small speakers, about an inch in diameter, were fixed over my grandparents' and my father's places on the tree. If they leaned in, audience members could hear family voices telling family stories. A cable ran from my position on the tree to a microphone stand in the middle of the otherwise empty room. I delivered the narrative from this position, alone in the empty room, facing my family tree, while the audience listened together from the theatre on the other side of the door. In the theatre space, Jason and I had created an installation in which a gleaming grand piano stood, hands on hips, in the middle of a giant map of the USA. An American desert landscape, composed of one ton of British sand, the map reflected my position as a dislocated auto-mythographer. Buried or half buried in the sand were the dismantled remains of a dilapidated old piano we found under the railway arches down at Paddy's Market and then pried apart with an ax on Sauchiehall Street. (Note: the piano came about because I wanted to use the entire theatre space, no flats, no hidden areas, no 'backstage,' but this meant that there would be a big black grand piano in the middle of my performance and that sort of thing is hard to ignore. It was, however, the year of Jane Campion, so we decided to go with it and put the piano smack bang over Oklahoma, though I specifically asked the audience not to look at it; to pretend it wasn't there.) The CCA's big fancy piano came to represent the aggressive presence of things which take pride of place; things that we all have to work around, things which park themselves right in the middle of our landscapes, while the moldering yellow piano from under the arches was 'Aunt Bill.' During the performances I

excavated the keys, strings, pedals and bones of the rotten piano from the sand and carried them piece by piece into the other room. For each piece I carried through and laid out on the black wooden floor, I gave the audience another fact, or story, or impression or fragment of my automythography via the microphone. After each segment of vocal narrative which carried through to the speakers above the audience's heads in the theatre, I returned and added another piece of my family tree, a pecan nut or a skull, to the line I was constructing on the floor parallel to the shoes of the people in the front row. In short, one installation was going out as the other was coming in. 'Absence' and 'presence' were constantly shifting in relation to artifact, physicality, history, narrative, audience and performer, as a trail of sand formed between the two spaces.

Jason always arranged the remains before performances so that I really had to work to find them. Because there were well over a hundred fragments I could never be sure if I had uncovered them all, producing an appropriate tension and uncertainty. The performances usually took just over an hour and were very demanding, not least of all because I was constructing the narrative in the moment. Some of the pieces of the piano were extremely heavy and awkward, spiky and wiry and by the time I had excavated them my jeans and vest were streaked in grime and rust and my bare arms were covered in bruises, fine trickles of blood and grains of sand that clung to my sweat. When all the remains I could find had been carried and laid out, when the line of family artifacts stretched from the far side of the audience to the swing door, when I felt I had said as much as I could under the circumstances, the performance came to a conclusion of sorts. I finished the piece by occupying the space at the end of the line of family artifacts between the audience and the door, addressing the audience directly, reuniting voice and body. When I had finished speaking, I asked the audience to step through to the other room; the room which had been my private space during the performance; the room where Aunt Bill was now laid out. In order to leave the space, audience members had to step over the family line and walk directly past me. With a live video feed hooked to a monitor that faced them as they entered the other room, I filmed their feet and their faces as they filed past, so that as they entered one space they were watching themselves leaving the other.

After the last person went, I focused the camera on the CCA piano, in effect moving it through to the other room; reconstructing it as the specter in the corner.

Now oddly enough, considering the somewhat abstract nature of the piece, if the object of my performance career was to pull, this would have been my most successful work to date. I don't deny that both my narrative and my physical presence in this piece were more consciously 'lesbianesque' than in any other piece I have done since, that I explicitly referred to my sexuality, that I purposefully adopted certain dyke iconography, that I wore the tight white vest and the snug ripped Levis with the black cowboy boots, that I exposed the audience to a physical spectacle, that I worked up a sweat, that I flexed my muscles from every angle, that I used extra hair gel. . . . This overt display of lesbian sexuality and physicality was, however, primarily an attempt to bring things which had been buried back to the surface, to place them in the foreground; to assert the absence/presence of Aunt Bill. In retrospect, I think that while I conceptualized the separation of body and voice as a format well suited to issues of absence and presence, with the inaccessibility of a 'whole' narrative, I found to my frustration that in a performance situation a silent, sweaty body hoisting heavy objects around a desert became a pretty easy target for full frontal objectification. It came as something of a shock to me when I found the performances eroti-cized to the extent that a lot of women didn't seem to have taken in the narrative. Flattering as it may be to receive phone numbers scribbled on ticket stubs, as an artist, it kind of pissed me off to hear a woman in the bar saying to her friend, "Who cares what it was about; I was looking at her tits." I resolved not to invite this kind of objectification again. When the performance transferred to the Institute of Contemporary Art (ICA), I reunited voice and body, swapped tight jeans for loose ones, changed the clingy white vest for a large white t-shirt, and put a 200-pound lectern of lard between me and the audi-ence. No one offered me their phone number.

TEXT AND CONTEXT

After this I became enamored of the 'talking person' format and the radio mike. Now on one level, this was an attempt to circumvent

the type of performer objectification that I felt might compromise the work (not to mention myself), but on another it was and is simply a format very well suited to my style. Drawing away from a consciously sexual stage presence was perhaps an overreaction on my part and somewhat uncharacteristic, considering that I am more than happy to perform my sexuality on the streets. As a text-based artist, however, being heard has always been the central most important thing to me in performance. Around this time, I became very interested in Laurie Anderson's performance persona–how she seemed to occupy a unique position, having managed to somehow neatly sidestep sexual objectification, creating a simple, yet astonishingly rare thing: space for a smart woman talking. Neither her form nor her content is overtly sexual, but a smart-talking woman is what I call sexy. In fact, as far as I'm concerned, listening to Laurie Anderson talk is much sexier than looking at Annie Sprinkle's cervix, but hey that's just me, the performer who got asked to write about technology. Anyway, I got hooked on radio mikes, kept my trousers on, and drew away from explicitly sexual material. This is not to say that the work I was making was independent of sexuality and gender, but rather that my lesbian sensibility, my queer body was the foundation of my work, not the subject of it. Positioning my work in the context of a larger community of female artists and queer artists, most of whom do make explicitly sexual work and get their kits off on a regular basis, it seemed that there was room for a "talk artist," that this could also be a powerful position for a woman/a queer to occupy.

As I became somewhat removed as a performer, I began to make work which demanded more sensory interaction on the part of the audience. In the original *Aunt Bill* the audience watched from a distance as I engaged in an extremely tactile performance, caressing parts of a 'body,' carefully brushing the cover-up away with my bare hands, constantly in motion. In subsequent pieces I changed this dynamic so that it was the audience who became engaged in tactile, sensuous actions, while I generally maintained something of a physical and critical distance. While I concentrated on voice and language in terms of my own presence in performance, I attempted to create installations or performance situations which would provide the audience with more visceral images, textures, tastes and

smells to complicate and contradict, to enhance and subvert the somewhat cerebral nature of the text/voice. During this phase I became particularly fascinated by issues of consumption and documentation, an obsession which resulted in a tide of Tequila and champagne, aerosol cheese, tape recorders and Polaroid photographs in my performances. I became engrossed in making installations and performances which were literally for and about consumption and documentation, the zenith of which was a time-based, all-you-can-eat installation, *Push the Boat Out*, commissioned for the ICA's *Jezebel* season, 1995.

In *Push the Boat Out* I constructed an American landscape of ignorance, greed and discontent, a territory where the rich get meaner, the poor get trashier, and no one expects to keep their own teeth past the age of thirty-five. At the base of this installation was giant map of the USA made from photocopy enlargements of (then) current tabloid newspapers: OKLAHOMA CITY BOMBER IS MAN OF MY DREAMS; TWELVE U.S. SENATORS ARE SPACE ALIENS; THE GHOST OF ELVIS GOT ME OFF DRUGS; O.J.'S ANGUISH: NICOLE WAS A LESBIAN. . . . I covered the map in a thick, rank rennet of consumables from the trashy white underbelly of America: Moonpies, Twinkies, Pepperoni Pizza flavored Corn Nuts, brain-shaped bubble gum, Beef Jerky, Licorice Super Ropes, Pocahontas Sweettarts, Power Rangers Fruit Chews, Coors beer, etc. A film screen above the map featured American TV clips from the week of the 4th of July, 1995: the Praise the Lord Club; QVC cable shopping; *Days of Our Lives*; WWF Wrestling; the Psychic Hotline; confessional talk shows; O.J. Simpson's trial; and the gala 4th of July celebrations at the White House. From a yellow rubber raft positioned in the center of the map, the landscape of my nightmares, I recreated and confronted my personal claustrophobia, nausea, anger and vulnerability in response to evangelical white trash culture and generated a counter discourse. I sent out hundreds of my own words via text confetti, paper airplanes and Red, White and Blue helium balloons which acted as carrier pigeons. This counter discourse consisted of written stories, recipes, statements and questions. I defined the border between 'America' and the ICA floor (Britain) with a six inch high, six inch thick line of pure refined salt and sugar, which followed the contour of the map. Over the two-

day period, as patrons waded back and forth steadily consuming the map, the border began to blur beyond recognition. Anxious Brits occasionally attempted to sweep it back into place, saying, "but you can't tell it's *America* anymore." I looked around at all those empty cans and empty wrappers and thought: *"My point exactly."*

Still in my raft by night, I gave a one-hour monologue each evening to a conventionally seated theatre audience, succinctly performing the text which had been drifting piecemeal through the installation. The differences in reception between the spoken text and the written text were very interesting to me as a writer/performer. Both texts consisted of the same words, distributed by the same person from the same boat, pitted against the same elements in the same art space, but were accorded very different status. The spoken text, which demanded no direct interaction on the part of the audience, was accorded higher rank from the outset (partly by virtue of the fact that admission to the performance cost five pounds more than admission to the installation). The printed text, language intended for consumption when I carefully folded it into paper airplanes, seemed to become 'garbage' the moment it hit the floor, an impasse only the audience could rescue it from. The spoken text, in contrast, was instantly given the audience's full, uninterrupted attention. Whereas the installation made me feel depressed and isolated as a would-be communicator, the evening performances seemed to bring me back into a feeling of direct contact with the audience which I found reassuring. When I conceptualized the piece I never anticipated the personal difficulties I would have with the silent performances within the installation. Why, I wondered, was sitting amidst my installation distributing text such a trial? As a writer I was accustomed to representing myself through printed texts. As a performer, however, I realized that I was used to controlling the space and the audience during performances–in *Aunt Bill*, for example, the audience was very specifically controlled in terms of what they could see, what they could hear, which space they occupied, how they entered, how they exited, etc. Even if I was objectified as a performer, I was exercising a great deal of control over the reception of the piece. In creating a highly interactive installation, I had relinquished a great deal of this control. As a performer I was used to being looked at by the audience, but again,

as most of my work is direct address this was a relatively controlled voyeurism. By setting myself up in the center of a 20-hour installation I was inviting people to look at me in a very different, much less comfortable way. Afterwards I questioned whether some or any of my discomfort with this type of objectification–having people walking around me, looking at me from all angles, taking photographs of me, leisurely picking up and putting down my printed words–stemmed from issues of sexuality and or gender. My feeling is that, unlike in *Aunt Bill*, the personal discomfort I felt with the audience reception of this installation was not so much to do with my sexuality or my body as it was to do with my fluctuating status as a writer/performer.

OTHER BODIES, OTHER VOICES, OTHER CONTEXTS

After the intense isolation of *Push the Boat Out*, the idea of collaboration suddenly held a new appeal and I have since made a number of collaborative pieces. In October 1995 I made a piece called *Strange Relations* with my brother, Jeff Resta. Confronted with the alarmingly protuberant sexuality of a gay man (even if he is my brother), I found it impossible to retain the somewhat detached stage presence I had been creating for myself. If I was going to perform with one of the boys, it seemed, I would have to get in there and get my hands dirty (but only after clipping my nails real short). I find the sexual presence of gay men so blatant, at times, as to be quite absurd, which is why I decided in the end just to strap a giant Jeff Stryker dildo to my forehead while asking my brother clinical questions about his life. He later retaliated by 'examining' me from behind a pubic-fringed muff-diver's mask. *Strange Relations* dealt with a parodic role reversal the two of us went through in response to Jeff's HIV+ diagnosis three years ago: I flew the lesbian love nest, developed an impressive drinking habit, slept with more women in six months than I had in the previous five years and gave my knitting needles to Oxfam; Jeff, in the meantime, had reinvented himself as a new age lesbian witch with all the appropriate accouterment (beads, crystals, native American charms, long hair, a 1970s feminist book collection) and devoted his leisure time to brewing dark slimy root teas and plotting a way to get into the

Michigan Women's Music Festival. Like a lot of lesbians and gay men, we were busily refashioning ourselves into 'queers' who borrowed freely from each other's stereotypes in what I would say was at least partially an attempt to develop new strategies of resistance–in a community which is occupied not only by HIV, but by homophobia, misogyny, separatism, spurious notions of political correctness, irritating 'post-feminism,' fear of sex, fear of death, fear of the status quo, and the ubiquitous his and hers goatee. In times of ecological instability the most highly specialized species are the first to perish, and so perhaps this '90s cross current is a natural, instinctive response to viral and political dangers. At the end of the day, however, I had to concede that a bloke is a bloke is a bloke is a bloke: even as a new age lesbian my brother averaged twice as many sexual partners as I did when I was at my most hoydenistic.

Commencing our performance in identical androgynous outfits from the Gap, Jeff and I spent the evening shamelessly pirating from each other's respective cultures in an exercise which was initially lighthearted and carnivalesque, later creepy and vampiric. A series of 'examinations' in which we took turns sitting on the 'stool of repentance' and reluctantly answering intrusive, menacing questions about ourselves began to underscore some of the uncomfortable, inescapable differences between us, the most obvious being, of course, his HIV status. Rather than removing the matching clothes to expose the bodies beneath, in the second half we added yet another layer, blue and white striped aprons from that commercial icon of clean-living middle-class domesticity, Habitat. In a final round of the mean game, 'stool of repentance,' the apparently identical aprons were turned around and put on backwards, to reveal life-size silk screens of our respective naked bodies, so that we ended the performance wearing our nakednesses in what we hoped was an interesting blend of denial and exposure, security and vulnerability, appropriation and occupation, pluralism and essentialism.

Is there something totally perverse, I ask myself, in the fact that the most overtly sexual piece of work I've done, both in form and content, was a collaboration with my brother? As one would expect, working with other artists has an entirely different dynamic, in my case forcing me out of myself, demanding constant reassessment

and renegotiation of identity and presence in relation to others. Alone on stage I felt I could present work from a comparatively neutral space in which I = I, whereas performing with Jeff, 'I' was immediately inscribed with relative identifiers: Jeff = gay boy, I = gay girl; Jeff = big brother, I = little sister; Jeff = HIV+, I = HIV −, etc. In my experience collaboration is a double-edged sword in that it brings different energies and sensibilities to the work, generating fantastic hybrids of intelligence and creativity, while simultaneously denying the individual the luxury of presenting material from a space in which I = I. This dynamic is hardly surprising if one takes into account the shifting nature of self-consciousness and self-representation in 'real life,' i.e., our awareness of our own sexuality and gender fluxes constantly in response to environment and to the people around us.

ELECTRONIC PERFORMANCE

Okay, I've just taken my kit off to write this section and the temperature in my friends' Edinburgh flat makes me wish I had got round to writing it a few weeks earlier. Do you believe me? If this were a live performance instead of a printed text you'd know the truth; as it is you just have to take my word for it. Now I'll tell you straight off, I'm not a technology expert by any means, but I do use technology and the practical and theoretical implications of its intersections with art—which are only going to become more frequent and more substantial—interest me greatly. I am attracted to Web publishing and CD-ROM development for some of the same reasons that I was initially attracted to writing for performance, namely its unique formal capacity to cut and paste freely from music, visual art, photography, video, theatre, etc., and its interactive relationship with its audience. If this were a hypertext article, you could click on the performance pieces I have mentioned and navigate through text, watch video clips, peruse photographs, or listen to my voice telling my stories, creating different contexts for and combinations of meanings. In this respect, electronic works can operate, or rather can be operated, in a fashion which is not dissimilar to the dynamics of, for example, the *Push the Boat Out* installation which relied on the radical enfranchisement of the perceiver.

As a would-be communicator, I make the same leap of faith in posting text, image and sound into cyberspace as I did when I sat alone on the boat folding my words into paper airplanes, throwing them into the void, and trusting someone to pick them up.

The tricky part for a live artist working with technology is that *live art* by definition relies on real time and space relationships between the artist, the art and the audience. What happens when this relationship is electronically mediated? Does this make it less 'real'? Live art and performance art traditionally locate concept and narrative in the (often naked) bodies of the artists—can this dynamic operate via CD-ROM and fiber optic networks? If cyberspace is a realm of placelessness how do we inhabit it? In an environment where people can communicate without being obliged to reveal their gender, color, sexual preference, physical disability, hair style, etc., can we expect less sexism, racism and homophobia or will we all be presumed to be geeky white males until proven innocent? Because I've been working in this new media for only a very short time these are questions I'm asking, rather than questions I make any pretense of being able to answer. My guiding assurance is this: whatever electronic art I release into cyberspace, its origin and its audience are still in living, breathing human bodies. To my mind, digital art doesn't threaten the integrity of the corporeal being of the artist any more than the ink on the page disembodied Homer when he moved from an oral tradition to a written one.

EVOLUTION?

Though the move from the raw physicality of *Aunt Bill* to radio mike performances to hypertext narrative may seem to be a regression from proper flesh and blood into a disembodied electronic bleep down a phone line, this is not how I perceive the evolution of my role within my work. Although multimedia is the newest format I'm working in, it is not the only. I still make solo and collaborative performances and videos. I think of the Internet as one of many possible venues for art and text—perhaps becoming one of the most easily accessible. People like myself who are writing from the margins and the outskirts can circumvent the publishing industry, for example, by making their texts or images available on the Web.

While "disembodiment" fears loom large as we approach the turn of the century, I imagine some highly playful and interesting forms of communication in a medium in which we can chose very different forms of self-representation. Live art is by nature a hybrid form and while multimedia complements this fabulously it is only one of many forms available to the artist. For those of us who perceive their task as artists to be one of constant reassessment and renegotiation of form in relation to content, electronic venues hold fascinating possibilities. It goes without saying, however, that if occasion demands, we reserve the right to get our kits off in public.

PART THREE:
FROM MARGIN TO CENTER:
SUBVERSION OR ASSIMILATION?

Drama Queens:
Ruling with a Rod of Irony

Joelle Taylor

SUMMARY. Why is it that many 'lesbian playwrights' are unwilling to define themselves as such? "Drama Queens: Ruling with a

Joelle Taylor is co-founder and joint Artistic Director of Spin/Stir Women's Physical Theatre Collective, a company committed to the development of new writing by women and explorations into radical performance techniques. She has written and produced two full plays, *Naming* and *Whorror Stories*, and is currently working on her third, *Angels with Dirty Fingernails*, and the novel of *Whorror Stories*. She recently directed *Loonatik* by Laura Bridgeman at the Battersea Arts Centre, and *Milk Tokens* by Vanessa Lee for Spin/Stir. She is the co-author of *Lesbians Talk: Violent Relationships,* published in Britain by Scarlet Press. She is a Queer Cultural Worker.

Address correspondence to Joelle Taylor, 180 Queensbridge Road, Hackney, London E8 4QE, United Kingdom.

[Haworth co-indexing entry note]: "Drama Queens: Ruling with a Rod of Irony." Taylor, Joelle. Co-published simultaneously in *Journal of Lesbian Studies* (The Haworth Press, Inc.) Vol. 2, No. 2/3, 1998, pp. 125-137; and: *Acts of Passion: Sexuality, Gender and Performance* (ed: Nina Rapi, and Maya Chowdhry) The Haworth Press, Inc., 1998, pp. 125-137; and: *Acts of Passion: Sexuality, Gender and Performance* (ed: Nina Rapi, and Maya Chowdhry) Harrington Park Press, an imprint of The Haworth Press, Inc., 1998, pp. 125-137. Single or multiple copies of this article are available for a fee from The Haworth Document Delivery Service [1-800-342-9678, 9:00 a.m. - 5:00 p.m. (EST). E-mail address: getinfo@haworthpressinc.com].

125

Rod of Irony" attempts to answer this question and to discover what the term 'lesbian playwright' means within contemporary culture. It dissects the dominant homophobic and misogynist mythologies that have outlawed 'queer' girl writers to the underskirts of British theatre, and ultimately denied them either artistic or commercial currency. It examines the history of the label in the context of feminism, gay liberation and positive representation, and queries its aesthetic and economic viability in a climate where the 'lesbian playwright' is not even supported by her own community. Finally, it is an exploration into radical forms, working methodologies and new genres stimulated by being neither semantic Man nor Woman. It is a piece about cultural terrorism–and how to avoid capture. *[Article copies available for a fee from The Haworth Document Delivery Service: 1-800-342-9678. E-mail address: getinfo@haworthpressinc.com]*

Writing a text which has homosexuality among its themes is a gamble. It is taking the risk that at every turn the formal element which is the theme will overdetermine the meaning, against the intention of the author who wants above all to create a literary work. [1]

The closet is full of yellowing manuscripts. The truth of the contemporary closet is that it is loaded with lesbians attempting to come out as writers in a cultural ideology which will accept one or the other. Never both. In dominant cultural terms, the 'lesbian playwright' is an oxymoron. It is a coupling which erases each of its parts. The original intention of this piece was to interview four high profile 'lesbian playwrights' about their work and their cultural positioning. Out of all the dramatists approached only one consented to a meeting, but on condition that the others agreed. They would not. Their refusal had little to do with shame or fear or suppression, but arose out of a desire to be defined by their words alone. One playwright had been a 'woman writer,' an 'Irish writer,' and now a 'lesbian writer.' All of which are true and none of which are the truth. This is the story of refusal.

DEFINITIONS

According to the critical canon, a 'lesbian playwright' is not someone who writes lesbian characters, played by lesbian perform-

ers to mainly lesbian audiences. Nor is she someone who explores her sexuality in order to experiment with theatre form and methodology. A 'lesbian playwright' is, very simply, any playwright who defines herself as a lesbian. It is irrelevant whether she staples her sexuality to paper or not. Outside of the 'lesbian community,' the term is derogatory and carries with it connotations of an arid agit-prop aesthetic. It is an anti-audience device. Whilst our own definition may be complex and concerns content, form and theatre process–the methodology of Otherness and of Difference–it has been used to confine and conceal us. Like writing in invisible ink.

Difficulties arise when the dramatist attempts to create lesbian characters that are placed in a context other than that of her sexuality. *The Madness of Esme and Shaz* by Sarah Daniels was universally received as a play about cycles of abuse, the misogyny of madness and fantastical escapisms. If anything, it is a survival play; but it featured one central lesbian character. American linguist and dramatist Monique Wittig elaborates the lesbian risk:

> *The text which adopts such a theme sees one of its parts taken for the whole, one of the constituent elements taken for the whole text and the [play] becomes a symbol, a manifesto.*[2]

Just as Woman is the gender and Man the general, so that anything written by a woman needs to be marked as non-universal, the same cultural laws apply to sexuality. There is no such category as a 'heterosexual writer.' Lesbian writing in theatre is pronounced to be not only tangential to the universal perspective, but also aesthetically 'less than.' A lesbian writer is not a Serious Writer, a lesbian play is never a Great Play. The term is confusing because it is at once loaded with meaning and entirely bereft of it. It makes no sense without an equivalent 'heterosexual' category to refer to. Conversely, it signifies a dull, dramatically uninspiring feminist journey narrative obsessed with the perpetual 'coming out' story: coming out of the closet, coming out about sexual practices, coming out politically, coming out about difference–the lesbian character is continually symbolically coming out. A theatre of revelation and resolution. As the playwright Bryony Lavery asserts in an interview with the *New Playwrights Trust*:

*These definitions were historically necessary but it's time now
we were looking at writers, at plays, not at women's theatre or
men's theatre.[3]*

Whilst we are still waiting in the wings to be received as Real
Writers, what the definition has afforded us, and why so many queer
cultural workers initially fought for it, is the potential to aestheti-
cally explore a space that is occupied by neither Man nor Woman. It
is a space that can be used for absolute experimentation. A space
where Aristotle's Poetics and the persistent regurgitation of Greek
Tragedy methodology makes no sense. A space where 'realism' is
recognized as someone else's fiction. A space where the form of the
piece is as important as the content. A space where the process is as
important as the product. A space of revolution rather than resolu-
tion.

QUEERING THE PITCH

The politics of 'positive representation' are the politics of sur-
vival. They are the politics of visibility. They are the politics of
controlling the 'gaze,' of creating counter-images and dynamics to
those presented by dominant cultural and social ideologies. It is
central to any art based debate concerning lesbians, and as cultural
workers we are acutely aware of the need to develop alternative
images. The problem is that positive representation has reached an
aesthetic stalemate: we have become bound by our own narrative
threads. We have countered the stereotypes with stereotypes and
character cliches. This is not true only of the representations but of
the stories that contain them. What the lesbian character *does* is as
important and as closely monitored as what she *is*. Responding to
homophobic accounts of our lives and ourselves has placed us in a
cultural position akin to cleaners: continually sweeping up the ste-
reotypes others leave behind. This leaves little time for exper-
imentation and progress. It has produced not only a theatre of stasis,
but one that is often highly unrepresentative. The popular patholog-
ical model of the lesbian has made it difficult artistically to explore
the more visceral dimensions of our desires and psyche. When a
queer playwright does address these issues, she appears to come

under attack from both positive representationalists *and* the arts establishment.

In 1995 Britain's oldest funded lesbian and gay theatre company Gay Sweatshop presented *The Hand*, a lesbian erotic-horror ballet featuring incest, murder, intestines and dildi. *The Times'* review of the performance was startling, in the same way that being given fashion advice by your grandmother would be:

> *If I were a lesbian, I would be very angry about Gay Sweatshop's The Hand . . . why paint lesbianism as homicidal erotomania, a madhouse of perversions?*[4]

The real question, though, is why *one* play containing moments of 'homicidal erotomania' should be perceived as a representation of and for *all* lesbians. Are we not allowed to be even a little bit bad? Or deranged? Or vaguely intriguing? Queer?

THE BODY OF WORK

> *It is impossible to define a feminist practice of writing, and this is an impossibility that will remain, for this practice can never be theorized, enclosed, coded—which doesn't mean that it doesn't exist.*[5]

Whenever we write, irrespective of what we write, we write ourselves. We make sentences of our skin. We write our bodies. But then we are forced by traditional notions of narrative to wear clothes that are much too tight for us. That inhibit our circulation. That look awkward on us. Like a butch in American Tan tights.

The traditional linear narrative is the story of masculinity, no matter what gender or sexuality it is written by. In the 1980s, essentialist feminists intrigued by Lacanian notions of theatre as male sexual release and surrogate birth, developed the theory of the 'feminine morphology' as a narrative alternative. They argued that traditional drama was formed around the male sexual experience—foreplay, excitation and ejaculation. It also symbolized the male social experience as linear, unbroken by internal cycles or ideas of a break and continuum epitomized by pregnancy and birth. If so, the femi-

nine morphology, the shape of a script, could reflect female biologi-
cal and sexual experience. It would use the fragmentary form of
women's lives, the cyclical essence (menstruation and birth), and
the capacity for multi-orgasm. It would eliminate the linear, the
simplistic structure that works toward one point. It would be multi-
climactic. It would be tangential. It would be surreal. It would
concentrate on the silent story, our mute response to everyday
oppressions. Most of all: it would be new.

It is irrelevant whether there is any political or social truth to the
argument. The form justifies the theory. Why should a narrative tell
only one story? Why should there be a resolution to a piece? Why
keep stuffing circles into square holes? The politics of essentialism
aside, a little aesthetic eclecticism never did a girl any harm . . .

Our social and biological difference is our aesthetic strength.

ON QUEER STREET: THE SEMANTICS OF SUCCESS

In spite of our struggles to the contrary, the term 'lesbian play-
wright' possesses little artistic currency, and is entirely devoid of
economic viability. It has limited a prospective audience at a time
when it is vital to create new markets for our work. Social and
cultural perceptions of the lesbian stage have erected fences around
the theatres we perform in, and those that are associated with our
work. As Mary Remnant argues in relation to 'women's theatre':

> *Those that claim to identify plays as women's plays, or play-
> wrights as women playwrights, identify them as second rate in
> some way, reveal more about their own attitudes to women's
> achievement than anything else . . . there is a vast difference
> between ghetto and community.*[6]

In January 1984, a conference of women theatre directors and
administrators working in both fringe and mainstream theatre pro-
duced a report on the position of women playwrights in Britain.[7]
The study found that only 7% of all produced plays were written by
women and, of that figure, Agatha Christie pieces accounted for
more than half. The situation does not seem to have radically
altered, despite the increase in numbers of women/lesbian theatre

workers throughout that decade. The companies that emerged then have now, for the most part, folded or been assimilated into larger, less culturally specific groups. A girl cannot survive on good reviews alone; particularly when those reviews do not extend beyond her immediate community.

The reality is that lesbian theatre cannot survive without an adequate audience. We cannot change the homo-misogynist perceptions that ghettoize our work without substantial financial support. Lesbian theatre as a commercially viable self-supporting structure within which to present new lesbian writers has always been doomed to failure. Gay theatre has the advantage of appealing to a gay male audience that has statistically 25% more disposable income than any other social grouping. When a lesbian enters a theatre, it is a tightly budgeted event; when a gay man passes through the box office, it is on the way to the bar. An audience dominated by women requires greater subsidy, not only to reduce ticket prices but to provide facilities, such as a crèche, in order to make it possible to see a piece. In addition, the 'lesbian play' requires but rarely acquires an enormous publicity budget to break through the social and cultural prejudices that keep critics, producers, agents, sponsorship bodies and, ultimately, the audience at home practicing tolerance before the television set. Phyllis Nagy, writer-in-residence at the Royal Court in 1991, spoke of her experience in touring *Entering Queens* as a part of a Gay Sweatshop threesome season:

> *Gay men weren't interested in my piece because there were no gay men in it: this appalling attitude that unless work speaks directly to a very small part of you—your sexual organs probably—you write it off like that.*[8]

Alternative and community theatre venues take the greatest interest in and give valuable support to lesbian writers, but are themselves underfunded/underequipped/are located on the perceived periphery of critics' vision/and without good or at least wide-angle eyesight, the chances of further investment into the writer are negligible. They are dominated by small studio spaces/with limited audience capacity/and reduced staging possibilities. Not that it really matters because the companies themselves are unable to provide a

budget for anything other than Theatre of Necessity/they are unable to provide the extensive publicity campaigns commonplace to major venues/which doesn't really matter because the publicity they do provide is undervalued or ignored. The staff are overworked and underpaid/they cannot provide adequate crèche coverage for a projected predominantly female audience/let alone the theatre workers themselves. They are unable to commission material from writers/ who are unable to publish their scripts/because they were produced at an alternative venue/and the critics just could not see that far.

The semantics of success, the alternative to welfare, means that it is imperative for us to move our work into higher profile theatres, in spite of the political unease nestling in the snake pit of our stomachs. Venues like The Royal Court, the Institute of Contemporary Arts, the Young Vic, and the Almeida have long established relationships with critics, agents and publishing bodies. Productions performed on their stages, which are frequently of a similar size and audience capacity to fringe theatres, are not only seen, but are *seen* to be seen. This is essential for the longevity of the work; for longer runs and for publishing opportunities. Published scripts allow for serious study of the work, and for progression in the art. They allow for re-performances by fresh minds. They allow for the development of strong female performances, at a time when roles written for men still outnumber those for women by a ratio of about seven to one. They allow new women/lesbian directors to refer to work that refers to themselves.

The creation of the *Plays by Women* by Methuen and Jill Davis's *Lesbian Plays* volumes[9] have provided the lesbian playwright with some opportunity, but they were created at a time when the marketability of feminist and lesbian politics was higher, when they were a definable commodity. Theatre and publishing are businesses. If a product will not sell, it will be left unmade. Post-feminism is not only politically inept and oppressive, but artistically and economically disastrous to us. It has erased the marketability of our 'product' and, with it, any hope of further investment.

The creation of Queer and the Queer Aesthetic, as a reaction to feminist and mainstream establishment, *is* forming new markets but is once again limited by its own definition. It remains to be seen

how long we, as Queer cultural workers, are able to sustain the momentum.

A FEAST OF FILTH: WHORROR AND THE EROTIC

If Tom Morriss, in an article published by *The Guardian*,[10] is to be believed, there is a developing trend in small-scale fringe theatre toward producing violent and raw pieces in intimate studio spaces. Murder in the front row. Although Morriss and others have attributed this increased interest in the poetry of violence, the ballet of blood, to the popularity of Tarantinoesque imagery and the emerging desire to touch the untouchable, both lesbian and feminist playwrights have been stabbing their pens around the fleshier parts of the theme for over two decades.

We have dissected the subject in detail, exploring links between desire and death, rape and the invasion of nations, the sexual control and ultimate occupation of girl-children, madness and misogyny, and the furies of survival. Of Sarah Daniels' 1994 production of *The Madness of Esme and Shaz*, a review in *The Times* read:

> *In Daniels' cosmos a statistically surprising number of problems may be traced back to a man with one hand aggressively clenched and the other unzipping his flies.*[11]

The dismissive arrogance of this review fails even to outline the play's synopsis adequately, which is concerned with the lesbian character Shaz's murder of her younger sister and her subsequent incarceration in a high security psychiatric hospital. She had killed her sibling in order to save her from the paternal abuse that she herself had suffered from early childhood. In spite of the reviewer's insinuation that the piece was one more lesbian-feminist man-hating circus of stereotypes, the work took risks not only with the theatre establishment but with that of feminism too. As one of Shaz's friends suggests: she killed the wrong gender.

The violence of the piece is contained within its ideas rather than its images. A woman/lesbian theatre audience is accustomed to violence presented as memory, abuses spoken of but rarely enacted in detail. This reflects not only the economy of small-scale produc-

tion, but the politics of voyeurism; a politique that appears to be losing its patience. There is only so much effete symbolism a girl can take before turning in desperation to prosthetics and red powder paint. Perhaps seeing really *is* believing. As Morriss concluded:

> *Watching the cruellest of these plays in a small studio theatre is like watching a simulated rape in your own living room.*[12]

The fear of how an audience will respond to such unrelenting and invasive imagery has always been the argument against showing violence in full–although we are equally divided into those who believe that it could only repel, and those who worry that an audience not like it too much. How responsible can the playwright be for the audience's reaction? And is that not what we want: the first twitching of a finger to signal the imminent emergence from coma? As Sarah Kane asserted after a battalion of critics had attacked her production *Blasted* as attempting only to shock:

> *I hate the idea of theatre just being an evening pastime. It should be emotionally and intellectually demanding. [The audience] expect to sit back and not participate.*[13]

Blasted, premiered upstairs at the Royal Court Theatre in 1995, was concerned with connections between war, sexuality and sexual violence, using a Bosnian Leeds as its central location and metaphor. A foul and flabby principled journalist, Ian, coerces the infantile and thumbsucking Cate into sex in a disintegrating hotel bedroom. In between physical invasions, she convulses–at which point a homicidal soldier knocks on the door seeking revenge for the death of his girlfriend. Anal rape, cannibalism, mutilation and murder ensue. Not to mention un-ladylike language and a distinctly unhappy ending.

Never before has the work of a 'lesbian playwright' been met with such vitriolic uniform damnation. We are usually simply ignored: cheaper and more effective. The critical majority sought not only to condemn Kane and *Blasted*, but also the artistic and professional integrity of the Royal Court selection panel, and the wisdom of the Jerwood Foundation in providing funding for the production. Precise budget details were released, Arts Council

funding for the Royal Court appeared in ominous paragraphs on
their own. The descriptive critiques ranged from "this poetry is the
poetry of horror, of despair, of excess,"[14] to the fabulous "feast of
filth"[15] headline. There were, however, those who noted the hypoc-
risy inherent in the reviews. The principal liberal objection to the
piece seemed not to be the violence itself, but the overall absence of
a moral directive:

> *. . . the trouble with Blasted is that, whatever its aims, it*
> *contributes little to our understanding, and its pointless vio-*
> *lence just comes over as pointless.*[16]

It is difficult to believe that this is from the same critical canon
that regularly dismisses the work of lesbian playwrights as being
too morally directive, of being too fervent and fanatical in the quest
for a happy ending. Or even a reason. It is also the same canon that
supported Bond in the censorship trial of *Romans in Britain*, which
was produced at the Royal Court in 1989 and also displayed an
explicit anal rape scene, and who actively support the work of our
more bloody major tragedians. Is there the scent of sexism in the
air? Louise Doughty, a supporter of the piece, wrote at the time:

> *One character sucking out another's eyes and then eating*
> *them for breakfast? No way, Jose, it would seem, unless your*
> *name is Seneca or Shakespeare, and you've been dead for*
> *centuries. . . .*[17]

Or you are a living male. That a critical audience is more preoccu-
pied with the presentation of physical and sexual abuse itself should
not surprise anyone. That they should also be preoccupied by who,
or what gender and sexuality presents the imagery is horrific.

THE EROTIC

While the heterosexual male-penned 'erotic lesbian musical'
Voyeurz earned itself a place on the West End, Gay Sweatshop's *The
Hand* struggled to fill three weeks at Jackson's Lane Theatre. *The
Hand* was a collaborative piece written by Stella Duffy with con-

tributions from Cherry Smyth and Caroline Forbes, and directed by Lois Weaver and Emilyn Claid. Their exploration of erotic horror left the critics blushing and pouting:

> *The explicit simulations of sexual acts and physical abuse suggest the team is not only determined to tell a story, but, like swaggering, defiant teenagers who have just discovered sex, to shove the discovery in our faces.*[18]

The primary aim of the Queer theatrical agenda has been to sex the lesbian subject, to be both the possessor and the recipient of the 'gaze.' It has been to tell the truth and the fiction of our sexual selves. The increase in erotic Queer-Girl theatre is also a fundamental aesthetic attempt to steer narratives away from the positive representation politics of the 'coming out' story, that dull journey from repressed heterosexual to politically adequate utopic Lesbian. It is about taking the inner-journey on the road.

This is most noticeable in Queer Performance Art, which encompasses venues as disparate as the Institute of Contemporary Arts and Fist, a Cyber-Queer fetish club. Fetish performances cast the audience as subject, in a complex voyeuristic exchange that pierces deeper than any dramatically applied labial ring. Its effect relies upon the spectator's memory of the act as performed upon themselves. It relies upon the individual's memory of the neo-shamanic journey of the flogged, restrained, penetrated and pierced performer. The body as an archive, as the plot, as the staging, as the script itself. Her power depends upon the desire of the spectator.

Queer Girl live art, or performance art, is developing both a critical and commercial currency. It cites the body as its resource, sexuality as its subject, and works toward creating a theatrical text that concentrates on lighting the inner journey. The act of writing is itself a sexual act. It feels masturbatory, it follows the curves and sharp contours of our individual erotic control. We are the form, the content and the process. The future of the 'lesbian playwright' depends upon our redefinition of ourselves. It depends upon our acts of cultural terrorism. We cannot change perceptions of our writing by words alone. Radical aesthetic and social revolutions are required. Most of all, we must write ourselves into the future:

[Y]ou've written a little, but in secret. And it wasn't good, because it was in secret, and because you punished yourself for writing, because you didn't go all the way, or because you wrote, irresistibly, as when we would masturbate in secret, not to go further, but to attenuate the tension a bit, just enough to take the edge off. And then as soon as we come, we go and make ourselves feel guilty—so as to be forgiven, or to forget, to bury it until the next time.[19]

NOTES

1. Wittig, Monique, "The Point of View: Universal or Particular," in ed. Diane Apostolos-Cappadonna and Lucinda Ebersole, *Women, Creativity and the Arts* (Continuum 1995).
2. Ibid.
3. Lavery, Bryony, *New Playwrights Trust, Newsletter no. 91* (1994).
4. Meisner, Nadine, *The Times*, 26/10/95.
5. Cixous, Hélène, "The Laugh of the Medusa," *Signs* (summer 1976).
6. Remnant, Mary, *Plays by Women Vol 5* (Methuen 1996).
7. See *What Share of the Cake, The Empowerment of Women in the English Theatre*, Caroline Gardiner, Women's Playhouse Trust, London, 1987.
8. Nagy, Phyllis, *New Playwrights Trust, Newsletter no. 91* (1994).
9. Davies, Jill Ed., *Lesbian Plays*, Methuen, 1987 & 1989 for Volumes I & II, respectively.
10. Morriss, Tom, *The Guardian*, 25/1/95.
11. Nightingale, Benedict, *The Times*, 17/2/1994.
12. As [8].
13. Kane, Sarah, *Independent on Sunday*, 22/1/95.
14. Peter, John, *The Sunday Times*, 29/1/95.
15. Tinker, Jack, *Daily Mail*, 19/1/95.
16. Hemming, Sarah, *Financial Times*, 23/1/95.
17. Doughty, Louise, *Mail on Sunday*, 29/1/95.
18. As [4].
19. As [5].

From Stage to Screen and Back: Tash Fairbanks' *Nocturne* Shedding Some Light on Lesbian Representation, and the Performance of Lesbian Desire

Jan Goulden

SUMMARY. This paper explores the differences in lesbian representation between theatre and film by focusing on Tash Fairbanks's television play *Nocturne*, which exemplifies the crossover from stage to television screen. The paper identifies the changes that have come about in lesbian theatre and the implications these changes have had for both the writer and the audience. A significant part of this change is the impact of Queer Politics and the political and social implications this has had on lesbian representation. The most radical area of Queer Politics is the 'mainstreaming' of lesbian performance and this paper explores the issues arising from Queering the performance space; the arguments for and against 'mainstreaming' lesbian performance and its implications for the future. *[Article copies available for a fee from The Haworth Document Delivery Service: 1-800-342-9678. E-mail address: getinfo@haworthpressinc.com]*

Jan Goulden is currently working on an MPhil with the Open University, Milton Keynes in the United Kingdom.

Address correspondence to Jan Goulden, 67 Severn Road, Canton, Cardiff, Wales CF1 9EA, United Kingdom.

[Haworth co-indexing entry note]: "From Stage to Screen and Back: Tash Fairbanks' *Nocturne* Shedding Some Light on Lesbian Representation, and the Performance of Lesbian Desire." Goulden, Jan. Co-published simultaneously in *Journal of Lesbian Studies* (The Haworth Press, Inc.) Vol. 2, No. 2/3, 1998, pp. 139-155; and: *Acts of Passion: Sexuality, Gender and Performance* (ed: Nina Rapi, and Maya Chowdhry) The Haworth Press, Inc., 1998, pp. 139-155; and: *Acts of Passion: Sexuality, Gender and Performance* (ed: Nina Rapi, and Maya Chowdhry) Harrington Park Press, an imprint of The Haworth Press, Inc., 1998, pp. 139-155. Single or multiple copies of this article are available for a fee from The Haworth Document Delivery Service [1-800-342-9678, 9:00 a.m. - 5:00 p.m. (EST). E-mail address: getinfo@haworthpressinc.com].

139

THE BEGINNINGS OF CHANGE

Tash Fairbanks, founder member of Siren lesbian theatre company wrote *Nocturne*, her television film for Channel 4 in 1988.[1] It was originally commissioned for the ground breaking television series *Out*, and then re-commissioned as a 50-minute play, as it was decided not to use drama in the program format. *Nocturne* was directed by Joy Chamberlain, in a disturbing psychological style. It featured Lisa Eichhorn as Marguerite, a sexually repressed middle-class forty-five-year-old woman, who has returned to her family home after the death of her mother. Two young women on the run from a detention center, played by Caroline Paterson and Karen Jones, break into the house, where a strange power game, based on sexuality and class, is played out between the women.

The film subtly explores the emotional and psychological dynamics between the women. As the story develops, using flashbacks to Marguerite's past, it becomes apparent that she is uncomfortable with her own sexuality, and her mother's relationship with her childhood tutor. The game acts as a catalyst for Marguerite and as the roles develop, with Marguerite acting as mistress, Sal playing the role of her tutor, and Ria playing the role of 'the child,' Marguerite is forced into remembering and coming to terms with a painful set of relationships between herself (as a child), her mother and her tutor, memories full of all kinds of repressed desire.

I shall explore here the shift from lesbian representation on stage to film, focusing on *Nocturne*, which exemplifies this crossover. In the process I shall analyze the influence that Queer Politics and the dominant culture have on those representations and look at the mainstreaming of lesbian culture.

CHANGES IN LESBIAN REPRESENTATION SINCE NOCTURNE

Since 1986 when *Nocturne* was first screened, there has been noticeably more lesbian representation on the screen (TV and film). In the early '90s, lesbians were definitely becoming more visible on the screen; *Portrait of a Marriage*, written by Penelope Mortimer and directed by Stephen Whittaker, screened on BBC 1 (1990), is a

case in point. The increased presence of U.K. soap operas, like Beth Jordash in *Brookside*, 1996, Channel 4; Zoe Tate in *Emmerdale Farm*, 1997, ITV; and Helen Cooper in *Drop the Dead Donkey*, 1997, Channel 4, illustrate a continuing trend.

IDEOLOGY AND REPRESENTATION

The politics of lesbian representation has changed as Tamsin Wilton notes in *Lesbian Studies: Setting An Agenda*:

> Lesbian sociology has shifted focus from a desire on the part of heterosexuals to understand lesbianism as pathology or alien lifestyle, through a changed desire to understand lesbians as an oppressed minority, to a desire on the part of lesbians to further the social, political and psychological needs of a lesbian community.[2]

A significant element of this cultural advance is the shift from stage performance to television, as vehicle for lesbian narrative. It could be argued that funding difficulties and lack of venue space have been relevant factors in the shift towards lesbian representation in the mass media. Also, increased social awareness of gay lifestyles and politics have had an influence on lesbian visibility.

I asked Fairbanks what were the significant differences for her, working in both theatre and film:

> In film there is a lot less dialogue, so much can be done visually, you can achieve a different kind of meaning. I think theatre is far more linear, film is more like dance, the connections are lateral. If you want to write beautiful language you don't write for film—film is much more direct. Film uses a less linear approach, film is more poetic—visual—I don't have to make a bridge from there to there, the camera makes it for me. So, the camera is a very forceful presence.[3]

Can a lot of language be made redundant in film then?

In a sense language has to be better, more precise, more focused.

FILM–THE REEL AND THE IMAGINARY: DIFFERENCES BETWEEN FILM AND STAGE AUDIENCES

Film has its own mythology, its own language; its own specific pleasures. The codes and signifiers are different, between film and theatre:

> Film has its own codes, shorthand methods of developing and establishing social or narrative meanings; and its own conventions–sets of rules which audiences agree to observe and which, for example allow us to overlook the lack of realism . . . [4]

A film audience has different expectations, i.e., film is a single performance, played the same each time an audience watches it. Whereas, a theatrical performance is different each time; live input is a variable, how the actors perform in any given performance and each audience will interact differently to a performance.

Live theatrical performance offers an intense sense of intimacy that comes from the live presence of the actors and the live action on the stage. Theatre, because of its immediacy, is a one to one experience. And it is the need for lesbians to identify with other lesbians in performance that helped create the grassroots of lesbian theatre. There is a danger that the social and cultural function of lesbian theatre will be lost if live lesbian performance becomes mainstreamed.

'MAINSTREAMING'– LESBIAN VISIBILITY IN PERFORMANCE

Fairbanks regards the mainstreaming of lesbian theatre an impossibility:

> I can never see lesbian theatre in the mainstream, and if that happened, it would be so glamorized and away from any real kind of bite or edge. It's the edge that keeps pushing. Theatre is not a mainstream activity: it is a fringe activity anyway, so you are talking about a fringe of a fringe and the mainstream fringe.

However, it would seem that lesbian representation has been 'mainstreamed' by television. In the past, theatrical productions were able to produce a radical edge, but now production has become more of an economic choice, rather than a political one. Television, in its capacity as purveyor of the popular arts, provides a limited cultural space for lesbian performance and representation. An obvious danger of the mainstream lesbian narrative is that now it is re-located into the heterosexual living room, and is produced with this in mind. The strategies involved in mainstreaming lesbian performance are changed by this shift. The possibilities for radical/ explicit narrative become diffused by the normative conventions of television. In effect the straight spectator in the armchair controls the product on the screen, by enacting (with the TV and video 'wands') their demands and expectations of what is acceptable. At present lesbian culture is perceived as being economically viable by the program makers and is therefore more culturally visible; yet it still has to operate in what is a dominant patriarchal/heterosexual culture. The theatrical space where lesbians could construct politics and explore their cultural codes has been colonized by the media and is re-situated under the banner of 'popular' culture.

Lesbian productions are now more frequently situated in what is predominantly a homophobic space. A space where the politics of representation is controlled and influenced by those who are not necessarily lesbian and whose remit does not allow the free expression of lesbianism, beyond a popular stereotype. (Although that stereotype is changing to a degree.)

The cultural space that lesbians have traditionally existed in, created by the slippage between heterosexuality and gayness, has been eroded and with it the crucial distancing, that allows innovative and creative freedom. The margins are being eclipsed by the mainstream. In the transference to the small screen lesbian culture is losing some of its claims to a privileged space and a strong base of lesbian cultural identity.

Tash Fairbanks explained the difficulties in putting on lesbian theatre and her approach as a writer:

> Venues for lesbian theatre hardly ever got funding, and often when Siren were trying to get venues for lesbian theatre, they frequently had to disguise what they were going to do, and get

in through the back door. You can get the radical message in at different levels. Audiences can take things in at different levels, even if a message is blatant. It's no good hammering people, you can approach the subject from different ways, that are more elliptical.

But for a non-elliptical approach, how about Queer?

QUEER POLITICS

But standing before the work of art requires you to act too. The tension you bring to the work is an action.[5]

Queer is a term that has been appropriated from homophobia, and one that implies a more radical statement than gay. bell hooks defined it as being a "chosen site of resistance," a "location of radical openness and possibility."[6] Queer is non-gender-specific, it is a site where traditional gender codes can be challenged and new positions worked out. The other side of Queer is defined by Sue Ellen Case as having once been a political movement and now a consumer 'lifestyle.' What was once a community, or subculture, is now a market sector. She goes on to argue that: "the interest . . . is not in collective agency, but in the individual action of intervention into the marketing process."[7]

The mainstreaming of lesbian and gay theatre and film is a debate that is very much alive at the moment. 'Mainstreaming' is, in part, a question of lesbian visibility and cultural changes; for example, the dissolution of radical political feminism and the Queer allying of gay men with lesbians, has created a new cultural position for lesbians. The emergence of the so-called Pink Pound has created 'new' economic power and a new equation has evolved, linking economics and lifestyle. It is from this media concept that the 'lipstick lesbian' and the consumer lesbian have materialized. And perhaps, more significantly, Queer Politics has emerged as a political response to the advent of the New Right fundamental politics, with its anti-gay rhetoric.

Queer could be seen as 'work in progress,' a destabilizing movement encompassing disobedience and transgression, within the

existing framework of gay culture. The codes and politics within any culturally defined social group are responsive to change, and with change a new set of myths emerge along with 'new' narratives to carry them. It seems ironic that Queer emerges as a reaction to existing gay cultural identity and politics, but has become the hyped commercial vanguard for mainstreaming gay culture. These aesthetics are reflected in films such as Tom Kalin's *Swoon* (1992) and Todd Haynes's *Poison* (1990), Jean Carlomusto's *I Is For the Way You Look* (1991). Queer Film is being shown at international film festivals, in San Francisco, Berlin, Amsterdam and London.

Queer theatrical performance has included: *My Queer Body* by Tim Miller (1993), *Leaking from Every Orifice* by Claire Dowey (1993), *The Hand* by Stella Duffy (1995), *pucker* by Helena Goldwater (1996), *Club Deviants* by Gay Sweatshop in association with Almeida (1996).

It could be argued that the self-styled "New Queer Cinema" is another name for independent, experimental cinema, hyped into the "New Wave" representation of gay sexuality and gay lifestyle. Christine Vachon, co-producer of *Swoon* and *Poison*, connected the interest in Queer Film as being money oriented: "Suddenly there's a spotlight that says these films can be commercially viable."[8]

However, lesbian film maker Pratibha Parmar's response to Queer Cinema is one that sees the emergence of gay counter culture as liberating:

> Queer came as a gift for me. It gave me space and enabled me to rethink the idea of a gay community. . . .
>
> I find the formal inventiveness of the recent films exciting and exhilarating. Queers have been marginalized to an extent that we have felt compelled to subvert dominant genres. Now the question of pleasure is very high on the agenda, not surprising in the age of AIDS. Cultural interventions can be pleasurable too.

She goes on to say:

> I want that outlook and sensibility to look at wider society. . . .
> A film doesn't have to be about gay/queer sexuality, or even

sexuality at all, to be queer. It's taking on taboos, saying the unsayable—to me that's what queerness is.[9]

But, it could be argued, Queer Politics is fundamentally a platform for gay middle-class white men and this is represented in theatre, film and the media. As Wilton put it: "The contemporary queer/lesbian and gay subcultural infrastructure is dominated by economically privileged gay men."[10] Amy Taubin in her article on Queer Cinema, "Beyond the Sons of Scorsese," defines Queer Cinema as being rooted in the male tradition of Cocteau, Warhol, Fassbinder, Kenneth Anger and Jack Smith, historically part of twenty-five years of gay activism. She comments on the lack of feminist film in Queer Cinema: "As long as that desire remains exclusively male, however, it's only queer by half."[11]

Perhaps it is at this point that distinctions between, gay, lesbian and feminist become more apparent.

The political shift toward Queer Politics has had repercussions in lesbian theatre; the 'I' figure of lesbian separatism has been recuperated into Queer identity. The lesbian I-dentity of Women's Theatre has become part of another performance, one that re-positions itself alongside a different theoretical base, one in which the lesbian 'I' has become subsumed by the consumer politics of the Queer Nation. Women, however, are still oppressed by men, even within the Land of Queer. For example, spending power, production power, and political power are still vested in male hands.

LESBIAN THEATRE:
A SPACE FOR LESBIAN IDENTITY
AND A POLITICAL ARENA

Although lesbian theatre is contained within the genres of 'women's theatre' and alternative theatre, an important distinction has to be made; lesbian theatre can be defined as being performed by lesbians occupying all the performative space. In lesbian theatre the gaze is re-directed by the performer and the performance.[12]

Lesbian theatre represents an immediate space where lesbian identities and culture can be intentionally produced for a lesbian audience, a space where lesbian audiences can expect to see lesbian culture and its

codes reproduced for their own entertainment. A lesbian reading is produced from constant negotiation, with signifying practices produced from a position 'outside' of the heterosexual norm.

Bonnie Zimmerman argues: "The lesbian is posited as being in a unique position to deconstruct heterosexuality, patriarchy, gender—indeed just about anything."[13] Although Zimmerman's argument implies subversion of the dominant heterosexual codes, I think that it highlights the power that lesbians have to change heterosexual codes and signs and re-appropriate them into lesbian culture. However, in overt lesbian performance we do not have 'crossover' from the gendered norm of heterosexuality into lesbian space. We do not have to lesbianize the narrative and use yet another level of fantasy to negotiate our positions. The implicit meaning is lesbian.

This is a significant position that allows a lesbian perspective and politics to be developed. Lesbian theatre creates a public arena where an ideological transaction takes place between a company of performers and the community of their audience. "Ideology is the source of collective ability of performers and audience to make more or less common sense of the signs used in performance, the spectator is engaged fundamentally in the active construction of meaning as performance events proceed."[14]

Lesbian identity in performance is frequently depicted through diversity of perspective. Subversion of cultural mores is still frequently the agency by which lesbians project their sexuality and identity. An example is Beau Coleman's experimental performance piece *Medusa*, which explores alienation and difference in society, both racial and sexual. In the performance a symbolic mask is worn, hiding the true self from society. The mask is a physical reminder that you are judged by how you look, and that people will label you and find reasons to cast you out, seeking to confirm their assumptions about the 'outsider.' Marginalization is still the position from which the lesbian performance comes; cultural representation is still reflected through homophobic consciousness.

Lesbian images of self-representation are created in a shifting matrix of possibilities. Lesbian identity is not fixed to the heterosexual norm of straight women; straight culture is the model that we choose to react against, rather than emulate. Lesbians, because of their position on the outside, are able to manipulate and subvert the

'norm' and the conventions of heterosexuality. This position gives lesbians the potential to re-invent ourselves and relocate identity and subjectivity in the multifarious facets of the gay continuum: "It is the differences within our difference that carry such exciting potential."[15]

A CHANGE OF IMAGE

Against this are the straight fixed images of lesbians. The stereo-typed lesbian image has picked up definition through literary and film representations of the twentieth century. Examples of these images range from Baudelaire's male fantasy poem "Les Fleurs du Mal" to Lillian Hellman's play *The Children's Hour* (1937), to Frank Marcus's negative 1968 play *The Killing of Sister George*, and Sharon Stone's depiction of a homicidal lesbian in the 1992 film *Basic Instinct*, directed by Paul Verhoeven. Each representation reflects the socio-historical position of its time.

The depiction of lesbians as perverted, murderous or alcoholic, and other damning stereotypical images persists in heterosexual culture. A positive image of a lesbian on stage or screen has had to fight its way through the barriers of invisibility, censorship, lack of venues and funding.

Although this is changing slowly, with the advent of films on general release like Donna Deitch's 1985 *Desert Hearts*, Rose Troche's 1994 *Go Fish*, and Patricia Rozena's 1996 film *Night is Falling*, more positive images have been made available. The ste-reotyped image is gradually being displaced, and this is reflected on both sides of sexual difference. The stereotype has its roots in popular representation, and like the myths that surround it, is sub-ject to the pressures of cultural changes. *Nocturne* can be seen as significant, as it did not focus on existing stereotypes, but rather allowed for the differences and complexities between the women, like class, for example, to be explored in the narrative.

CLASS IN NOCTURNE

Inherent in lesbian imagery and images of the self are signifiers of class and social position. Class is firmly entrenched in society,

whether lesbian or straight. In *Nocturne* the characters come from different classes. Marguerite is from an upper-middle-class background, signified by her attitudes, accent and the house in which she grew up, the setting for the play. Sal and Ria, the interlopers and complicit game players, are portrayed as lower class, signified by their behavior, attitudes, accent and dress. And it is significant that despite the fact that Marguerite adopts the role of madam in their game, Ria and Sal are in fact in charge of the performance. The narrative indicates that Marguerite is not happy in her designated class role. She is shown as a woman trapped in a lifestyle governed by middle-class rules and conventions. As the narrative progresses we see her attempting to break out of her middle-class lifestyle; she is unconcerned about the material goods and status of her mother's home and indifferent about what 'people' think. Marguerite feels a sense of loss, having grown up distanced from her mother by the conventions of class and 'proper' behavior. Also, it is significant that as the narrative develops the audience sees how she becomes aware and is able to acknowledge her own potential lesbian sexuality.

The 'working-class' girls are set up as agents of change; their difference and confidence opens the door for Marguerite to break with her middle-class past and its social expectations. In this sense *Nocturne* effectively undercuts the traditional lines of class of British society.

PERFORMANCE AND THE DYKE

Performance is part of a dyke's everyday life, both in the public and private sphere. Frequently, lesbian women have to 'pass' as not being lesbian in the straight world, for employment and for reasons of physical safety. Lesbians have to give a 'performance' and play roles in everyday life, on the bus, in the office, in a restaurant, anywhere where the heterosexual model is predominant and potentially homophobic. There are two audiences for a lesbian: the straight and the gay; in private we can perform whatever act we choose.

I was interested in the dynamics between the characters in *Nocturne* and remarked to Fairbanks that a significant part of the rela-

tionship between the characters in the film is based on power games. I asked what the feeling had been about this.

> It was a power play; everyone knew what was going on. Yes it was consensual, they *[the characters]* were exploring their relationship to power within the games.

Also, sexual tension and body language form a significant part of the narrative in *Nocturne*: how difficult was it to translate this from script to screen?

> I think having food there really helped because it was the thing in between that managed to get sexual tension right through. It was probably easier because none of the actors were lesbian; so the actors could focus on what was happening at the table, rather than on each other.

Part of the power of *Nocturne* is how it manipulates the atmosphere of a scene in subtle ways, exploring the psychological tensions between the characters; the actors do not rely on the spoken word to convey the emotion of a situation, rather it is what is implied, or what is not said that provides the dramatic statement. But when Fairbanks revealed the actors were all heterosexual, suddenly that became the issue:

> Was that a deliberate choice, that they weren't lesbian?

> No, it was the director. I think they were going for somebody who was quite well known, but it was how she wanted those characters.

The fact that the director wanted a 'well-known' actress is obviously a commercial decision, concerned with audience pulling power. But the fact that the actors were not lesbian fits a larger pattern: there are few out lesbian actresses, and by implication if an actress is well known and successful she tends not to be identified as lesbian. Whereas, there are several well-known gay men who are acknowledged as being gay–e.g., Sir Ian McKellen, Simon Callow, and Michael Cashman.[16]

THE FILM OF NOCTURNE:
A DEMONSTRATION OF THE MEDIUM
AND THE POWER–DIFFERENCES

The potential and power of film as a medium of performance is demonstrated in the dinner scene referred to earlier. The three actors translate sexual power through ambiguity of language, eye contact and body language. Eating food and drinking wine becomes a cathartic ritual for the older woman. In this pivotal scene the three women sit around a formal dinner table. The script describes the action as

> a strange mish-mash of odd bits and pieces not quite gelling. The effect should be one of genteel elegance out of sync. During the meal the three move in and out of their roles. Ria's face is covered in garish make up. In her child's dress she looks a parody of innocence. The atmosphere is one of tension of opposing forces: restraint and formal politeness perched delicately over an abyss.[17]

The language of the script is transformed by the camera into a disturbing scene, where the sexually ambiguous dialogue becomes more potent by not articulating what is happening; rather it is the actors' physicality and their relationship to the camera that carries the meaning. This is apparent in the scene set in the past where Marguerite and her tutor arrive home, after being caught in a heavy rain storm. They burst into the living room where the mother is startled by their sudden appearance. She cannot keep her eyes away from the tutor's wet clinging dress. It is clear by her body language that she is both fascinated and horrified by the other woman's physicality and sexuality. The camera defines and holds the tensions in the scene. The two women converse about the rain and how wet the tutor and the child are, yet the mother wants to prolong the conversation asking if Marguerite's behavior is satisfactory, and if her room is comfortable. By her facial expression, we see that the tutor is puzzled and the spell is broken, and the mother looks painfully embarrassed and awkward. She asks them if they had an enjoyable walk–the child replies: "It was raining mother." Unspoken desire is articulated by the camera, visually translating the

dialogue into filmic meta language, language beyond the word. The spectator becomes curious, empowered by the scene that is projected through the camera lens. The audience has the power to understand events; the disparate images and signs come together into a coherent pattern.

In *Nocturne* this is illustrated in the flashback sequences that reveal the background events, and the psychological development of the central character Marguerite. The audience sees Marguerite as a young child and the complex relationship between her and her mother, her relationship with her governess, and her mother's relationship with the governess. The camera crosses in time back and forth, building a remembered picture of the past and an explanation of the present. Piano music, a nocturne, is a central motif in the play. It creates a musical and emotional link; bridging past and present carrying the audience through time in conjunction with the flashback sequences. The filmic images of past and present merge, creating a reality for the audience.

THE END IS NOT IN SIGHT, BUT MERELY A PART OF 'WORK IN PROGRESS'

Nocturne can be seen as part of the change towards mainstreaming lesbian representation. It did not disrupt or challenge the heterosexual gaze, but it did reach a wide audience by being shown on television. *Nocturne* represents one of the few televised lesbian films made available to a general audience and in this sense it was a radical piece of performance, one that questioned the conventions of class, as well as lesbian stereotypes.

Change and the potential for change are inherent within our culture, we are all caught up in the process of shifting definitions and moving boundaries. An example of change is the growing trend for collectives to be replaced by companies who hire writers, because funding is more readily available.

A further example of funding-enforced change is evident in Britain's longest-running gay theatre company, Gay Sweatshop. The company has been in existence since 1975 and is to lose its Arts Council funding. [Gay Sweatshop has now lost its funding and no longer exists.] Guy Chapman, ex Gay Sweatshop, is quoted as

saying that he: "suspects the market will be freed up" by this move, implying that new companies will emerge from the ashes of the old. Further: "a growing awareness of an untapped West End market is giving gay performance more mainstream credibility. . . . and new—particularly lesbian–artists could benefit from the fresh outlook of a new gay stable."[18]

As this article intimates, changes are taking place within the organization of performance venues; the fringe has been sub-divided and re-defined by the media. *Time Out*, the London-based arts and media weekly has divided the fringe into a new category. There is now the Off West End theatre, which is the new setting for some quality productions that have backers, and is effectively a venue for mainstream productions. The fringe (in London) still exists but it has become more defined, e.g., the diversity and quality of both venue and production has become narrower. It would seem lesbian theatre has to acknowledge the mainstream to survive, in whatever form.[19]

And yes, Hollywood is allowing the occasional lesbian onto its mainstream screen, but it is still strictly on their terms; as Whoopi Goldberg's squeaky clean lesbian in the film *Boys on the Side* illustrates. (There was one deathbed kiss.) Lesbian audiences are still having to read between the lines to identify with lesbian characters on the mainstream cinema screen and scrabble for crumbs of lesbian representation; hence the proliferation of the ambiguous lesbian icons. Lesbians and positive lesbian representation have not yet entered the heterosexual collective unconscious.

But, undeniably there has been a shift in the mainstreaming of lesbian and gay culture. Television, particularly Channel 4, is the most promising venue for lesbian representation at the moment in the UK. But will this trend last, lesbians representing lesbians on the screen?

I would argue, lesbians (and gay men) are still controversial enough to be an 'issue.' It is not a given right, lesbians appearing on mainstream television. It does not mean that lesbians have become socially acceptable. Are we perhaps being sold out and marketed as a fashionable trend? It is important to remember that commercialism enforces its own form of censorship on productions and content.

I do find the mainstreaming of lesbian culture ambiguous. The lesbian narrative is not fixed; it is tenuous, determined by cultural interaction and interplay of political consciousness. This 'freedom' gives artistic strength and innovative power. Lesbian culture needs to be fluid, have the capacity to evolve and change, utilizing its own cultural codes; drawing from the transgressive and the radical. The danger is that we will become trapped in a new set of stereotypes and performative conventions, influenced by commercialism and 'straight' thinking. I am afraid that we will lose the innovative energy of lesbian politics and radical performance and become hegemonized, our strength/identity diluted by heterosexual culture.

In the end the dilemma is, do we accept mainstreaming and its implications for lesbians (still unequal in the phallocentric gender stakes), and embrace our Queerness, with its tantalizing offer of visibility and venues? Or do we risk becoming (more) invisible, and face a lack of funding and venues to act out our own narratives? It is unlikely lesbians will ever have full control of the mainstream or the power invested in that position, or the freedom to make our own images and representations, without stricture. Perhaps the frisson/ space between the fringe and mainstream will provide a possible arena for lesbian performance, beyond the confines of heterosexuality, a space where lesbians are free to draw from the transgressive and the radical. Perhaps not.

NOTES

1. Tash Fairbanks has written extensively for the theatre, with a career spanning over 20 years. She was a founding member of lesbian feminist theatre company Siren, for whom she wrote numerous scripts. She has also written a television screenplay (*Nocturne*). Siren was a lesbian politically oriented theatre company, which placed an emphasis on contemporary cultural issues. The company was founded in 1979 by Tash Fairbanks, Jane Boston and Jude Winter.

List of plays by Siren: *Mamma's Gone a-Hunting*, 1980, devised with Siren, scripted by Tash Fairbanks. *Curfew*, 1981, devised with Siren, scripted by Tash Fairbanks. *Pulp*, 1985/86, written by Tash Fairbanks. *Hotel Destiny*, 1987, written by Tash Fairbanks, and *Swamp*, 1988, devised with Siren.

The following is a quote from Siren in 1992: "Siren were established in a climate of the late 70's Punk explosion in the music scene and the growth of the Women's movement in the West. Siren developed a theatrical style which owed much to both. Work usually included the interweaving of live electric music,

visual humor and serious narrative to make pertinent political and social comments. In this way, the early plays drew their energy from the immediacy of street theatre techniques and the Women's Movement itself. The issues of women's oppression and resistance became the starting point for Siren Theatre."

Siren Theatre Company is now defunct, but a book of Siren's work is to be published by Harwood Press in the near future.

2. Tamsin Wilton, *Lesbian Studies: Setting An Agenda* (London: Routledge 1995), p. 174.

3. All the following interview sections are taken from an interview that Tash Fairbanks gave to Jan Goulden in London, June 1996.

4. See John Ellis, *Visible Fictions* (London: Routledge 1992), pp. 24-25.

5. Jean Genet, Gay *Sunshine Interviews*, ed. Winston Leyland (San Francisco: Gay Sunshine, 1978), p. 73.

6. bell hooks, "Choosing the Margins as a Space of Radical Openness," in *Yearning: Race, Gender, and Cultural Politics* (Boston: South End, 1990), p. 153.

7. Sue Ellen Case: Key Note Address, "Queering the Pitch Conference," Manchester, England, 1994.

8. B. Ruby Rich, "Sight and Sound" Number 41. Sept. 92, p. 32.

9. Pratibha Parmar, "Sight and Sound" Number 41. Sept. 92, pp. 34- 35.

10. Tamsin Wilton, *Lesbian Studies: Setting an Agenda* (London: Routledge 1995), p. 17.

11. Amy Taupin, "Sight and Sound" Number 41. Sept. 92, p. 37.

12. Lizbeth Goodman, *Feminist Stages* ed. Lizbeth Goodman, (London: Harwood, 1996) pp. 116-117.

13. Bonnie Zimmerman, "Lesbians Like This and That: Some Notes on Lesbian Criticism for the Nineties" *New Lesbian Criticism: Literary and Cultural Readings* ed. Sally Munt (London: Harvester Wheatsheaf 1992), p. 7.

14. See Baz Kershaw, *The Politics of Performance; Radical Theatre as Social Intervention* (London: Routledge 1992), p. 36.

15. Bonnie Zimmerman, "Lesbians Like This And That" *New Lesbian Criticism: Literary and Cultural Readings* ed. Sally Munt (London: Harvester Wheatsheaf 1992) p. 12.

16. It is interesting to note that Jodie Foster is rumored to have lost a starring role in a forthcoming film, as gossip hints she is about to come out as a lesbian.

17. Scene 16 *Nocturne* A Television Drama by Tash Fairbanks. Maya Vision, London. 1988 Unpublished Script.

18. "Pink Paper," 18 October, 1996.

19. Taken from an interview with Nina Rapi, 1995.

The Laugh That Dare Not Speak Its Name

Maria Esposito

SUMMARY. This piece is an exploration into the world of lesbian humor, lesbian comedy and the lesbian comedian. A brief look at the history of lesbian comedy shows us that it is definitely not a contemporary movement but has been around for well over a decade. How do we define lesbian humor and what is a lesbian comic? The answers to these questions are discussed with reference to my own performing career as a lesbian comedian in Britain. The difference between the lesbian comedian and the gay comedian is explained and examined along with the attitudes of acceptability in Britain toward gay male humor and the gay performer. But what does the future hold for the lesbian stand-up comedian and what of the introduction of lesbian characters into mainstream sitcoms? Lesbian humor will certainly not be going away, but it is finally finding its own niche in the big wide world of comedy. *[Article copies available for a fee from The Haworth Document Delivery Service: 1-800-342-9678. E-mail address: getinfo@haworthpressinc.com]*

Sexuality has always been a popular subject for comedians. Unfortunately most of it has been heterosexual with women cover-

Maria Esposito has been performing lesbian stand-up comedy for eight years. She has performed regularly at Pride UK, Pride Scotland, Glasgay, Queer Up North, Leicester Comedy Festival, May Fest as well as numerous gay clubs around the UK. She has also performed at Michigan Womyn's Music Festival and Spring Fest in the USA. She was the presenter for Channel 4's lesbian and gay series *Out* and is currently a comedy producer and director for the BBC.

Maria Esposito can be contacted via e-mail at maria.esposito@bbc.co.uk

[Haworth co-indexing entry note]: "The Laugh That Dare Not Speak Its Name." Esposito, Maria. Co-published simultaneously in *Journal of Lesbian Studies* (The Haworth Press, Inc.) Vol. 2, No. 2/3, 1998, pp. 157-163; and: *Acts of Passion: Sexuality, Gender and Performance* (ed: Nina Rapi, and Maya Chowdhry) The Haworth Press, Inc., 1998, pp. 157-163; and: *Acts of Passion: Sexuality, Gender and Performance* (ed: Nina Rapi, and Maya Chowdhry) Harrington Park Press, an imprint of The Haworth Press, Inc., 1998, pp. 157-163. Single or multiple copies of this article are available for a fee from The Haworth Document Delivery Service [1-800-342-9678, 9:00 a.m. - 5:00 p.m. (EST). E-mail address: getinfo@haworthpressinc.com].

157

ing the subject of not being able to get a boyfriend and men lambasting us with 'nob' jokes. The revolution has happened though and both lesbian and gay comics have emerged in abundance over the past 10 years.

HISTORY OF LESBIAN STAND UP

A couple of years ago at the Edinburgh Festival it seemed as if the whole of the female performing world was coming out, with Donna McPhail, Rhona Cameron and, from the USA, Lea Delaria performing lesbian material. This sent the heterosexual media hounds into a frenzy of excitement and horror, while the rest of us gay folk were going "yeah, well I could have told you that years ago!" Their reaction was one of discovering DNA or splitting the atom, but the fact of the matter is that lesbian humor was not born at Edinburgh 1994. Lesbian comics have been around a lot longer than Cameron, Delaria, and McPhail. My own introduction to lesbian humor was in 1987 with the American stand up Kate Clinton. Kate Clinton began performing lesbian stand up in 1981, playing in venues for mostly lesbian audiences. As she put it,

> I didn't want my life goal to be simply making straight people laugh.[1]

Like many before me the thrill at discovering a performer who was telling jokes about *my* lifestyle and performing with an attitude that I could identify with was inspirational. I had at that time just embarked on my own intrepid journey into the world of being a lesbian stand-up comic but it wasn't until hearing Kate Clinton that I felt brave enough to say "yes I want to perform *lesbian* comedy." And so in 1987 I returned to London and joined Claire Dowie as the only lesbians on the circuit doing lesbian material.

However, while showing respect and acknowledging the work of Kate Clinton, it has to be said that she was not treading an unmarked trail: the real pioneer for all lesbian comics is Robin Tyler. In 1970 Tyler, also American, was performing in a comedy duo with Patty Harrison and it was then that they helped develop the women's comedy scene. Tyler was already performing openly les-

bian material and, while acceptable in some clubs, others were not too keen. In fact she was actually thrown out of one club in LA for performing lesbian comedy. Tyler's biggest breakthrough though was in 1979 when she was asked to appear on *The Phyllis Diller Show.* This made her the first openly lesbian comedian to perform on national television. As Tyler says,

I was the first on the path.[2]

WHAT IS LESBIAN COMEDY?

But what defines lesbian humor and lesbian comedy? Firstly it is not exclusive to lesbians, straight people can laugh at it too, if they allow themselves. I can laugh at the comedy of Thea Vidale, Jackie Mason and Ardal O'Hanlon. I do not have to be black, Jewish or Irish to do so. In the same vein as the performers just mentioned, lesbian humor is about embracing a culture and who you are. For me being a lesbian has a very specific culture that goes along with it and that's what I make jokes about. I like to delve into that culture, explore the lifestyle and talk about how I see the world through my gay eyes. It is important for any culture to be able to laugh at themselves and for many years lesbians had been branded as having little if any sense of humor. I am sure we have all heard of the phrase 'lesbians against laughing,' a handy excuse for many a straight comic if they were dying on stage.

THE LESBIAN STAND UP

Over the past few years there has been much debate about what is a lesbian stand up comic. What actually defines a lesbian stand-up comic? Is it a comic who performs lesbian material or is it a comic who just happens to be a lesbian? Both of these answers are true. Personally I fall into the category of the comic who performs lesbian material and that is how I would define a lesbian stand up.

As important as it was for comics like Lenny Bruce to stand up and challenge the so-called unchallengeable, so has it been for the

lesbian stand up. It was indeed scary going out on to the straight circuit in London and going through the process of 'coming out' every night but I knew I was doing something important. However, after about two years I was very worn down by the experience and pretty much gave up performing in those clubs. 'Coming out' on stage, I found, would provoke a couple of regular reactions. The first would be a slight silence followed by a general feeling of acceptance, the 'right on' factor if you know what I mean. The second reaction would be silence followed by more silence and even more silence. Being young and naive I was truly shocked at the levels of homophobia that existed. I knew I still wanted to perform stand-up comedy and lesbian stand-up comedy at that but this was wearing me out and so I decided to start my own club. *Alice's Cabaret* was born in 1988, the second women's comedy and cabaret club in London. (The first, which had closed by then, was *The Cave of Harmony* at The Kings Head in Islington.) After Alice's came *Juicy Lucy's*. We now had places to perform regularly and develop the skills of a stand-up comic. It was important for me to carry on performing lesbian material because it wasn't being done anywhere else. I felt it was important to talk about being a lesbian on stage, and I realized, first and foremost, it was important for the gay audiences and then if the straight people want to join in that would be fine. Now my favorite audiences to perform to are not gay only, I like to have straight people there too, but when they are all straight it's hard to say "welcome to my gay world." Lea Delaria describes her aims for performing lesbian comedy thus:

> To provide gays and lesbians with the kind of role models that we didn't have. So some gay kid in Someplace, Minnesota, can look at his TV and say "Wow! She's gay and she's happy. She's on TV, I'm not such a bad person."[3]

The idea of being a lesbian has, over the past few years, had its moment of being high in the media as an extremely trendy and popular notion and lifestyle but when you really get down to it lesbianism in comedy is still a strange and unwelcome combination. It is still extremely hard to break onto the mainstream comedy circuit performing lesbian humor. There are lesbian comics on the mainstream circuit but few of them risk performing lesbian material

and have often built up a safe image of heterosexuality or at least ambiguity before attempting the 'L' word.

By the time I started performing, the 'right on' audiences of the Ben Elton era had begun to diminish and the comedy lager lout 'lad' audiences were emerging. They are still with us today and they can be fiercely homophobic; and that applies to the comedians too. The very last time I played a straight club (1995), the act to follow me, a straight man, went on stage with the opening joke of "all she needs is a bloody good shag and we're just the blokes to do it."

THE DIFFERENCE BETWEEN THE GAY COMIC AND THE LESBIAN COMIC

At this point it is important to emphasize and examine the distinction between the lesbian stand-up comic and the gay stand-up comic. This essay is written from the perspective of the lesbian stand-up comic which is a vastly different experience from that of the gay stand-up comic. The reaction and retaliation the straight comic had to my lesbian act I doubt would ever happen to a gay man in the 1990s. That incident highlights just how acceptable gay men's humor is in comparison to lesbian humor. Why, for these sometimes homophobic, but maybe more specifically anti-lesbian, audiences is being a gay man acceptable?

In Britain we have all grown up with an image of a gay comedy character. Just think about it. Julian and Sandy from *Round the Horn*, Kenneth Williams in *Hancock's Half Hour* (1954), Charles Hautrey in *The Army Game* (1957), as well as all his various camp characters in the Carry On films, Mr. Humphreys in *Are You Being Served?* (1973), Nausius in *Up Pompeii* (1969), *The Secret Life of Kenneth Williams* (1971), Mervyn Hayes's Bombardier Beaumont dragged up as 'Gloria' in *It Ain't Half Hot Mum* (1974), Duncan Norvelle, a comedian with the catch phrase of "chase me!", Jane's neighbors Rob and Michael in *Agony* (1979), Forbe's Mason in *The High Life*, as well as entertainers such as Larry Grayson all the way through to Julian Clarey and most recently the character of Constable Goody in *The Thin Blue Line* (1995). Even the ambiguity of Morcombe and Wise sharing a bed, the domesticity of Felix Unger in *The Odd Couple* and the femininity of Frank Spencer in *Some*

Mothers Do 'Ave 'Em all go to reinforce the acceptability of male homosexuality in British humor. This is a list of some nineteen characters and I am sure there are many more that I have omitted. But there has only been one openly lesbian character that I know of in a British sit-com, the character Cissy in *You Rang M'Lord.* I must point out, though, that while having lines in the show that clearly indicated her sexuality, the *Guinness Book of British Sit-Coms*, happy to list homosexual male characters, listed Cissy as androgynous.

The breakthrough for lesbian characters in sit-coms came with the introduction of Nancy, played by Sandra Bernhard, in *Roseanne* but even she had to be seen to have a history of heterosexuality before coming out. So it's no wonder that our comedy-club-going audiences are more accepting of the humor of Scott Capurro, Julian Clarey, Graham Norton, etc. It's *camp* and *camp* is an integral part of British humor. Even straight men know the catchphrase of Mr. Humphreys'!

However this is not so for Americans. The inclusion of a gay character still does create great controversy with the networks and advertising sponsors although this has been challenged, with much success, by *Roseanne* and, more recently, *Friends* in which there is a lesbian couple. But the problem is far from being solved as we can witness from the endless speculation in the press as to whether the character played by Ellen Degeneres, in her hit show *Ellen*, is to become gay. Will people still watch the show, the networks continue to ask. [Both character and actress have now come out and the ratings have soared. So, the networks can relax!]

LOOKING TO THE FUTURE

I do feel though that we are moving into an era in which lesbian comedy is becoming more acceptable. We have a long way to go but we have come far from the 'feminist lesbians with no sense of humor' era. There are many lesbians out there making millions of people laugh. However there are still too few clubs that are doing gay comedy. In fact the only gay comedy club in Britain at present is Screamers in Soho and it is a place you will be able to see the likes of Hufty, Ali Jay, Twinkle, and myself. Gay comedy clubs,

though, cannot be mentioned without paying tribute to Josie's Juice Joint, probably the most famous gay comedy club to date, based in San Francisco. You can be entertained there by lesbian talent such as Suzanne Westenhoeffer, Sabrina Matthews, Marga Gomez, Suzy Berger, Lisa Geduldig, Karen Williams, Lea Delaria, and Kate Clinton. So you can see that since Robin Tyler took that first step on that untrodden path many of us have joined her en route.

I have been asked many times if I regret 'coming out' and risking the potential to become successful by staying in the closet. Suzy Berger and Kate Clinton have very clear feelings about this:

> doing lesbian comedy is empowering–to take my life and perceptions, no matter how different, and know by their immediate laughter that I am understood and accepted.

> I know for myself it's been wonderful. I have to do it this way.[5]

I agree with them.

NOTES

1-3,5,6. *Revolutionary Laughter: The World of Women Comics*. Roz Warren, The Crossing Press, 1995.

4. *The Guinness Book of British Sitcoms*, Rod Taylor, Guinness Publishing, 1994.

Fo(u)r Women:
The Art of Collaboration

Adeola Agbebiyi

SUMMARY. This piece is about *Fo(u)r Women,* a collaborative poly-vocal performance piece featuring music, poetry, prose and movement. It traces the journey from feeling through idea to actualization of a collaborative creative project: how to make a piece of Live Art from the experience of listening to a Nina Simone song and three lives.

Dream, breath, hope, wish, act
a prayer to you to reach out to touch
Four women made flesh in a place of revelation . . .

Adeola Agbebiyi is a singer/songwriter of Nigerian and English heritage. Born in Toronto, she was brought up in the North and Midlands of England. After studying psychology and physiology in Oxford, she moved to London, where she now lives and works: singing, writing, and on performance projects that excite her. Adeola played the lead role of the Jazz Singer in the film *B. D. Women* (directed by Inge Blackman, produced by Cultural Partnerships 1994). She has released one album, *Crystal Visions,* on her label Shango Music and is working on a second.

Address correspondence to Adeola Agbebiyi, Flat 2, 147 Hertford Road, London, N1 4LR England (e-mail: adeola@shango.demon.co.uk).

Its creators plan to develop and perform *Fo(u)r Women* around the UK.

Quotations from the show *Fo(u)r Women* Copyright Adeola Agbebiyi, Dorothea Smartt and Patience Agbabi ©1996 and *Four Women* by Nina Simone copyright EMI Tunes Ltd. ©1970. All rights reserved.

Thanks to Dorothea Smartt, Patience Agbabi, Jillian Tipene, Catherine Ugwu and Lois Keidan at the ICA, Gareth Underwood, Birgitta Hosea, Babes and Horny.

[Haworth co-indexing entry note]: *"Fo(u)r Women:* The Art of Collaboration." Agbebiyi, Adeola. Co-published simultaneously in *Journal of Lesbian Studies* (The Haworth Press, Inc.) Vol. 2, No. 2/3, 1998, pp. 165-175; and: *Acts of Passion: Sexuality, Gender and Performance* (ed: Nina Rapi, and Maya Chowdhry) The Haworth Press, Inc., 1998, pp. 165-175; and: *Acts of Passion: Sexuality, Gender and Performance* (ed: Nina Rapi, and Maya Chowdhry) Harrington Park Press, an imprint of The Haworth Press, Inc., 1998, pp. 165-175. Single or multiple copies of this article are available for a fee from The Haworth Document Delivery Service [1-800-342-9678, 9:00 a.m. - 5:00 p.m. (EST). E-mail address: getinfo@haworthpressinc.com].

In the essay, I explore aspects of process, collaboration, critical context and issues informing the art. Issues of race, gender, sexual identities, relationships, love and place. Dear reader, for those of you at home, it's like you were there, all the time it was being made. But to feel the show, you really have to see it. *[Article copies available for a fee from The Haworth Document Delivery Service: 1-800-342-9678. E-mail address: getinfo@haworthpressinc.com]*

Fo(u)r Women is a collaborative polyvocal performance piece featuring music, poetry, prose and movement. Devised by Adeola Agbebiyi and written by Adeola, Patience Agbabi and Dorothea Smartt, it was first performed–as a work in progress–at The Institute of Contemporary Art, London, in May 1996. The piece explores identities and relationships pertinent to Black British women around the themes of 'Mother, lover, sister, other.' This is played out in the space created behind and between four empty old gold frames of diminishing size.

Fo(u)r Women is a

Dream, breath, hope, wish, act
a prayer to you to reach out to touch
Four women made flesh in a place of revelation . . .

1: DREAM

Patience and I are sitting in her front room. A huge painting of a cross in a blood red field hangs over us. Nina Simone's "Four Women" is playing:

My skin is black . . .

We both start on how much we like this song. I particularly love the bongo fills and the line: "I'm awfully bitter these days. . . ." Somewhere I haven't forgiven Sandra Bernhard for her "peaches" piece in *Without You I'm Nothing*; honest title if nothing else.

I am riding on a wave of consciousness, inspired by a new relationship with Lisa, a post-graduate student in the US. I have been unfreezing brain cells and nerve endings which have been in cold

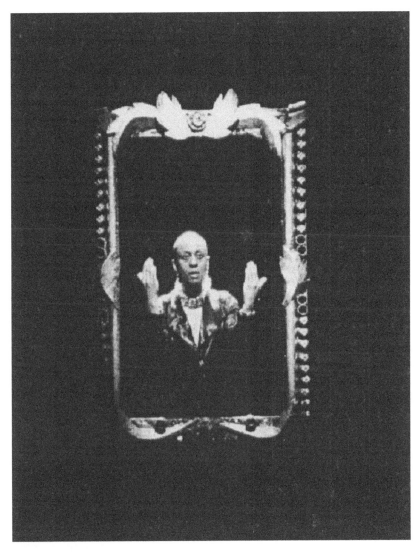

Patience Agbabi

Photo by Ingrid Pollard. Used by permission.

storage, never expecting to be used on topics like *my life*. As if that were a proper subject for study. And here I am, again, still reluctant–looking at the personal–that subtly Revolutionary Art.

Nina spit-sings: "They call me . . . "

In my head an idea crystallizes. It would be great to actually personify the women, bring them to life, only make them relevant to us–Black women in the UK. ('Cos even I had noticed that severe lack of representation of Black British voices by publishers and the media . . . a few Americans, some white people, Stuart Hall . . . ; The Chosen Voices.)

I wanted us to speak for ourselves. Our Four Women.

2: BREATH

Six months later, I take a big breath and call Patience and Dorothea Smartt and ask them to be in a show called *Four Women*. They say yes. Another breath. All I know is we will write it together and it will be about whatever we want it to be, based around our identities–I have not heard nearly enough about all the different Black British experiences and I have spent too long living other people's definitions of myself, conservative white male definitions, blinkered white socialist-feminist definitions, fetishizing white lesbian definitions.

I also know that the piece will feature music, ideally as a skeletal structure like the bassline holding Nina's song together. It will be funded. Parts will be polyvocal, some pieces will already exist. I have a grand three-act plan: act one: introductions and statements of identity using pre-existing work; act two: improvisation around themes–whatever it is we get to talking about when we Black folks meet up; act three: resolution.

By minimizing our obvious differences, we are all Black and our primary relationships are with women, we should be able to explore the deep and subtle differences that get obscured by discussions of the obvious: gender, sexual orientation, etc. I do not include race, as too often in Lesbian pieces, issues pertaining to race are treated either with pitiful superficiality to avoid wounding the feelings of the majority or with ferocious and unexplained rage which fails to engage the minds of the majority. I want us to deal with things like

where we feel culturally attached or rooted, forms of expression, languages, preoccupations. Our Four Women issues.

We all meet at First Out Cafe. Everyone is excited and has ideas. Lisa gives us the 'post modern' fo(u)r women. We consider calling it Fur Women for a while, a hymn to sensuality and fake fur. . . . We decide to apply to the ICA for a commission and to meet later in the year. It is April 1995.

3: HOPE

I write our proposed outline for the ICA. No commission is offered, but we do get offered a Ripple Effect slot in September. This is way too soon. We are all variously busy. Everything is put off until early '96. Meanwhile, as Lisa is in the US and we have a weeny budget, we look for a British Fourth Woman. Two come and go in the twinkling of an eye. I decide it's fate and to leave the piece with the three of us. The fourth woman's place becomes a space for us to play with. Whoever she is, our projection, the empty chair at the dinner, the future, the past, the space around a partial commitment, potential, the dead, the unborn, whatever!

4: WISH/ACT OR "I NEED TEXT"

The ICA give us a date: May 20th, 1996. We are all busy until March and resolve to start writing then. Meanwhile we have a series of get-to-know-you meetings. We have appeared together but never created together. I am the only one never to have collaborated, being off in my solo world with my "I don't need no one but my guitar" attitude. It is immediately obvious that three acts is a bit of a big mouthful, so we settle for what we can write and pull together in 8 weeks.

So far, we have met about three or four times and so far no concrete written work has appeared. I am well scared. I have been calmly confident that it will all be fine, but I find it hard to hold onto the fact that it is all possible. We have already sorted the publicity, something which gave us all pause. I have written a piece of PR blurb and sent in to the ICA without even having a show written!

March: Crunch meeting. We have eaten and supped, chatted and shared again. Now we must write. We have all brought pieces and ideas to share. My central idea is around "I know my name"; an unwritten song/chant that's been hanging around in my ideas book for years. Dorothea has some rarely performed pieces on family themes, and a poem about skin/shade issues in Barbadian nation language. Patience has two killer ideas, one about an ex, "Snow Queen," the other an identity piece. It had become clear to us that actually we none of us had any "I am a . . ." pieces. All of the introductory identity will need to be written.

We plan out all our meetings between now and the performance. There will be about ten. A couple of days later, Patience leaves "The Snow Queen" on our answer phones. Its a killer: bitter, passionate, full of her word play. It features two of my songs. I decide to rearrange one, "Crystal Visions," to make it brighter, harder, dancier.

I am in the throes of ending my relationship with Lisa, sudden, awkward and unpleasant. I look at my obsessional attachments and the "I don't want this, I want *that*" issues: "For You," a poem, emerges.

Now, I am not a poet. At our next meeting I cringe with shyness offering items up for approval and as quickly withdrawing them. This is bugging Patience. Dorothea is being totally cool about the: "Oh, this takes time . . ." process. We flesh out a kind of set of ideas. Before our next meeting, Patience insists we have text.

So there we are at Patience's house, rice and fish, Nigerian chilli and . . . text. Like the feeding of the five thousand we are pulling a show out of a few ideas and some pieces of paper. We thrash out a structure. Now we have a show.

It is clear where our polyvocals need to go and what they might be about. Using a minor key 12-bar bassline as a springboard; "My skin is : . ." takes shape, "I know my name" will come at the end and we need a title piece. We have four weeks.

Round to my house to my work room. I set up my mike in the room and we walk around it while my computer plays beats and bass lines. We tape everything. We squeak, we beat rhythms on our chests, we swear, curse and get inspired. Round and round in circles

. . . round and round and round we go. Like a child's birthday party we all take home samples of the cake; only these are taped.

Fo(u)r women . . .
My skin is . . .
I know my name . . . doesn't get a look in.

Three weeks to go and we call in Jillian Tipene, the director. More brainstorming about a set–something I had barely thought about–frames and mirrors is all I know: a door frame Patience can walk through in "Snow Queen" to a new dimension; mirrors to reflect ourselves and the audience. We meet Gareth the designer at the ICA on the night Franko B is letting out half a unit of his blood onto the stage floor. The idea of four frames, gold, in receding perspective, emerges.

From here, we meet about four or five more times, rehearsing, learning lines, writing entire pieces. We block the show out in dusty rehearsal rooms, chanting, declaiming, forgetting and revising.

The weekend before the show is crazy. I spend two days running around with Gareth buying wood and paint and sticking bits of frame together. Saturday, we will spend at Birgitta Hosea's studio in Wapping, making frames. It's like Blue Peter except with a stunning absence of the one prepared earlier. The set has expanded to fill time and space in a truly remarkable way. It looks great, which almost makes up for the fact that I am seething with resentment against it and making a note to learn how to delegate better!

5: A PRAYER TO YOU

The show goes off really well. The house is full and appreciative. The piece holds together and lifts into a higher gear about half way through. The jokes in my identity piece get laughs, there is enough music, we all look great, the lighting and sound is good and although a few lines go astray here and there, and Patience's radio mike falls off when we are being dramatic out in the audience; it is pretty damn fine for a first outing.

We had a Question and Answer session after the show.

6: *TO REACH OUT*

I had been guarded, expecting some negative feedback, and none came. The majority of the feedback was high on seeing the likes of us doing and saying the things we did, on the quality of the poetry, how we looked, the enjoyability of it all, the value of having our stories/voices up and out there and please do it again. I had been expecting to be asked about form or content, but we weren't.

I thought about this two weeks later as I went to see Olamide Pratt's film *Illuminations* at Goldsmith's College. Also about Black UK women and creativity; it featured people I knew and my first responses were associated with: "Ooh that's x. Doesn't she look good/come over well" and so on.

I went home and thought long and hard about my lack of a critical context for these occasions. Some of the lack is very much associated with not seeing very much other stuff around to compare, where appropriate, and being close to the material. Dazzled by novelty. Other areas of difficulty lie in the funding. We had some funding and sold out a one off night so weren't totally reliant on box office/bums on seats commercial feedback (which in any case doesn't provide immediate detailed criticism). I am also used to filtering things through an American perspective and neither *Fo(u)r Women* nor *Illuminations* had an American perspective. We are part of a growing body of lesbian-relevant, personally honest Black British performance/art.

7: *TO TOUCH* FO(U)R WOMEN

Fo(u)r Women is not defined by us as Lesbian Art, despite having some very up front textual lesbian elements. The reason is that the piece is not exclusively Lesbian. It is personal, referencing issues of identity, attachment and vision for and from three Black British women who are or have been placed in a lesbian social or relation-ship context. We are wary of the Lesbian tag. For some peculiar reason, the label 'Lesbian' (and Gay) like 'feminist,' 'woman,' 'man' get used as though they refer only to white people. This thinking has been used by both Black and White groups to exclude Black people from any Lesbian and Gay community (such as it is)

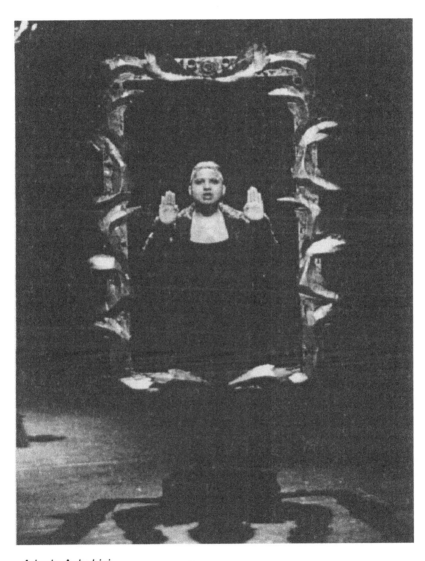

Adeola Agbebiyi

Photo by Ingrid Pollard. Used by permission

or to exclude Lesbians and Gays from Black communities. This is clearly nonsense. The labels should be racially neutral, but are no longer. With *Fo(u)r Women*, we are not concerned with being represented within or of a community but with defining our own agendas, exploring our own issues, in our own terms. In addition, the tag of Lesbian Art or Performance Art may be read by viewers in a way which would cause them to have expectations and pre- judgements of the piece which would not be realized.

Fo(u)r Women is a work in progress, in it we discuss our relationships with ourselves; mothers and family; potential and ex-lovers and Britain; from our particular perspective. Its context is unashamedly female, feisty and erotic. The language currently used is standard English and Barbadian, the music takes contemporary Black British (junglist, soul), African, and British Establishment (Westminster chimes) elements to explore the themes and variations of the piece. The text speaks of us as we are experienced by others and as we experience ourselves; as we are and where we find ourselves. It is personal. Our most visible 'issue' is our Blackness. We may talk of :

> Clit licking, nipple piercing,
> sassy walking, ass slapping,
> woman loving, woman fucking,
> butch, femme, switch.

But we speak as well of dislocation and alienation within a British culture pickled in its colonial racism:

> I've learnt the language, read the VDU
> and watched the video twice. Mother Earth
> do you read me? Why then stamp my passport
> ALIEN at Heath Row? Did I come third
> in the World Race? Does my iridescent
> sky-blue-pink skin offend you, mother?

and from "homelands" where we don't fit, or are subject to the tyranny of a post-British Colonial pecking order of: "black? brown-skin? highbrown? red? yellow?"

It is the exploration of 'mother,' 'lover,' 'sister,' 'other,' our lives, not the labels, which are our context.

Fo(u)r Women is about stretching and pushing out from self-defining centers. It is about communicating our lives and thoughts. It is Live Art. If labels like 'Black,' 'Lesbian and Gay Community' and 'British Citizen' stretch to warmly embrace us all in our glorious fullness–great. Our priority is to write and perform honestly, craft and share our work in a way that affects people from the inside out.

It's Queer Up North:
Production Values:
Sarah-Jane Interviews Tanja Farman

Sarah-Jane

SUMMARY. It's Queer Up North is a British national arts organiza-
tion which promotes international queer work during a high profile,
biennial festival of the same name. It has been running since 1992
and has been increasing in prestige and scope with every festival.
Here, Sarah-Jane interviews Tanja Farman, its co-director, raising
important questions regarding the mainstreaming of lesbian and gay
work, censorship, programming of lesbian work, targeting of a les-
bian audience, and the power and influence of funding/sponsorship
on the selection process, content and aesthetics. *[Article copies avail-
able for a fee from The Haworth Document Delivery Service: 1-800-342-9678.
E-mail address: getinfo@haworthpressinc.com]*

*It's Queer Up North is a British national arts organization pro-
moting international queer work during a high profile, prestigious*

Sarah-Jane is the editor of the on-line subcultural magazine *Freakscene* (Web
address: http://www.geek.co.uk/freak). She is also a writer and freelance arts
journalist whose reviews have appeared in *The Pink Paper, The Face, Headpress,*
and various listings magazines. Based in Manchester, she dreams of living in New
Orleans or New York City. Amongst her passions are movies, comics and music.
She is in love with a disillusioned, dark angel called Emma.

Address correspondence to Sarah-Jane, 172 Oswald Road, Chorlton, Man-
chester, M21 9A2, United Kingdom.

[Haworth co-indexing entry note]: "It's Queer Up North: Production Values: Sarah-Jane Interviews
Tanja Farman." Sarah-Jane. Co-published simultaneously in *Journal of Lesbian Studies* (The Haworth
Press, Inc.) Vol. 2, No. 2/3, 1998, pp. 177-186; and: *Acts of Passion: Sexuality, Gender and Perfor-
mance* (ed: Nina Rapi, and Maya Chowdhry) The Haworth Press, Inc., 1998, pp. 177-186; and: *Acts of
Passion: Sexuality, Gender and Performance* (ed: Nina Rapi, and Maya Chowdhry) Harrington Park
Press, an imprint of The Haworth Press, Inc., 1998, pp. 177-186. Single or multiple copies of this article
are available for a fee from The Haworth Document Delivery Service [1-800-342-9678, 9:00 a.m. - 5:00
p.m. (EST). E-mail address: getinfo@haworthpressinc.com].

177

festival. SARAH-JANE interviews TANJA FARMAN, its artistic co-director.

SARAH-JANE: How did It's Queer Up North surface? Can you give me a brief history of the festival and its origins?

TANJA: It's Queer Up North started in 1992 when I was still working at the Green Room and (my partner) Gavin had just left to work at the Contact Theatre. We did the first festival as part of my work there and then, more independently, we did festivals in 1993 and 1994. After the 1994 one we made a conscious decision to miss a year and become biennial, which brings us to 1996 and the end of the last one.

SARAH-JANE: Which events were the most popular this year and why do you think that was?

TANJA: The fact that the most popular shows were those that featured (and focused on) nudity says a lot about gay male culture and that *can* be used as a useful marketing tip, something to keep in mind when we program things in the future. I would like to say, however, that nudity is definitely *not* something we see as a priority, and as a lesbian spectator, I personally find male nudity very boring. Sometimes it's relevant to the piece and therefore interesting, but to have it there for the sake of it . . .

SARAH-JANE: At several events I went to this year I recognized the same faces, a large percentage of them being other performers, journalists, etc. How have you and Gavin gone about targeting an audience for the festival?

TANJA: We try to target as wide an audience as possible and I think the brochure is our main marketing tool. We also have individual flyers for specific shows and we distribute these at the theatres, bars and places we feel most relevant. One of the problems we have found ourselves facing is how to target an audience for less mainstream shows and performers, like John Kelly or Marisa Carr. Really the more mainstream and popular the performers are, the more tickets we sell. This might turn out to be a problem or it might

not, we're not really sure yet. I suppose it does conflict with our ideals in some way, as one of our aims is to commission daring new work by radical performers. What will happen? We hope that more and more people will begin to attend the festival, allowing us to present both mainstream and alternative performers.

SARAH-JANE: Have you felt content with the number of lesbians in the audience and how have you attempted to target them?

TANJA: We've tried very hard to target lesbians in particular, especially for dyke shows like The Go-Go Girls and Lois Weaver. What we've found is that it's much more difficult to target lesbians as a lot of the time they're more invisible than gay men. We still distribute flyers wherever we think there are lesbians and we keep a mailing list of dykes who attended our previous shows. A really good way to attract lesbians is obviously through the press, through *The Pink Paper, Everywoman, Diva* and other publications. What we have found is that dykes will pay to see familiar or well-known performers like Lois Weaver or Helena Goldwater, but it's harder to tempt them to see performers they've never heard of. Club Swing was incredibly popular and that was most probably because they were from Australia and therefore they were a specialty. The press releases and features on Club Swing were also very sassy and daring and the women tapped into that! Regarding targeting lesbians in the future, we'll hopefully find new ways and ideas because there's certainly room for improvement.

SARAH-JANE: In the last It's Queer Up North program and in interviews with mainstream style magazines like The Face, *you clearly indicate that the festival is for everyone: gay, lesbian, heterosexual, etc. Is this because It's Queer Up North aims for a more integrated audience, or is there a practical reason, like, keeping the festival afloat financially?*

TANJA: I guess the answer is a bit of both really. On a practical level, we cannot survive without a certain amount of sponsorship and ticket sales. Our funding criteria are also really strict, so we *have* to make the festival attractive to a large cross-section of people. The funders and North West Arts Boards acknowledge that

we are primarily a gay and lesbian festival but they also insist that we appeal to everybody. It's a difficult situation but the simple fact is, as an organization we wouldn't exist without funding money or the money of straight consumers. We need that income to survive.

We want the festival to have a wider audience anyhow. One of our main aims has always been to educate, entertain and enlighten *everybody*. We hope that we are putting on some of the best queer work around, work which we feel deserves as wide an audience as possible. Why shouldn't heterosexuals be introduced to stunning artists like Robert Pacitti and Helena Goldwater? For a mixed audience to understand and appreciate the queer aesthetic is something we both feel very positive about.

PROGRAMMING STRATEGIES

SARAH-JANE: Do you think you would succeed better if It's Queer Up North wasn't so visibly queer? For example, would you be more secure financially if you decided to call yourselves "Theatre Up North"?

TANJA: I certainly wouldn't be involved in anything that was more like the Mardi Gras, a jamboree appealing to everybody without so much of a mention of gays and lesbians. Obviously we'd be more successful if we presented ourselves as less queer but we'd hate to do that. We have secure roots in what we do, we've both worked in the theatre for a number of years now and we both have strong ideas about gay culture and what we want to promote. The Mardi Gras this year was sponsored and plugged very heavily by a wide range of sources because it was seen as a good tourist attraction: it was plugged as something like the Notting Hill Carnival and therefore generating a lot of money for Manchester as a city. Similarly, Manchester Airport sponsored us this year because they realize that the festival brings an awful lot of people to Manchester; people come from all over to see or participate in It's Queer Up North.

One of the problems is that all marketing is expensive and to promote ourselves as a national and international festival takes a large amount of income. We can't compete with something like the Mardi Gras, no arts festival can because no arts festival deals in

large numbers. We all keep going but we never make a fortune! To answer your question more directly, yes, if we were a diluted, cross-over, less gay, jamboree-type festival, then we could probably achieve far greater success, especially concerning sponsors. If we played down the name of the festival or omitted it all together, we would probably have a more mainstream audience and a lot more money *but* that would mean putting on different performers, ones that were more mainstream and popular themselves, and that's not what we want to do.

SARAH-JANE: What do you think is the difference between It's Queer Up North and other festivals like Freedom Arts in London?

TANJA: The essential difference is that a lot of other festivals like Freedom Arts are used as an umbrella: they put on work which has already been shown at other venues, or they work as a springboard for specific theatres like Barclay's New Stages or the ICA. With the exception of *Edward* at the Octagon Theatre, It's Queer Up North independently produced and paid for all its shows and performers. We try to commission and present as many new shows as humanly feasible. This year we commissioned new work from Robert Pacitti amongst others, knowing that the festival would be showcasing his company's show first, before any other venues anywhere in the world. We also collaborated with the Sydney Gay and Lesbian Mardi Gras, bringing Australian performers to Manchester and introducing an international flavor to the festival. We hope to show-case more international work and more collaborations at future festivals as Club Bent and Club Swing were amongst the most popular shows. On the whole, we also want to present and support radical, queer, cutting-edge work; work that isn't shown anywhere else.

SARAH-JANE: Why is the festival biennial?

TANJA: We want to allow ourselves time to recover from the last one and, of course, to plan and research the next one properly. If we want to collaborate with anybody or we want to present interna-tional artists, all of that takes a lot of time and resources. In order to commission new work and new artists, Gavin and I have to travel

and research the arts and theatre circuits, we have to see what's happening, see what we might be missing out on. We also have to collaborate with venues and technical assistants, where would we put on that specific act? All that has to be thought about and planned before we even go about getting the money together! Sometimes it takes a year to sort out the grants and fine details for one particular artist.

SARAH-JANE: How do you go about selecting the program and particular performers? Do you invite performers to submit work or do they apply to you for a show?

TANJA: It's a combination of the two, really. Artists approach us with proposals and we try to see as much new work as possible and then invite the performers we were most impressed with. Our main priority is to actually look at innovative work that would fit well into a queer festival. We have to make sure we get a balanced program; some cutting-edge queer work, some lesbian work, some gay work, etc. Obviously we never get to see as much work as we'd like to, even if we're taking regular trips to London, Glasgow, Edinburgh, etc.–there just isn't enough time and money.

SARAH-JANE: Do you have a particular theme or intention when you develop each program?

TANJA: We are funded by North West Arts Board so we do have to actively promote some Northern artists but, other than that, it's really up to us as an organization. It's important to us that we include more international work and more radical work but as far as themes go, we never really plan one. Sometimes themes develop or emerge, but we've never particularly developed one. This year's festival had a lot of performers and shows focusing on AIDS and HIV, but I wouldn't say that AIDS was this year's central theme. We welcome diversity regarding both themes and performers.

SARAH-JANE: 1994's It's Queer Up North festival featured Karen Finley, who has suffered a great deal of censorship and controversy in the U.S. Did you experience any difficulties when trying to program her show and exhibition?

TANJA: When we programmed her work we suspected we might have difficulties . . . yet none of these ever surfaced. I wanted very much to program Karen as I had seen one of her solo shows at the Green Room and found it totally engaging. It was one of the first pieces of 'performance art' I'd ever witnessed and it was brilliant, she had the audience intimidated and frightened and ecstatic. I knew there and then, after the show: *I want to be involved in promoting Karen's work; I want to see more of it.* We were lucky in that the Cornerhouse was very good to collaborate with and whilst we focused on Karen's show, they organized and presented her installation "Written in the Sand." I have a huge amount of respect for Karen's work and she now writes to us with details of her new shows.

To be frank, we've not really had any problems regarding programming or censorship with anybody. It might be a problem in the future, if we attempted to put on some of the more radical performers from places like San Francisco. Somebody like Annie Sprinkle might cause a bit of a problem too, but only regarding public response and how sex-positive people are. If we tried to put on Annie or somebody similar to her, we'd obviously try to program her in relation to other performers and work on 'the body' or 'exploring sexuality.' It's hard to predict how an audience will respond to certain performers and their work; they might be ready for it and they might not. I'd like to think they were ready for anything!

FUNDING

SARAH-JANE: Do you think that in the future there will be a lot more censorship surrounding transgressive work?

TANJA: As far as I know, the only place that has ever managed to actively promote really radical/queer work is the ICA. Obviously they suffer censorship again and again, but the reason they remain promoting queer work is because they're already established and they have a lot of support, from artists and a large queer audience. For us or another arts festival, it's like starting from scratch–you have to win over the arts boards and the arts council, you have to ignore and not be discouraged by the homophobia you'll encounter.

I do think that at the moment people are sustaining themselves at

a certain level of tolerance, and I don't think it's a situation that will stick. I feel almost certain that there will be change for the worst, that both promoters and performers will be hit by censorship, that the 'rules' will become unbearable. I imagine that it will take a few years coming but there will be a backlash.

SARAH-JANE: What is the funding and sponsorship situation for lesbian performers, and what difficulties have you discovered?

TANJA: I think that funding for any queer performer or theatre group is hard enough but that it's definitely harder for lesbians than it is for gay men. There isn't a deep enough understanding of lesbian work and what lesbian performers are trying to achieve. In comparison, there's a vague understanding of gay male work but it's a very superficial one: nudity, the body, AIDS, etc. More and more funders are aware that gay culture is bigger than ever and it's in their interest to support gay work and gay plays, but lesbian work? *What is it? Who, if anybody, is at the center of the lesbian performance circuit? Are there any lesbian issues?*

SARAH-JANE: I know that certain lesbian/bisexual performers like Marisa Carr have great difficulty finding sponsors precisely because their work is deemed too political, radical or confrontational. Do you think gay male performers get more support than lesbians and are therefore programmed more?

TANJA: Gay plays are relatively safe investments for funders, especially with the economic climate and the media obsession with the Pink Pound. Sponsors aren't interested in paying out money to people who are on the fringe, they want to back someone who will become big and successful, which is why Robert Pacitti has had so much support. Funders just don't have a clue how to even go about looking at and dissecting lesbian work, especially if the work is radical lesbian work. Partly this is because lesbians are a lot less visible in the theatre and in society, whereas gay men are associated with drag, camp and lots of other things. It's much harder for lesbian performers to gain sponsorship as well because they'll probably never become mainstream. In order for lesbians to find sufficient funding and to get more support we have to re-address certain

issues and we have to educate funders and promoters. If promoters support lesbian work, it might finally be taken seriously.

SARAH-JANE: Have you come across complications involving sexism, homophobia and censorship, either regarding yourself or your performers? For example—the "Brenda, HIV and Me" exhibition at the Cornerhouse was slammed and criticized in every paper there is; it incited people enough to protest it should be withdrawn, etc. Obviously the majority of this was reactionary nonsense but it was still very frightening to realize just how intolerant and prejudiced people still are about sexuality, gender and AIDS.

TANJA: We have had snide bits of press and occasional nasty remarks but we weren't attacked in the way the exhibition was, by either the media or our audience(s). What we have had is a Tory Councillor outraged by our funding, and press cuttings about that: "Gay Arts Festival Sponsors AIDS Work," that sort of rubbish. The only way we've encountered a great deal of homophobia is through anonymous letters and threats, some of them pretty nasty. I suspect that as we grow as an organization our profile will become more public, *then* we'll suffer from homophobic attacks.

SARAH-JANE: How have you developed and maintained relationships with sponsors, Arts Boards, venues and promoters?

TANJA: We've maintained excellent relationships with the places and the people we worked with before. We have also worked very hard at communicating and forming links with other people, trying to do things efficiently and to the best of our abilities.

The good thing is that people do see It's Queer Up North as a respectable and groundbreaking company, so they *want* to be involved with us. We now have people phoning up eighteen months in advance saying they'd like us to use their venues, or start working on a project with them. We've had a lot of financial support from North West Arts Board but obviously not enough. They've also been great verbally, a lot of patting on the back and words of praise. For the first time this year we actually got support from the Council but we're still struggling with money.

AIMS AND FUTURE DEVELOPMENTS

SARAH-JANE: Do you feel you have achieved a lot of your original aims?

TANJA: I think we have in that we've done what we wanted to do: we've become a national arts organization promoting queer work. We've also introduced more of an international slant and we've now started our own commissioning program. For this festival we commissioned three or four different artists and we definitely hope to maintain that. Club Bent was an important part of the festival and it will hopefully give some of our Mancunian artists the chance to go over to Australia and perform in some context at the Mardi Gras.

SARAH-JANE: Where and how could It's Queer Up North develop and progress?

TANJA: We need to raise an awful lot more money so we can commission and develop new work that is unique to It's Queer Up North. We need to support less-recognized artists, too, especially those in Manchester and Merseyside. We do realize quite clearly, however, that it's not our sole responsibility, that others have expected certain things of us that *weren't* our original aims. People expect you to be responsible for local, national and international queer artists and that's an impossible expectation.

SARAH-JANE: What does the future hold for Queer arts and lesbian performers?

TANJA: To begin with, the emergence of a new monthly club night called Gag, which will be along the lines of something like Duckie's in London. It'll be a low-key kind of affair with performers like Helena Goldwater and Divine David and music like retro and indie. As for the rest of queer arts . . . I desperately hope that it will improve and flourish. Programmers and promoters need to wake up and take an interest in queer arts because unless we reach a higher level of recognition soon, there will be a backlash. The queer community needs to wake up too and start watching what talent is there, in *their* community!

PART FOUR:
WRITING THE SELF
IN PERFORMANCE:
FEMMES AND BUTCHES,
DRAG QUEENS AND KINGS,
VAMPIRES AND CLOWNS

Performing Butch/Femme Theory

Lois Weaver

SUMMARY. This paper is a description of a performance workshop that is designed to give the language of the butch/femme theory a ride. Using theatre exercises and performance techniques that put the terms butch and femme onto the actions of the body, the writer hopes to encourage both an irreverence and a respect for the arbitrary

Lois Weaver has been a founding member of the international touring theatre company Split Britches for more than fifteen years. She has also performed with other theatre companies, including Spiderwoman and Bloolips and has acted in various films, including *She Must Be Seeing Things*. She is currently teaching Contemporary Performance Practice at Queen Mary and Westfield College, London.

[Haworth co-indexing entry note]: "Performing Butch/Femme Theory." Weaver, Lois. Co-published simultaneously in *Journal of Lesbian Studies* (The Haworth Press, Inc.) Vol. 2, No. 2/3, 1998, pp. 187-199; and: *Acts of Passion: Sexuality, Gender and Performance* (ed: Nina Rapi, and Maya Chowdhry) The Haworth Press, Inc., 1998, pp. 187-199; and: *Acts of Passion: Sexuality, Gender and Performance* (ed: Nina Rapi, and Maya Chowdhry) Harrington Park Press, an imprint of The Haworth Press, Inc., 1998 pp. 187-199. Single or multiple copies of this article are available for a fee from The Haworth Document Delivery Service [1-800-342-9678, 9:00 a.m. - 5:00 p.m. (EST). E-mail address: getinfo@haworthpressinc.com].

nature of a language that attempts to define identity. *[Article copies available for a fee from The Haworth Document Delivery Service: 1-800-342-9678. E-mail address: getinfo@haworthpressinc.com]*

THEORY INTO PRACTICE

- *Performing:* carrying into effect; executing; acting; singing; doing tricks as in the case of animals; creating a fuss, a scene, a public exhibition.
- *Butch:* masculine; tough looking; a mannish woman; a mannish lesbian.
- *Femme:* no definition in the dictionary.
- *Theory:* system of ideas explaining something, especially one based on general principles independent of the particular things to be explained.

In live performance, language rides on action. In theory, language lives on the page. The following is a description of a performance workshop that is designed to give the language of butch/femme theory a ride. Using theatre exercises and performance techniques that put the terms butch and femme onto the actions of the body, I hope to encourage both an irreverence and a respect for the arbitrary nature of a language that attempts to define identity.

The workshop consists of techniques that I have used with the Split Britches Theatre Company to create material and to develop performances. It is an impulsive and associative approach to performance that is designed to complement but also challenge the cognitive approach to traditional acting and playwrighting. It makes room for the illogical, the nonlinear, the unpredictable and encourages a tension between language and action. In other words, you don't always have to do what you say. These techniques are geared toward independent performance artists who create and perform their own material but they can also be useful to actors and directors working in a more conventional setting. The workshop includes impulse exercises based on sound and movement, word association games, character building and improvisation techniques and creative writing exercises. These techniques are tools that can be used to develop theatrical material from themes or to deconstruct classi-

cal texts but they can also be applied to the language of theory in order to bring that theory into the body of practice. They are designed to bring a playfullness to the creative process. In this workshop I will apply these techniques to the terms Butch and Femme in order to create new material, perform new characters and put some fun into the exploration of gender identity.

Although this work is based on past workshops like *Performing Theory,* which was presented at the Queering the Pitch Conference in Manchester in 1995, it is written in the present as if the article itself were the workshop. You are the reader and the participant. You are sitting at a desk or in a chair so that the words can pass from the page to you. You are standing in a circle and can pass images, impulses and objects to other people in the room. You have on comfortable clothing so you can move freely through both body movements and gender roles. You are male, female or transsexual, hetero or homo, reader or writer, practitioner or theorist, actor or non-actor. This is a workshop for anyone. It is a way to create performance, a way to act out theory but mostly it is a way to stretch out your gender imagination.

ANY QUESTIONS?

- *Personal:* relating or peculiar to an individual and her private affairs
- *Professional:* following an occupation as a means of livelihood rather than a pastime or sport
- *Mundane:* common; ordinary; secular; temporal; worldly; terrestrial; earthly
- *Profound:* intellectually deep

I always begin a workshop by requiring everyone to ask me one question. Ask and I'll answer as honestly and as quickly as I can. I'll give you my first response. That's the basic principle of this work. Your first response is your most original response. When you take time to search for the most original idea you usually come up with the most habitual. Ask me the first thing that comes to mind. Any question. It can be personal or professional, mundane or profound. This is an opportunity to put the teacher on the spot and to

reinforce the idea that there are no right and wrong answers, only a willingness to play. For all you know I could be lying. So, one question from everyone. What's your question?

"Is that your natural hair color or is that too personal?" Although I like to think of myself as a natural born blonde femme, this is not my real hair color and no, that is not too personal. Besides I like personal. I think that is the difference between contemporary performance and conventional theatre. For me, contemporary performance is personal the way painting and sculpture are personal. It reflects the experiences, politics, aesthetics and personality of the writer who is also the performer. Also one of the ways I differentiate performance from naturalistic theatre is the ability to see the personality of the performer through the veil of the character. So for me as an independent performance artist the personal is essential. I like to see the roots, to see that the character's hair color is not necessarily the performer's natural color.

"Do you think someone has to identify as either butch or femme? Can't you be somewhere in between?"

Gender identity is different from sexuality. In other words, like the tension between language and action, you don't have to *do* what you say or *be* what you look like. For example, you don't have to be a lesbian to be butch or femme and you don't have to be butch or femme to be lesbian. For me, butch/femme is like a barometric scale. It's a measurement. It indicates the weather, it isn't the weather and you could fall anywhere on the barometric scale. And because we are working in the theatre we have the freedom to play with the scale. In *Persistent Desire*, Joan Nestle talks about butch/femme as a product of the lesbian erotic imagination. Sue Ellen Case describes butch/femme as lesbian sex toys. Both of these ideas indicate a sense of play. In this workshop I'll encourage you to use your erotic imagination to play with ideas of gender. Butch and femme are words that give us some distance from the ideas of male and female. They are words that allow us to play with character representation without being confined to the biological definitions of male and female. It's theatre. We can play without having to count chromosomes and account for hormones. We can both clarify and subvert the representations of gender on the stage. So my

answer to that question is: Take what is useful and necessary and *play* with it in order to make it *work* for you.

Next question? And so on around the circle.

FREEING THE ASSOCIATED LANGUAGE

- *Association:* a mental connection between ideas
- *Passing:* transferring from one person or place to another; be accepted or currently known as
- *Censor:* an impulse which is said to prevent certain memories from entering into consciousness
- *Image:* a mental idea, an idea or conception, a representation of an external form of an object

Think of language as something you can pass around like an object. In fact, would someone give me something from their pocket? What is it? A key ring. Pass it around the circle. Passing is an action we'll use repeatedly. As the key ring gets to you, say the first thing that comes to mind. So the key ring becomes a key, a door, a gate, a toothbrush, a movie ticket, a parallelogram, a rhinoceros. Pass it around the circle several times. Notice how the language rides the action: how the association gives meaning to the object. That is how we will approach language, as a raw element of performance. It has its own meaning but can also be freed of that meaning by providing it with different actions, intentions, objects or associations.

This isn't easy. What gets in the way? The censor. The editor. The explorer ever in search of the original idea, forgetting the meaning of the word original. We use the censor to protect us from the fear of appearing insane, obscene, boring or, worst of all, politically deficient. I prefer the word deficient to avoid using politically correct and/or incorrect. Like with butch/femme, we all occupy different places on that scale.

Exercise 1: Word Association

Dislodge the censor by doing some simple word association. Stand in a circle and one after the other quickly say the first word

that comes to mind. Try not to use the inhale or the gap or the gulp in between you and your neighbor to think. That's where the editor lives. That instant, that inhale is what guards you against appearing insane, obscene, boring or politically deficient. Do several rounds of association trying each time to go faster, trying to eliminate the thinking space in between.

Exercise 2: What's IN/What's OUT?

Think of a word. Bridge, for instance. Turn to your neighbor and say:

Bridges are IN.

Your neighbor will respond by saying,

Bridges are OUT. *Snowshoes* (replacing bridges with the first word that comes to mind) are IN.

Continue the game around the circle trying to fill in the blank with the first word that comes to mind.

Exercise 3: What's BUTCH/What's FEMME?

Keep the format of What's IN/What's OUT but change the words in and out to BUTCH and FEMME. Say for instance:

Black shoes are BUTCH.

The person next to you says:

Black shoes are FEMME. My nose is BUTCH.

Continue around the circle. Try to use the first words that come to mind and enjoy the effect on meaning. Watch how the game attaches different meanings to gender by attaching different associations to the words butch and femme.

Exercise 4: It Can't Be Butch. . . .

This exercise is based on an exercise used by Keith Johnstone called "It's Tuesday." I have substituted the words Tuesday with

the words butch and/or femme. Work in partners. One person will be the pusher and the other the pushed. The pusher repeats the phrase "It's butch" or "It's femme," to which the pushed replies "It can't be butch (or femme) because . . . " saying the first thing that comes to mind. For example:

Pusher: "It's butch."
Pushed: "It can't be butch because . . . *my mother is here.*"
Pusher: "It's femme."
Pushed: "It can't be femme because . . . *my hair is bleached*"
or "It can't be femme because . . . I didn't sleep last night."

Switch roles after a while and remember that the role of the pusher is to get the pushed to respond associatively without thinking about what should or shouldn't be considered butch or femme, masculine or feminine.

Taking Notes

Throughout the workshop, I'll ask you to keep a mental notebook in order to record images, ideas, impulses that can be pulled forward into the next exercise. So think back through the previous exercises and recall some images or associations that amused you, surprised you, disturbed you, and record two of them in your mental notebook. Look for the images that have some juice. We are beginning to accumulate text by recording images from these association exercises.

FREE ASSOCIATING THE BODY

- *Impulse:* a sudden desire or tendency to act without reflection

Although we don't do it often, we're used to free associating our minds. Now let's think about it in terms of the body. When I work with free associating the body, the term I use is impulse. You've all heard "Just act on impulse" or "It was impulse shopping!" This means that the action was performed without thinking. We let the body move without taking the time to make a decision. I believe the body is a valuable resource particularly for the gender imagination.

However, we have to learn to free associate with the body and to disregard the same censors who say "That's insane, obscene, boring or politically deficient behavior." I define impulses as anything we do with our body that is not thought out or considered in advance: picking your nose, stifling a sneeze, reacting to a loud noise, taking a deep breath. But impulses can also be abstract. Abstract impulses are simple sounds and movements that cannot be read as literal actions or recognizable human gestures. In the beginning, in order to outwit the censor, we'll work mostly with abstract impulses. Also we'll always include sound when working with physical impulses in order to keep the door open between movement and language. So that when you do come to applying text to movement you will have a vocal impulse as well as body impulse and you won't have to pry your mouth open to speak.

Exercise 5: Body Hoohah

This exercise was named by Linda Putnam and is based on the Sound and Movement exercises used by Joseph Chaikin and the Open Theatre. It's like the children's game of Follow the Leader. Make a movement with your body that you can repeat. Don't think, just move and make a sound at the same time. Now keep repeating the sound and the movement so that the others in the circle can join you. Like the game of Follow the Leader, you lead by repeating your sound and movement impulse while everyone else follows and then you pass the leadership to the person next to you in the circle who will lead with another sound and movement. Try not to stop or drop the energy between leaders. Think of the impulse as an electrical current in a copper wire. You want to keep the current flowing because if you stop you short circuit. It's in that stop, that gap that the censor makes an appearance. And commit yourself fully to the leader's impulses. That commitment allows you to use body movements that are very different from your own, to go places you wouldn't ordinarily go and you can do so without taking responsibility for going there. Remember to always work with sound so that when it comes time to add language you don't have to pry your mouth open to say the words.

Taking Notes

After several times around the circle stop and see if you can recall the impulses you created. We are not trained to remember physical movement in the same way we are trained to remember language. But I believe the body will hold that memory just like the mind holds words. Try to recall where the impulse originated in your body or perhaps the dynamics or rhythm of the sound and movement. Ask others in the circle to help you remember an impulse. One of these clues will recall the whole impulse. Now choose three impulses (both sound and movement) and record them in your notebook. Like with images we are beginning to accumulate impulses for creating material.

MAKING BODY LANGUAGE

- *Rehearsal:* a trial performance or practice
- *Phrase:* an idiomatic or short pithy expression
- *Stereotype:* a person or thing that conforms to an unjustifiably fixed mental picture

Exercise 6: Putting Meaning on the Body

In your mental notebook you have stored some images associated with butch/femme. Select two and say them out loud. These will be your working text. You also have three impulses stored in your notebook. Recall and rehearse them. These will be your working impulses. Choose one of your three impulses and repeat it as if rehearsing a movement phrase. Now we'll add some text. We'll begin with your name. Repeat the impulse and say your name at the same time. Let the language (your name) ride on top of the impulse. Try to maintain the integrity of the impulse. Try to keep the same quality of movement and sound while adding the text. Don't let the language influence the sound and movement. Let the sound and movement simply carry the language. That will be your first text/ impulse phrase. Now choose another impulse from your notebook and rehearse it. After you have rehearsed the second impulse

choose one of your images from your selected working text and let that image ride on this second impulse. We are accumulating a series of text/impulse phrases for performance. The important thing is not to worry that the impulse doesn't match the language. That is the point. We can stretch the meaning of words associated with butch/femme, by giving them an unexpected body. Now apply the same process to the third impulse and the second image from your working text. You now have a total of three text/impulse phrases. We'll each perform a story by inserting these text/impulse phrases into these lines of text:

> My name is . . . (text/impulse). Sometimes I am . . . (text/impulse). Other times I am . . . (text/impulse).

These mini-stories question the singular meaning of language and solid definitions of gender and give us a permission to be playful and nonsensical when making work or establishing identities.

Exercise 7: Finding Body Language in Objects

Go to your personal belongings and select an object: a comb, filofax, tampon, orange, etc. Come back to the circle and perform a butch action with that object. Try to use your first impulses and simply perform an action with the object in a butch-like manner. You don't have to write the play or analyze the character. Just perform one butch action with your object. Don't be afraid of performing the stereotype. Stereotypes are very theatrical. They are also useful. Sometimes you have to recognize and embody the stereotype before you can create a new representation. Remember your censor's goal to keep you from appearing politically deficient. Now with the same object, perform a femme action. Using the objects, your stereotypical ideas about butch/femme and your first impulses, you have created a butch gesture and a femme gesture. I use the word gesture rather than impulse when the action is literal (that is recognizable as some form of human behavior) rather than abstract.

Exercise 8: Performing a Butch/Femme Text

Choose one of the images that you selected for your working text. Make a simple sentence using that image. Feel free to make

nonsense or poetry or a simple statement using the word that describes your image. Now choose either the femme gesture or the butch gesture created in the previous exercise and perform the gesture letting the language of your sentence come along for the ride. Perform these around the circle. Pay attention to the theatrical tension created when the language of the sentence doesn't necessarily 'fit' the gesture and enjoy the humor of identification when the text/gesture supports the stereotype. By combining the gesture with the sentence, you have created a butch or femme text/gesture.

Taking Notes

Record this butch or femme text/gesture. Then spend a few minutes thinking about the previous exercise. Make some notes. Try answering these questions: What was funny? What seemed true? What was surprising? How did the performance of butch or femme feel in your body? When did you feel comfortable or ridiculous or powerful?

PERFORMING AND READING THE SCENE IN THE SOCIAL CONTEXT

- *Scene:* place or circumstance in which any event takes place
- *Spectator:* one who looks on; observer; witness

Exercise 9: Reading and Writing the Scene

Choose a partner and spend a few minutes rehearsing a way to combine your butch or femme text/gesture with theirs. Don't worry if they don't 'fit' or 'make sense' together. And don't work so hard. One text/gesture might simply follow the other. Now each set of partners will perform their 'scene.' After each performance we, the spectators, will describe the scene. We will say what we saw in terms of gender, setting, character traits, character relationships and possible plot lines. The partners will also comment on what they saw from within. Again be impulsive. Say the first thing that comes to mind. Now go back into rehearsal with your partner and begin to

'write' a very quick and rough draft of a scene based on the information you found or the information given to you by the spectators. Be sure to incorporate your original text/gesture in this version of the scene. After no more than ten minutes, come back to the group and perform this draft of your scene.

Taking Notes

Record the elements of your scene that you like, that surprised you, that disturbed you. Take particular note of the 'character' that emerged from this exercise.

WRITING THE BUTCH/FEMME CHARACTER

- *Character:* a person; a personage in a play or novel; a structural or functional trait of a plant or animal

Exercise 10: Is She Butch or Is He Femme?

Let's focus on the individual characters found in the previous exercise. Perform their gesture again and think where in your body, in what specific part, do they live? Shoulder, little finger, pelvic bones? Now walk around the room letting that part of your body completely dictate how, when, and where you move. Exaggerate. Go beyond your idea of human shape. Keeping that shape, make a sound that follows the impulse of the body. Continue to move around the room. It is easier to work from impulse if the body and voice are already in motion. As you move in that shape and with your sound try to answer these questions: What is your name? (Remember to say the first thing that comes to mind.) Where do you live? What do you do for a living? How do you spend your free time? What do you hold most dear? Now bring that body, that character, into the circle and keeping the integrity of the impulse (both sound and movement) introduce yourself by giving/using some of the answers to the previous questions. Finish the introduction by stating whether your character is butch or femme.

Taking Notes

Transfer some of the information you have recorded in your mental notebook into an actual notebook and begin to consider

using some of this material as the beginning of a performance of a butch/femme character or performance piece.

ANY QUESTIONS?

I usually finish the workshop by asking the group to 'interview' the character just created by asking them questions. Ask any question, just as you asked me in the beginning of the workshop. I encourage you to ask questions because you want the information and want these new characters to discover things about themselves. Don't ask a question because you think you know the answer. These questions are usually based on the assumptions you have made upon being introduced to this new character. When you respond as your character, respond with the body and voice of the character you created. Let the physical impulses give you the answers to the questions and remember to say the first image that comes to mind. There is no right or wrong answer, only your character's story. This is a good beginning for writing the character's biography and a good exercise for working through prejudice that is based on body type and gender behavior.

Any other questions?

Coming Out at Night–
Performing as the Lesbian Vampire
Rosie Lugosi

Rosie Garland

SUMMARY. Rosie Lugosi is the lesbian vampire queen of Manchester, an electrifying performance poet, a fang-in-cheek compere and a sultry *chanteuse.* This article examines what has led to her creation and development: her past incarnations as a Wicked Queen and screaming Goth; the impact of coming out; the discovery of feminism and the importance of the image of the lesbian vampire as defiant rebel. *[Article copies available for a fee from The Haworth Document Delivery Service: 1-800-342-9678. E-mail address: getinfo@haworthpressinc. com]*

Why Rosie Lugosi, the lesbian vampire queen, performance poet, compere and singer? At times it feels as if I'm creating the

Rosie Lugosi is the alter ego of Rosie Garland, writer, performer and singer. Born in London, she has embraced Manchester as her home. She has been performing and writing for as long as she can remember, and her eclectic performance history ranges from singing loudly (yet in tune) in '80s Goth band *The March Violets* to sharp-edged comedy in lesbian duo *The Pink Ladies.* She likes the fact that her Master's was in obscure medieval apocrypha. Her work has been anthologized widely, and her first solo publication of poetry, *Hell and Eden,* was published by Dagger Press in 1996.

Address correspondence to Rosie Garland, 5, Longford Road, Chorlton, Manchester, England M21 9WP.

[Haworth co-indexing entry note]: "Coming Out at Night–Performing as the Lesbian Vampire Rosie Lugosi." Garland, Rosie. Co-published simultaneously in *Journal of Lesbian Studies* (The Haworth Press, Inc.) Vol. 2, No. 2/3, 1998, pp. 201-207; and: *Acts of Passion: Sexuality, Gender and Performance* (ed: Nina Rapi, and Maya Chowdhry) The Haworth Press, Inc., 1998, pp. 201-207; and: *Acts of Passion: Sexuality, Gender and Performance* (ed: Nina Rapi, and Maya Chowdhry) Harrington Park Press, an imprint of The Haworth Press, Inc., 1998, pp. 201-207. Single or multiple copies of this article are available for a fee from The Haworth Document Delivery Service [1-800-342-9678, 9:00 a.m. - 5:00 p.m. (EST). E-mail address: getinfo@haworthpressinc.com].

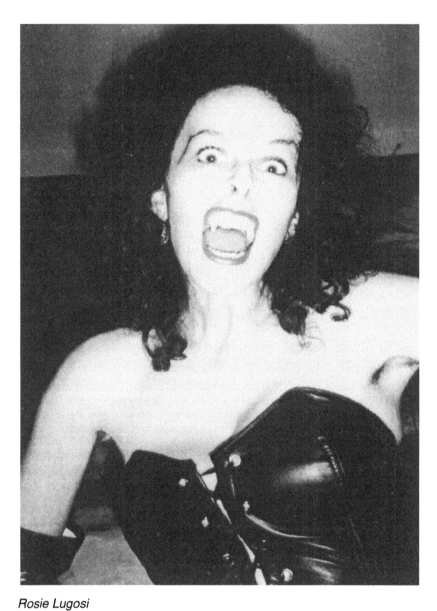

Rosie Lugosi

Photo by Marguerite McLaughlin. Used by permission.

image out of thin air. Lesbian vampires are the products of a largely male imagination (remember all those blonde lovelies in the '60s Hammer horrors?) though some dykes do dabble in the genre–if only in fiction[1] or in film.[2] Being a lesbian Goth, too, remains a contradiction. Put simply: apart from me, there aren't any. Bisexual Goths abound, but no dykes. I wonder if this says more about lesbians than it does about Goths. . . . So how can I reclaim the arcane push-up wiring of the Hammer fangstress for a lesbian audience?

Rosie Lugosi is neither a pastiche of a lesbian type, as in the spot-on observations of Twinkle, the shiny dyke babe, nor is she grittily realistic, like Hufty, to name two lesbian performers Up North. She's a Frankenstein creation, sewn together from worst nightmares and wildest dreams, the murky parts that lesbians aren't *supposed* to think about. I perform dramatically on the Manchester poetry scene and at gay performance nights such as *Gag*, boldly going where no vampire has gone before; as a fang-in-cheek compere at the monthly women's performance night *The Launch*; and as a torch singer in small, preferably smoky, venues. There's a diversification, an exploration of different forms. I choose the right form of performance for the right occasion, rather than try to impose the wrong form on the wrong audience. I see this as integrative, bringing the different selves that I am together. I'm integrating my past with who I am now, making sense of it and making peace with it.

In the past I needed the audience's gaze to give me a sense of self which I lacked. Then it was: "I am empty–fill me!" Now it is: "I *am*–fuel me!" The character of Rosie Lugosi is "not an icon but an inroad"[3] into my own self-awareness of what it means to be a lesbian performer. I am looked at, but the difference now is that I am in possession of knowledge and I look back.

FROM VAMPIRE BRAT TO SCREAMING QUEEN

I have been developing the character of Rosie Lugosi since 1995, but her roots are deep in the past. My first memory of performing to an audience was in Infant School. I was five, and was playing the Elf Queen. Not exactly the Wicked Witch of the West, but not

Glinda the Good Witch of the North either. My task was to call my loyal elves on stage. I crooked an index finger to beckon them.

"Oh dear, no!" chirped the teacher helpfully. "You're a *queen!* Big arm gestures, dear. Big arm gestures."

Something fell into place. I raised my arm, swept it up over my head and the magic occurred. All my elves obeyed me. I *was* that powerful woman. I was watched, I was admired, I had power and I was in control of it. It was very exciting.

From 1981-1984 I performed in the Goth band *The March Violets*. It was loud, thrashy, music for monsters with song titles like "Children on Stun," "Crow Baby," "Snake Dance." I backcombed my hair and punched a hole in the ozone layer with Boots Extra Firm Hold Hairspray. My foundation could have underpinned the Albert Hall. I wore anything as long as it was black and leather. I slunk around on stage, snarled at the audience, screamed, howled, sang. They went crazy. It was great. I was watched, I was admired. I had power and I was in control of it. It was very *very* exciting.

Still, Goth bands reflect the general aspect of rock bands as straight and male. Although *The March Violets* was unusual in having a female as well as a male singer fronting the band, I was still the 'girlsinger' in a male band, providing interest for the male gaze. At that time I needed that gaze to tell me who I was, to give me the adrenalin rush, to reassure me that I existed. I may have had some measure of self-determination when on stage, but off stage, back in the real world, my power was severely proscribed.

SHOWING OFF

Here I stand now in the 1990s as Rosie Lugosi, the lesbian vampire queen. The character of Rosie Lugosi is characterized by flamboyance (OED: florid, of wavy outline; flamingly or gorgeously colored). She's showy, extrovert, with plenty of big arm gestures (exactly as was revealed to the Elf Queen). She struts, she prowls, she laughs. It's not just about wearing make-up or thrusting a lesbian cleavage into the entertainment world. I'm not talking about a subtle smear of this season's shade of lipstick and a *soupçon* of eyeliner. Rosie Lugosi means scarlet lips, trowel-loads of slap and false eyelashes. This goes further than being a lipstick lesbian

or a disco bunny. And it is most definitely nothing to do with looking or acting 'feminine'–the social construct of the disempowered and passive female. At heart, I'm reclaiming the power of being a *show-off*, that sign of ego and expression of energy so much frowned upon in female children. Yes, I'm being too big for my pvc stiletto boots, and it's wonderful.

Rosie Lugosi is also about clothing as an instrument of power. I wear even more extreme clothing than when I was a Goth. I'll show my cleavage now, which I never would have done then. Because I'm calling the shots now, and I'm doing it for myself. However, I do realize that patriarchal systems force women into uneasy relationships with their bodies; but how long *are* lesbians going to hide their breasts? Don't we find breasts attractive? Are lesbians still afraid and ashamed of what they desire, or afraid and ashamed that they desire at all?

THE IMPACT OF FEMINISM

Coming out as a dyke in the early 1980s coincided with my discovery of radical feminism. The feminist critique of patriarchy and the struggle against women's oppression opened doors in my mind and gave me insights into my own lack of real power off stage, however powerful I may have felt on stage. Things fell into place.

It would be intellectual arrogance to think that there could be a single feminist voice to speak for all women, whatever their race, class or sexuality, yet it is precisely this narrow range of politically 'acceptable' choices that has disappointed me so sorely:

> The irony of this feminist resistance is that in opposing the privileges of knowledge and the construction of women as "feminine" subjects, a form of feminist discourse which actually excludes and oppresses some women has evolved with its own regime of governing the individual.[4]

I left heterosexuality with an overwhelming sense of relief that no-one was ever going to guilt-trip me about my clothes, my hair, or my performance again. But my voice dissents and by *some* femi-

nists I have found myself dismissed or reviled, ironically in much the same way that the patriarchy dismisses and reviles feminists themselves. I feel like the baby thrown out with the bathwater: still the vampire outsider. But it doesn't have to be that way . . .

COMING OUT OF THE COFFIN

So finally, why Rosie Lugosi the lesbian *vampire?* She has nothing to do with the poverty of originality demonstrated by the female fans of the Anne Rice (author of *Interview with the Vampire*) school of vampire imagery, dressed in wispy pseudo-Victoriana, and inhabiting a sub-Mills and Boon world. Part of it has come from a lifelong fascination with vampires. At an early age I was hooked. All my adolescent rebellion and loneliness coalesced around those figures flickering on late-night TV. I read voraciously and in secret. I knew I was supposed to feel relieved when the vampire got staked. I didn't. I wrote stories in which the vampire emerged triumphant, or survived untroubled by the conventional world. I knew I was supposed to find vampires frightening, and home and family expectations of me comforting, safe. I didn't. I imagined vampires as my powerful protectors, invisible friends who soothed away my fear of the dark.

I was attracted to their unconventional sexuality. To me it seemed radical to propose a form of sexual expression not focussed entirely on male genitalia (it still does). Later, when I came out, I found compelling resonances in the vampire as a creature of outlaw sexuality. Quintessentially queer; outside society; challenging, outraging, yet fascinating it. There is an extensive literature on the female vampire as undermining social mores and expectations, as *abject*— meaning that which does not "respect borders, positions, rules" and "disturbs identity, system, order."[5] And why abject?

> The female vampire is abject because . . . she does not respect the dictates of the law which set down the rules of proper sexual conduct.[6]

However, this has often been viewed negatively; female vampires have been viewed as

an expression of women's position as outsiders, women's not belonging, of social and cultural alienation.[7]

For me, this misses an important point, that the female vampire can be seen as an outsider through choice: she has not been thrown out of society, she defies it. She's a woman in rebellion against, not merely abjected from, the family and expectations of sexual passivity. She is not a leech upon the patriarchal beast which is drawn to her yet tries to destroy her: She gets her blood elsewhere. By so doing she breaks the pattern of being hooked into patriarchy's push-mepullyou relationship with powerful sexually active women.

Rosie Lugosi embodies the power of that defiant and avenging angel. Not "*they* are family and I hover forever outside their window" but "we are family, I got all my sisters with me."

Now my external vampire protectors have been integrated. Traditionally, vampires are supposed to be the living dead. The paradox is that as a suppressed, passive, unintegrated, acceptable heterosexual I was never nearer death. As a lesbian vampire I have never been more alive.

NOTES

1. Califia, P. (1988) "The Vampire," *Macho Sluts*, New York: Allyson.
2. Goldstein, A. dir. *Because the Dawn*, USA 1988.
3. Young, S. (1988) "Feminism and the Politics of Power," *The Female Gaze*, eds. Gamman, L. and Marshment, M., London: Women's Press.
4. Ibid.
5. Kristeva, J. (1982) *Powers of Horror: An Essay on Abjection*, New York: Columbia University Press.
6. Creed, B. (1993) *The Monstrous-Feminine*, London: Routledge.
7. Jackson, R. (1981) *Fantasy, The Literature of Subversion*, London: Methuen.

Presentation of Self as Performance:
The Birth of Queenie
aka Valerie Mason-John

Savitri Hensman

SUMMARY. Valerie Mason-John is an artist who draws on performance, orature and text. In an interview she traces the roots of her development as a performer to her early childhood; examines the creation of personas on stage and television, including outspoken, fun-loving Queenie, who has hosted at Pride; and explores the responses of black lesbian and other audiences. She also considers possible future directions for her work, including the impact which greater integration of different aspects of her life might have on her growth as a performer. *[Article copies available for a fee from The Haworth Document Delivery Service: 1-800-342-9678. E-mail address: getinfo@haworthpressinc.com]*

Valerie Mason-John is an artist who draws on performance, orature and text. The characters she has created include Queenie, who hosted on the main stage at Pride 1996. She has performed in

Savitri Hensman, born in Sri Lanka in 1962, has lived in Hackney, London, most of her life. She is a community worker, writer, trainer, consultant and occasional performer of poetry.

Address correspondence to Savitri Hensman, 31 Millington House, Stoke Newington Church Street, London N16 9JA.

[Haworth co-indexing entry note]: "Presentation of Self as Performance: The Birth of Queenie aka Valerie Mason-John." Hensman, Savitri. Co-published simultaneously in *Journal of Lesbian Studies* (The Haworth Press, Inc.) Vol. 2, No. 2/3, 1998, pp. 209-219; and: *Acts of Passion: Sexuality, Gender and Performance* (ed: Nina Rapi, and Maya Chowdhry) The Haworth Press, Inc., 1998, pp. 209-219; and: *Acts of Passion: Sexuality, Gender and Performance* (ed: Nina Rapi, and Maya Chowdhry) Harrington Park Press, an imprint of The Haworth Press, Inc., 1998, pp. 209-219. Single or multiple copies of this article are available for a fee from The Haworth Document Delivery Service [1-800-342-9678, 9:00 a.m. - 5:00 p.m. (EST). E-mail address: getinfo@haworthpressinc.com].

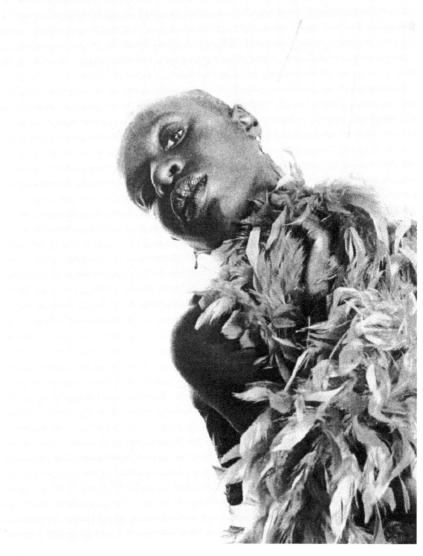

Queenie (aka: Valerie Mason-John)

Photo by Simon Richardson. Used by permission.

Britain and elsewhere in Europe, written and acted in plays and appeared on television. She is also widely known as a journalist, a co-author of *Making Black Waves* (Scarlet Press, London, 1993), the first book about black lesbians in Britain, and the editor of *Talking Black* (Cassell, London, 1994), the first anthology of Asian and African academic essays about lesbian culture in Britain.

I interviewed her in her South London flat to explore the influences which shaped her development as a performer; how she perceived the role of the performer in the black lesbian and wider communities; the similarities and contrasts between her stage persona and what she conveyed in everyday interactions and as a writer; what performance meant to her and her performances to other people; and how this related to the rest of her life.

ROOTS OF PERFORMANCE

Valerie Mason-John traced the beginnings of her development as a performer to early childhood:

> I've always performed, really. I think, when you're the only black person in a white environment, you're always on show. I grew up in an orphanage, and every year we would go away on holiday. It would always be connected with the church, and we would stay in a church hall. Every Sunday we had to go to church, and it was mentioned, "Here we have the Barnardo kids to sing a song for you." I remember having to traipse up in front of these people and sing, and wishing everybody would go away–it was just so excruciating! I think there I really learnt to perform, because it was something you just had to get used to.
>
> I had a very lucky childhood, in the sense that there was a lot of input into performing. As a kid I belonged to Tufty club and was always performing in that. I was part of the Secret Seven club: we used to act out Enid Blyton's Secret Seven and Famous Five. I grew up in a village; we went out to play and used to act out different scenarios. I used to enjoy being George and also Barnabas–he was the traveller with the chimpanzee and he didn't have a family, so I identified with him too.

I also have a memory of when our village school closed down and we had to go to outside schools, when I was about eight. On the first day I get into a fight, because somebody calls me a nigger or a wog: you're on show again, the only black kid in a white school except for a couple of others from the kids' home.

As a girl with a flair for drama, her path might have been very different: a leading role in the school play and later, perhaps, Shakespearean heroines or hapless wives in drawing-room comedies. However, in the late 1960s and early 1970s, few staff would consider casting a black Cinderella or Sleeping Beauty.

Valerie moved from Essex to London, but even in mainly black surroundings she found herself conspicuous. "I was a black kid in a black school with a thick country accent, which I learnt to change very quickly because I was very, very different. I can always remember the end-of-year party, and black kids looking at me as if I came from Mars and thinking: what was this girl doing, bopping away to reggae–didn't she know how to dance like black people?"

However, being noticed on the dance floor could be utilized positively, being different from others become a means of connection rather than a source of isolation. "In my teens, really, my performing took place in nightclubs." At the time, black people were seldom seen in West End clubs except in the company of white partners, and women usually sought to look decorative rather than taking their space: "It was unladylike to throw your body around on the dance floor." Valerie Mason-John avoided being excluded or marginalized by being distinctive. "I was a punk in my time: I used to walk around with green hair, a safety-pin in my mouth religiously, a white dustbin-liner for a tee-shirt. But I was what some people might call a designer punk–it was very much for show." Within the black community, too, she and her best friend were "very different" from the other girls in their lined skirts and granny shoes.

"In nightclubs I used to draw crowds, and I competed with the boys. People used to come and see us dance; I was very much performing on the nightclub scene."

DEVELOPING AS A PERFORMER

Mason-John grew to recognize that her activity on the dance floor involved performance. "I began hanging out on to the women's scene, and it was like, 'She's weird, she's outrageous' "; the thought entered her mind that it was about time that she started getting paid for this! Others, too, saw her potential. "I remember being asked, would I dance at Venus Rising, which was then the biggest women's club in Europe, and that was really good. It was quite exciting having to dance there once a month, because you had to be creative. I couldn't wear the same outfit twice, I had to look different: it wasn't just about dancing, it was about performance art."

As a journalist, she was familiar with conveying meanings precisely through the written word; as she gained confidence as a creative writer, she explored other ways of using language and integrating it with spectacle and sound. When other writers had given readings, she had wondered, "Why do people just read from their books? If I did it, I wouldn't." In the early 1990s she was invited to perform at the Glasgow Women's Festival. For her performance, *Body Politics*, she memorized several of her poems on the theme of the body: the issues explored included rape and eating disorders.

She found this experience deeply liberating. So, too, were her fifteen months at the Desmond Jones School of Physical Theatre and Mime, which led to performances on the women's, lesbian and black circuits.

Performing had been primarily a spare-time activity, but over the past year she had come to take it more seriously, and had launched herself as Queenie, a name given to her by gay men in San Francisco.

In 1995, on Channel Four, she presented a computer program called *Electronic Eden* in which she appeared as a character inside the computer. The producers liked her performance so much that they used part of it as a trailer to advertise the program.

PERSONAS

People who associate Valerie Mason-John's name with features on Nicaragua and aboriginal struggles in Australia or books on

black lesbians' experience may be surprised at their initial encounter with the arrestingly dressed figure on dance floor, stage or screen. She does not easily fit stereotypes of artists (or, for that matter, of black women). Indeed perhaps the performer draws on some of the same qualities as the journalist, author and editor: creativity, discipline, desire to communicate.

> I have two personas, really. I've got Queenie, who is that fun person. I'm working on a pilot show, called South Thames Live, which is a cutting edge show with new and up-and-coming entertainers, musicians, etc., and I'm the resident presenter with a celebrity presenter: I'm lady of the manor! They had me, with the credits, coming out of Buckingham Palace with one of my wonderful hats. We did all the shoots at Buckingham Palace, I was standing in the road and a woman in a great big Range Rover stopped, held the traffic up, just so that she could take a picture of me. That often happens to me.

As a performer she is accustomed to being a familiar figure to people whom she has not herself met. "When I was on Channel Four last year, this dark-skinned black face would come up on your screen and then there would be a wink inside this computer–I still have people saying, 'I'm sure I know you, haven't I seen you?' I'd have kids coming up to me in supermarkets and I couldn't understand why, then one day it clicked, I winked at them and they ran off!"

Her performance persona is very different from her writing persona.

People may perceive a rigid division between cultural activities and everyday life, and be uncomfortable with behavior which, in other settings, they would find quite acceptable.

> I think when Queenie, or Valerie, is on stage, people can cope with me, love me and accept me. I hosted on the main stage at Pride this year and I had an outfit for the march which was absolutely wonderful: all the gay boys loved it! I also had an outfit for the main stage, which everybody loved as well. I do wear these outfits in everyday situation, but it's, "Oh, that's too much!" When I'm on the stage, people can receive me and

think, "Okay, she's an entity on her own, she's a performer." I suppose, when I'm offstage, there's a part of me that reduces myself, shrinks myself because I think people have found me quite difficult to digest. They haven't been ready for me: I've always been ahead of my times, in terms of fashion, outlook and how I thought.

I think that's why for a while I got into messing around with drink and drugs. Those are things which tame your personality and sedate you.

Valerie stopped using alcohol and drugs in this way, but others found this difficult to accept. "People can't cope with you when you're not on anything. For me, my biggest high is adrenalin and natural energy."

Conformity with societal pressure does not come easily to her. This is clearly expressed by her stage persona: "Queenie doesn't make compromises—it's like, 'This is who I am, and you can either take it or you don't,' whereas as a journalist I've had to make compromises." It is also reflected in her choice of role models. In addition to Joan Armatrading, whose image Valerie Mason-John saw displayed in a central London record store when she was twelve—the first time she can remember a black woman profiled in such a public space—they are Grace Jones, who epitomized the "Different Black Woman," and Madonna: "She's outrageous—she's sassy—she's good at what she does."

Sometimes performing can bring up difficult emotions. "At times I do find performing painful. Certain material is cathartic. Around *Body Politics*, looking at issues around food, body and rape, I found it very traumatic rehearsing and doing that. I've recently written a one-woman show called *Brown Girl in the Ring*, and there's a lot of painful stuff in that, although it's very exciting. As a performer, your work does take you on particular journeys, sometimes painful."

Perhaps the different personas have more similarities than are at first apparent: "In a way, rather than looking at Valerie the writer and saying, 'Oh, she's so different from Queenie,' it's just another facet of me: I'm multi-faceted."

AUDIENCES

Mason-John performs to a variety of audiences, including some made up predominantly of gay men. Indeed she has been described in the *Voice* newspaper as a "gay icon," though she questions the meaningfulness of the phrase: "At the moment it's fashionable to use the word 'icon.'" However she does believe that "there is a part of me which gay men love, because I'm a black woman who dresses up, and gay men have always loved women who dress up and who look sassy; it's almost like they would like to look like that. I suppose it's me doing drag on a particular level. I dress up because I feel like this particular type of woman."

She believes that women's response to her tends to be more complicated:

> Gay men can receive me a lot more easily: women enjoy me but they're scared. I act out some of their secret fantasies; I do break boundaries. When I was performing at the Fridge, Venus Rising, one night, I wore a top hat and tails, Victorian bloomers and a strap-on dildo. Women really did enjoy it. Women always remember it, it's party talk. When I came off the stage, I actually had black women coming up and shaking my hand, saying, "I've got one of those under my bed," and I thought, "Flipping hell, I don't even possess one of these—I actually borrowed this to perform in."

She may choose different material, and get different responses, depending on her audience:

> If I know that I'm performing to black women, then there's particular material that I feel it is okay to use, but would I use it in a predominantly white women audience or heterosexual audience? It's not always the case. I tailor my material to the audience.
>
> It's interesting to see how the lesbian audience has changed. At one stage the lesbian audience didn't mind hearing performance poetry which looked at issues around rape, sexual abuse, racism, all those things which oppress us. But now it's, "I want to go out and enjoy myself." In a way, that was challenging for me as a writer and performer.

She has learned not to undervalue the importance of sheer entertainment: "I do host a lot on the circuit. It's really nice, at times people say, 'You're hosting.' I say, 'Yeah.' They say, 'We know we're going to have a good time then.' There are people out there who love what I'm doing and support me from the sidelines."

However she also recognizes that challenging audiences can be valuable: "When I did *Body Politics* on International Women's Day, some people in the audience said, 'We do love our bodies.' People came up to me afterwards and said, 'We think it's really important, what you're doing, because there just isn't dialogue around this.' "

Other occasions which have proved particularly memorable to audiences include her appearance as Marilyn Monroe on Dyke TV; when she became the first-ever black person to be hosting on the main stage at Pride; the week when Queenie was featured in the *Voice*; and, particularly among white lesbians, the first Drag King competition in Britain, which she hosted.

When Valerie Mason-John began performing professionally, few black lesbians were open about their identity in a public arena, leading some to disbelieve in their own reality. Images of gays and lesbians were almost invariably of white people, black women as heterosexual. She has played her part in changing public perceptions, though ignorance is still widespread and much remains to be done. "I think my impact on other people has been that I've been upfront and helped to put black lesbians on the map. People might not have liked everything I've done, but I have helped to make black lesbians visible."

FUTURE PERFORMANCE DIRECTIONS

Over the next few years, she hopes to extend her scope. She has an Institute of Contemporary Arts commission in the year ahead which she believes will appeal to diverse audiences: she does not want enjoyment of her work to be restricted to certain sections of the population. The piece *Femininescapes* is based on eight of her poems around the sea, named after women. It will involve not only performance poetry but also dance and physical theatre with another woman, Delta Street. A white heterosexual composer, Nigel

Shaw, and Lola Flash, an African-American lesbian photographer, who will be providing the visuals, will join in creating an overall theatrical experience.

Mason-John's next book will integrate the serious and fun-loving aspects of herself. "It's actually bringing my performance side and my writer's side together." The same applies to her recent play *Sin Dykes*:

> I explore serious issues like mixed relationships, SM in mixed relationships, SM between two black women. But also there is a lot of humor and fun in it.
>
> I feel I'm on a journey at the moment. One thing I want to achieve–I want to earn money for what I do, enough to live on so I can rest and come up with new material! As a performer– and I'm a performer in everything I do, give me an event and I will perform for you–I want to be a role model for black women, all women, not just lesbians, somebody who is out there doing things, who is strong and visible. I've transcended a lot in my childhood and adolescence to get where I've got to; I've had to struggle for everything I've got.

Paradoxically, I believe she may be able to reach new depths as a performer as she gradually learns how, at times, to stop performing and move beyond personas.

> After Pride, I went back to friends; it was, "I can take this mask off now."
>
> There's a part of me that's very spiritual–I have a strong meditation practice as a Buddhist. Within that is actually stripping down all the masks and trying to integrate all those parts of myself. People see you out there, and it's, "Valerie's very strong and has a lot of wisdom." I am strong and I do have wisdom and insight but I need people to be strong for me; I'm learning to be vulnerable.

TRANSCENDING PERSONAS

Performance has been an integral part of her life, and the persona which an audience perceives is not the product simply of artifice,

like a glove puppet which can be packed in a box after a performance. At the same time it would be simplistic to suggest that, when she performs, she is engaging in straightforward self-expression and that any persona fully conveys her being, in all its complexity. As she tries out new methods of working, reaches new audiences and simultaneously seeks to achieve greater integration in her life, her development as a performer may progress in original and exciting ways.

Angela de Castro:
Clown in a Cold Country

Louise Carolin

SUMMARY. Angela de Castro, 41, is a theatre clown. In a male-dominated genre that incorporates elements from mime and elevates traditional circus slapstick to a high art, she is internationally recognized as a performer and teacher. Born in Brazil, de Castro came to England in 1986 in order to train. She has worked with British street- and circus-theatre companies including Mummerandada, Ra Ra Zoo, and The Right Size, and women's theatre company Skin and Blisters. Her own show, *The Gift*, has toured throughout Britain, and she has directed and appeared in spectacular circus-inspired performances at London's Heaven night-club. In 1995 she was invited to work with world-famous exponent of the art, Slava Polunin, in his phenomenally successful *Snowshow*, in which Angela toured internationally during 1996. She lives in London with her partner, Catherine. *[Article copies available for a fee from The Haworth Document Delivery Service: 1-800-342-9678. E-mail address: getinfo@haworthpressinc.com]*

Angela de Castro never set out to be a clown. Already an award-winning author and up-and-coming actor/producer in her native Brazil, it was pure chance that brought her, while touring in Europe,

Louise Carolin is a writer and journalist. She has contributed to a number of British lesbian/gay and feminist publications over the years, including *Shocking Pink*, *Square Peg*, *Everywoman* and *Diva*. Her poems have been published in *Whatever You Desire* (Oscars Press) and *Dancing on Diamonds* (Crocus). She lives in London.

Address correspondence to Louise Carolin, Top Flat, 2 Acre Lane, Brixton, London SW2 5SG.

[Haworth co-indexing entry note]: "Angela de Castro: Clown in a Cold Country." Carolin, Louise. Co-published simultaneously in *Journal of Lesbian Studies* (The Haworth Press, Inc.) Vol. 2, No. 2/3, 1998, pp. 221-226; and: *Acts of Passion: Sexuality, Gender and Performance* (ed: Nina Rapi, and Maya Chowdhry) The Haworth Press, Inc., 1998, pp. 221-226; and: *Acts of Passion: Sexuality, Gender and Performance* (ed: Nina Rapi, and Maya Chowdhry) Harrington Park Press, an imprint of The Haworth Press, Inc., 1998, pp. 221-226. Single or multiple copies of this article are available for a fee from The Haworth Document Delivery Service [1-800-342-9678, 9:00 a.m. - 5:00 p.m. (EST). E-mail address: getinfo@haworthpressinc.com].

Angela De Castro

Photo by Della Grace. Used by permission.

to the theatre in Germany where she first laid eyes on "theatre clowns." "The world of clowns is very hierarchical," says de Castro, explaining the distinction. "Circus clowns or augustes, with the red nose, are funny and loveable, but they are very low status. The tradition of theatre clowns is very old. They are the white-faces, the fools, and their work is very subtle. They have high status."

For de Castro, the attraction was instant. "Everybody could be a clown if they wanted," she says. "What you have to do is liberate the fantasy land of your mind. Clowns follow the logic of the unconscious, so you portray characters everybody relates to. They do things you think but never do because it's not acceptable in society. Which is why we laugh, and why, sometimes, it is tragic." Already an actor who was drawn to minor roles, often silent, clowning opened up whole new possibilities for communication with an audience. "I wanted to play with things people say I can't do, because I'm fat, or because I'm black, or gay, or a woman. I wanted to talk about minorities—people that are discriminated against." Clowns, the loveable aliens, outsiders who embody all that is absolutely familiar and absolutely taboo about ourselves, were the perfect vehicle for her subversive ambitions.

Back home in Rio de Janeiro, de Castro searched in vain over a period of five years for someone to train her in the art of clowning. Alone, she spent long afternoons in the city's film archives, where she studied the technique of Hollywood's masters, Laurel and Hardy, Buster Keaton and Harold Lloyd. Meanwhile her burgeoning career as a theatre producer was keeping her occupied and providing further opportunities for travel in Europe. It was at the end of one of these tours that de Castro stopped off in London to visit an old friend from home. The friend, who knew of her long-standing obsession, had discovered that a course in clowning for beginners was about to start at a London college, and suggested she apply for a place. At age 29, speaking no English at all, de Castro abandoned her life in Brazil to become a clown.

RESISTING EXTERNAL DEFINITIONS

Settling here, she found that London life grabbed her by the lapels in more ways than one. A life-long lesbian (she had her first

affair with a woman at age 14), de Castro explains that in Brazil it is impossible to be 'out' in the sense we think of it here. "Being a dyke in Brazil is a hard job; you can never come out. If you do, it is a big scandal. Of course there's a huge dyke community, and we always know who's who and go to places where we can meet, but it is all unspoken. We are on the dark side. We compromise all the time." In Britain she felt more at liberty to express herself than she ever had at home: "Brazil has a strong body culture. If you don't have a 'nice figure' you're not quite acceptable. In London it is more your philosophy of life that is important. I began to express my butch identity when I came here because in Brazil I didn't; it was all repressed."

Her training in London was followed by a four-year stint with a touring company while she honed her skills as a performer and adapted to life in a cold country. Working for the first time with self-identified feminists, she received a crash course in the concept of equal opportunities and women's rights, learning to expect respect as a gay person, and influencing the way women were represented in the shows that the company devised. "In Brazil I always worked with straight people," she remembers. "I was never out. That was very oppressive, like having a double life. Here I could be more open. I've never had any hassle from anyone I worked with here."

As an artiste, however, de Castro has resisted being labelled gay. "That would restrict my work very much," she says. "I want to reach as many people as possible, without prejudice about what I am in my private life." But this does not mean that her work does not tackle issues of gender and sexuality. Clowns, she points out, are practically genderless, which has huge advantages for the queer performer. Although most of her work has been with straight companies, in one show she found herself working with another dyke and the opportunity for a little subversion was too good to miss: "We put women's issues into the show in a subtle way. We even had a passionate kiss—two women in this family show—and everybody just went, 'aaaaah, how sweet,' because it wasn't in a gay context, it was in a *feelings* context." This was a freedom she could never have dreamed of in Brazil: "It was very empowering to have a chance to incorporate in my show something that was personally

important to me, and to put it in a street show, that it is not what you do but who you are that matters."

There were, however, drawbacks to her new life. Leaving Brazil she abandoned a successful career, her own theatre company, a comfortable home, security and respect. In Britain she was forced to scrape a living between shows at jobs which ranged from driving cabs to washing dishes, and moving from one low-rent accommodation to another. Ironically, her chief advantage–a talent for organizing financial support for productions, essential in Brazil where public funding for the arts is non-existent–was rendered useless in Britain, where her shaky grasp of the language damaged her confidence in dealing with funding applications. But over ten years, through work with various British companies, extensive touring of her own show, *The Gift*, to critical acclaim, and teaching in Britain and abroad, de Castro has established herself as a leading light in her field.

DIFFICULTIES ARE GIFTS

In many ways, de Castro's disadvantages, as an immigrant who spoke little English and was often misunderstood, became her advantages as a clown. "For clowns," she points out, "difficulties are gifts. The fact that you don't speak means you can reach more people; because there is no barrier with age, nationality, cultural background and so on, everybody can take from it." Gradually she developed a character, Souza, star of her show, *The Gift*, and her primary identity as a clown. A younger character, Silva, nephew to Souza, emerges to help her teach workshops. (In Brazil the names Souza and Silva are as common as Smith and Jones). "Souza is very close to me," says de Castro, explaining her relationship to her clown. "As I become mature, so does Souza. Sometimes I have to make time to let Souza digest his age. *The Gift* has changed as Souza has grown up. He is much more confident now, with new issues to worry about."

The clown character she developed, together with co-star Slava Polunin, for *Snowshow*, is another kettle of fish again: a colorless creature called Rough whom she describes as "almost dying." On stage together, de Castro and Polunin fairly yank at the heart-

strings. Polunin's Yellow, reminiscent of a down-and-out Ronald McDonald, wanders through an empty world vacillating between hope and hopelessness, dogged by de Castro's Rough. It sounds depressing, and in some ways it is, but the startling moments of comedy, the raw pathos and the beauty of the staging, in particular the final scenes, stay in the head long after the curtain falls.

Although both de Castro's clowns, and Rough, are nominally male, mirroring her identity as a butch, playing female roles is not out of the question. However, she rails against the stereotyping she has encountered, as a woman and an immigrant, in work with supposedly 'alternative' companies. In one show, she remembers angrily, her character was raped and killed. "Where is the subversion in that? There is no challenge there, nothing to provoke the audience," she says. Gradually she has learned to set limits in respect of her own objectives as a performer, right from the start of work with a new company.

The invitation to work with Slava Polunin, an internationally renowned Russian clown, was perhaps the greatest possible recognition of her talents, but it has come as something of a double-edged sword to de Castro, whose professional status has been severely challenged. "It was very overwhelming to be asked to work with such a guy. He is considered a genius of modern clowning," she explains, but goes on to name difficulties which include a systematic attempt to exclude her from the show's publicity. "I am working for him, not with him. It is his show and I am not really respected." Besides dealing with the ego of a great performer, there is the strain of constant touring with a predominantly male company: "The Russian culture is very chauvinist. The technician will not let me hold a tool because that is not 'a woman's job.' I can't sew but I'm good with a hammer, and for them, that's hard to understand." It is, she says, her ability to compromise and "find a balance" of her own, learned as an undercover lesbian in Brazil, that has saved her sanity over the past year.

But, in spite of the stresses encountered, *Snowshow*'s phenomenal success and the attendant publicity mean that she may never again need to drive taxis in order to supplement her living. As 1996 draws to a close, de Castro is poised to launch herself on a world already curious to know more of her unique talent for combining entertainment with hilarious observation and universal human truths.

Feminine and Masculine Personnas in Performance: Sade Huron: A Drag Queen with a Dick

Michelle Atherton

SUMMARY. Sade Huron is a self-confessed Lesbian drag artist. In this article she discusses how her performance character, the highly glamorized Tutu L'Amour, came into existence. She considers the role of Cabaret within her work, its importance historically for gay performers as a vehicle for raising issues concerned with sexuality. Sade goes on to explain that her performance looks at the complexities that surround the notion of gender, in particular femininity, and how she paradoxically presents Tutu L'Amour as a ludicrous parody of her own sex and an affirmation of 'glamorous femininity.' She introduces Elvis as a butch dyke icon to challenge the idea of binary opposites within gender, i.e., the masculine and the feminine. Lastly she looks at how these issues are received by different audiences. *[Article copies available for a fee from The Haworth Document Delivery Service: 1-800-342-9678. E-mail address: getinfo@haworthpressinc.com]*

Michelle Atherton is a practicing artist who has studied Art History at De Montford University and Fine Art at Sheffield Hallam University. Her work has been shown in regional and international exhibitions.

Address correspondence to Michelle Atherton, 19 Verdon Street, Sheffield 53 9QT, United Kingdom.

[Haworth co-indexing entry note]: "Feminine and Masculine Personnas in Performance: Sade Huron: A Drag Queen with a Dick." Atherton, Michelle. Co-published simultaneously in *Journal of Lesbian Studies* (The Haworth Press, Inc.) Vol. 2, No. 2/3, 1998, pp. 227-233; and: *Acts of Passion: Sexuality, Gender and Performance* (ed: Nina Rapi, and Maya Chowdhry) The Haworth Press, Inc., 1998, pp. 227-233; and: *Acts of Passion: Sexuality, Gender and Performance* (ed: Nina Rapi, and Maya Chowdhry) Harrington Park Press, an imprint of The Haworth Press, Inc., 1998, pp. 227-233. Single or multiple copies of this article are available for a fee from The Haworth Document Delivery Service [1-800-342-9678, 9:00 a.m. - 5:00 p.m. (EST). E-mail address: getinfo@haworthpressinc.com].

Sade Huron is a self-confessed lesbian drag queen who, in a recent article, was described "as wearing a frock to make Barbara Cartland green with envy."[1] She has been working for the last five years as an artist, expressing her ideas through performance, photography, film and video. I met Sade in the appropriately named Queen's Court to find out more about her performance "Natural Born Beehive." In the piece Sade takes on the character Tutu L'Amour–a woman who drips gold lamé and unravels a fantasy world where she cross-dresses with Elvis. The following covers Sade's beginnings in relation to sexuality and gender.

THE BEGINNINGS OF A PERFORMANCE

Sade talks about the inception of "Natural Born Beehive":

> The performance was spurred one night at the town and country club, Leeds. It was a women-only night and the organizers were asking for performers from the audience. So I stood up and sang a few Shirley Bassey songs–that's how it all started. I just had on jumble sale clothes plus a wig and I remember feeling like a drag queen. It was the way I wanted to express myself. I wasn't dressed up trying to be Shirley Bassey, rather I was dressing up as a caricature of a woman. An ultra feminine woman–something that I've never felt, even though I feel 100% woman. It's that kind of over-the-topness; more of a woman than a woman could ever be. It was very exciting taking on that persona of a drag queen.

Gay[2] performers have a long tradition in using a cabaret style. This is reflected in Sade's performance and she went on to talk about the reasons for this:

> There is a tendency for me to go towards a cabaret style. I didn't decide to copy the cabaret form, although I'm sure that I've been influenced by seeing male drag queens; but rather it was something that came from inside of me. I didn't want to just stand up and sing songs. Historically, especially for lesbians and gays, cabaret has been used as a vehicle to raise

issues. For example my favorite film is *Cabaret* which deals with fascism and sexuality. There can be a problem with the cabaret style because it can be viewed simply as entertainment but it's not just about singing songs. I want people to be entertained, to enjoy it, but I also want it to be about something.

Numerous nineties artists are using the figure of the popular 'entertainer' as a vehicle to talk about the issues of performance often in relation to identity, a strategy numerous gay artists have used over the years, from the lesbian theatre company Split Britches to Julian Clarey. However, to avoid being simply repetitive, 'the entertainer' figure needs to have a critical underpinning if it is to be discursive.

Sade's style can also be placed within the context of those female artists who have used stereotypes to discuss notions of femininity.[3] For her character, Tutu L'Amour, Sade draws upon the image of woman as highly glamorized. The lights ricochet off her gold lamé dress and sequined coat which are accompanied by a mock ostrich boa and blonde beehive wig. Sade wants her character to be seen as a caricature, thereby raising issues of gender. She comments,

Straight culture has norms of femininity and masculinity that it expects to be adhered to. But growing up a dyke, you're outside of it and consequently you want to experiment with different things such as gender. When I sang Shirley Bassey songs it just seemed natural to want to dress up in a nice dress and do my hair—but it didn't feel like me. Dressing like that made me feel like I was in drag, regardless of whether I was doing it in a more cartoon or caricature like manner. The character is ludicrous in so far as it's me dressed up so excessively. It's more like a ludicrous parody. It makes me feel like I'm a parody of my own sex. I send up this image with what I say and the fictitious nature of the character.

PERFORMANCE–FEMININITY AND MASCULINITY

As a performance, "Natural Born Beehive" has a strong sense of affirmation. The image of such a glamorous female character comes across as highly celebratory. However, as with male drag acts Sade

wants her performance to be seen as a paradox; on the one hand it could be seen as reveling in female glamour and on the other as a critique of enforced gender roles, the way in which the female sex is automatically aligned to the female gender, femininity. However, the connotations of a man dressed as a woman (if still recognizable as a man) are different than a woman dressed as a woman. The latter does not automatically present any contradiction to the audience. Sade went on to describe the dual nature of her performance. "I'm dressing as a drag queen which is a parody and at the same time it's celebratory. I believe in the glamour and love dressing up. It's more about having fun, than the work I did in the past around my childhood. I wanted it to be less didactic and more subtle. I'm trying to get across the idea that there's more to life than binary opposites. I am a woman playing a role that traditionally belongs to a gay man, but then being like a drag king because I'm packing–so I hope it works."

The binary 'characteristics' of the masculine and feminine are, largely, no longer thought to be naturally innate, but rather seen to be a social construct. As I have commented above, traditionally, in a heterosexually dominated culture, gender is aligned to sex, that is, femininity to female. For gender to be recognized it has to be shown to another person. Hence gender relies upon being performed. It is the playing out of specific characteristics that are then recognized and classified as either the feminine or the masculine.[4] Sade describes the reasons for her use of a feminine character:

> I think the very feminized character is more outside myself. I dress up as a caricature of a woman–of what I desire to be and what I am in everyday life. I grew up thinking I was androgynous and had a lot of dreams about being a hermaphrodite. It took a very long time to accept that I was a woman. But now that I have I enjoy it. In my performance I want to play with what I could be in terms of gender. I play a drag queen with a dick; I have a gun under my dress. It was good the other week, when I did a performance at the Green Room, for the live art showcase in Manchester. The man organizing the event came up to me afterwards and said he really liked the drag queen with an erection. No one has said that before and I've always

wanted to get across that image. It is an image that could be seen as hermaphrodite. To me, the transgender movement is really exciting because it's blasting the binaries of masculine and feminine, for example there are now women who have flat chests and an enlarged clitoris. The character Tutu L'Amour lets out my feminine side (one that I enjoy), but she also talks about the fact that I desire a masculine identity when she mentions Elvis. I want to show that gender isn't clear cut, that's why I dress as a drag queen with a dick. I don't just dress up as a woman and sing, or dress as an Elvis impersonator. I want to show the complexity of my gender and that gender is becoming more confused and fluid. I want to say in the act that I'm a woman desiring male attributes, but not wanting to give up my 'womanliness.'

Sade describes how Elvis fits into her performance:

I use Elvis as a prop in lots of different ways in the piece. He's a fantasy figure and I can make him into whatever I want. I think that's what all fans do with Stars. I use him to show my desire for masculinity. He's someone I desire to be, for example, when I see him in his fifties movies, *Jailhouse Rock* and *King Creole*, that's an image I desire to look like. But when he's in his jumpsuit I just think of him as a drag queen. That's why in the piece I talk about cross-dressing with him (U.S. southern drawl):

> "I pour myself into his leather suit–his
> 68 Special
> MAN–I looked good.
> And as I was checking myself out in his
> big
> fancy mirror
> I caught a glimpse of him
> He wasn't mad or nothing.
> He just had something on his mind.
> I found out what that was
> as I helped him into my sequin dress."
>
> (Tutu L'Amour, "Natural Born Beehive")

In the performance I, as Tutu L'Amour, take his masculine persona and give him my feminine persona. As I pinch his persona I'm encouraging him to be a transvestite. The performance goes on to talk about our relationship which is based on the recognition of the blurring of gender boundaries. I also see Elvis as an object of desire and as being a butch dyke icon. The lack of lesbian and gay men represented in the media means that I don't see the butch dyke that I desire. So I transfer this desire onto Elvis–I identify and desire him as a fantasy. It's about lesbians and gays changing the script for themselves.

Sade's ideas reflect the slow recognition of a wider range of sexual identities and experiences. A diverse audience, including bisexuals and transexuals, have for years been re-interpreting scripts to include their own experience. The implications of these sexualities are only recently being explored within the gay community.

READING THE GENDER BLUR

Sade's performance functions through the use of parody. Sade acknowledges the diversity of her audience and their potentially different responses. She describes how varying audiences respond to her work. "I've been surprised. I thought I might have had a bad response from women-only audiences because I talk about the desire to be masculinized. Some people have been hostile, but mostly it's been a positive response. I think this has a lot to do with the climate changing–in that lesbians are talking about different desires."

For the content of "Natural Born Beehive" to be conveyed Sade relies upon Tutu L'Amour being seen as a drag queen, rather than just a woman excessively dressed. Sade commented that her performance

means different things to different people. Some older straight women don't get that I'm a drag queen and that the gun represents a dick. I think maybe I unconsciously gear my work towards a gay audience because of the content of the performance. What started me off, before I started the performances

was thinking about–what does lesbian mean? What does dyke mean? And what images represent that–well you can't because it's so diverse. That's where it started from, so I suppose it's like using a language. I don't just want to communicate to the gay community. But I want to continue exploring what it means to me and that involves using that language. The people that understand are the people who have a similar experience.

NOTES

1. Article "Northern Uproar: This month's tip for the top," *All Points North*, June 1996 p. 8.
2. In this article I am using the word 'gay' as a generic term, thereby it refers to bisexuals, transexuals, lesbians and gay men.
3. From Cindy Sherman to Sam Taylor Wood female artists have analyzed the way in which 'woman' has been represented. For an historical context to such artists see *Framing Feminism*, Parker and Pollock, 1987.
4. For a more detailed discussion of gender and its performitivity see "Imitation and Gender Subordination," Butler in *The Gay and Lesbian Reader*, Routledge 1993.

REFERENCES

Abelove, Henry; Barale, Michele Aina and Halperin, David, M. 1993. *The Gay and Lesbian Reader*, Routledge.

Butler, Judith. 1990. *Gender Trouble: Feminism and the Subversion of Identity*. Routledge.

Parker, Andrew and Sedgwick, Eve. 1995. *Performative and Performance*. Routledge.

Parker, Roszsika and Pollock, Griselda. 1987. *Framing Feminism*. Routledge.

Riviere, Joan. 1929. "Womanliness as a Masquerade." *International Journal of Psycho-Analysis*. 10: 303-13.

Drag Kings and Subjects

Diane Torr
Jane Czyzselska

Having had to question our sexual identity from the moment we were aware that we were called lesbian, it is perhaps unsurprising that we are at the centre of a continuing discourse on being. On the stage in particular, lesbians from differing backgrounds and experiences seem to be at the forefront in developing this discourse further than other sections of society, as this book demonstrates.

Much of this exploration has revealed the performative nature of gender-based identity in daily life as well as on stage. Codes of

Diane Torr is a performance artist, writer, teacher and director who graduated from Dartington College of Arts in 1976 and moved to New York in that same year to become an international artist. She has created 15 original full-length stage productions and numerous cabaret performances, and her work is presented throughout the U.S., Canada and Europe. She has received funding for her work from the New York State Council on the Arts, Jerome Foundation, Art Matters. She is a regular guest teacher at the European Dance Development Centre (EDDC) in Arnhem and Dusseldorf.

Jane Czyzselska was editor of the lesbian and gay lifestyle monthly *All Points North* from 1995-1997. During this time she followed and identified trends in contemporary lesbian and gay culture. She now works as a freelance journalist, writing critical features, reviews, op-eds and interviews for *The Guardian* newspaper, *DIVA Magazine, Artists Newsletter, The Big Issue*, the lesbian sex magazine *Flirt*, and *Thud*, a lesbian and gay weekly. In her writing, she explores issues of sexual dissidence and cultural identity.

Address correspondence to Diane Torr, P.O. Box 481, New York, NY 10009, USA. Jane Czyzselska can be contacted via e-mail at j.czyzselska@leeds.ac.uk

[Haworth co-indexing entry note]: "Drag Kings and Subjects." Torr, Diane, and Jane Czyzselska. Co-published simultaneously in *Journal of Lesbian Studies* (The Haworth Press, Inc.) Vol. 2, No. 2/3, 1998, pp. 235-238; and: *Acts of Passion: Sexuality, Gender and Performance* (ed: Nina Rapi, and Maya Chowdhry) The Haworth Press, Inc., 1998, pp. 235-238; and: *Acts of Passion: Sexuality, Gender and Performance* (ed: Nina Rapi, and Maya Chowdhry) Harrington Park Press, an imprint of The Haworth Press, Inc., 1998, pp. 235-238. Single or multiple copies of this article are available for a fee from The Haworth Document Delivery Service [1-800-342-9678, 9:00 a.m. - 5:00 p.m. (EST). E-mail address: getinfo@haworthpressinc.com].

conduct passed down from generation to generation have been modified through the ages but there are still rigid conventions that underpin these changes.

The idea of what it is to be a woman is still very clearly defined by masculinist, heterosexist society and culture. It is in pushing the boundaries of so-called female behaviour that lesbians are changing definitions of gender on and offstage.

Drag Kings are not necessarily butch dykes, though they have definitely been influenced by them. Drag Kings have been an integral part of lesbian subcultures for some time, e.g., twenties Paris, thirties Berlin, and fifties New York. They re-emerged in the early nineties in New York and mid-nineties in London, where the first ever Drag King contest in the U.K. took place at the National Theatre, as part of the Lesbian and Gay Film Festival, in March 1995. (The first ever Drag King contest in the USA took place at the Pyramid Club, New York, in 1991, co-organized by Diane Torr and her make-up artist Johnny Science.) Diane Torr is one artist who has popularized Drag Kings with her work on an international level.

As a performer, Diane Torr, a self-defined sexual polymorph, has been creating androgynous roles for herself since 1978. As Diana-tone in loud pink pants, cowboy tie, black shirt and hi-heels, she was the she-male in Martha Wilson's performance band, Disband. In 1989, the term Drag King was not part of the vernacular and Torr, together with Johnny Science, used the term at that time, defining Drag Kings as women who take on male identities for performance or experimentation that went beyond simply male facial hair and dress-up.

Over the past 15 years, Torr has continued with her enquiry, sometimes in collaboration with other performers, as in *Girls Will Be Boys Will Be Queens* (1986). In this performance, Torr investigated the possibility to be more than one gender, utilizing Foucault's *Herculine Barbin*[1] as a text in her investigation.

Torr also directed other performers in her own productions, as in *Ready, Aye Ready* (a standing cock has nae conscience) (1992), presented at La Mama and PS122, New York. This was a performance of the bawdy poems of the Scottish poet, Robert Burns. Originally written for men, as a form of safe sexual release through laughter, Torr wanted to appropriate the material, and thereby 'own'

the male territory of dirty language and bawdy songs. In taking on male personae, female performers were allowed access to material that they might never consider viable as women.

In 1995, Torr created her most recent solo performance, *Drag Kings and Subjects*, a redefinition of the erotic which conveys the fluidity of gender and questions notions of sexual identity.

As a woman taking on male characters, Torr's working focus is to make sense of certain physical characteristics and of what constitutes maleness: how the male body carries weight differently, nuances of gesture and motion, ways of looking, how the gaze is directed, creating new facial expressions, and so on—all the subtle characteristics that go into the creation of a separate identity.

Torr began teaching her Drag King Workshop in 1989 and continues to teach this performance class throughout Europe and North America. The workshop contains much of the information that she has learned through observations, in daily life and as a performer. Aikido, for which she has a second degree black belt, has taught Torr about so-called 'male' behaviour. This includes how to take up space, how to physically exude a sense of self-possession and how to have a sense of neutrality that is exhibited in the gaze.

In her workshop, women develop male personae, which enable them to intercept their normal female behaviour and expand their repertoire of performing gender. The workshop culminates in a visit to a space where the newly-found drag kings test their new identities in a public performance. Some places we've visited in New York include Circle Line Boat Ride, sports bars, Crowbar, Edelweiss, W.O.W Cafe, Chinatown and a Whitney Museum art opening. For some women, the workshop is a continuation of their own exploration, and for others, a once-only experience. Many who have attended Drag King workshops have proceeded to develop a Drag King culture in their own cities and communities by setting up Drag King clubs, bars and contests.

Women performing as men suggest options to the audience, many of whom have made their own gender excursions. These include the possibility to become more than a conventional gender role permits. To realize the erotic potential implicit in cross-dress-

ing; to think of gender as a strategy, rather than a constraint; to expand the territory of so-called 'female' (and as a consequence 'male') behavior, and as the performers documented in this book have also begun to do, to continue to confound expectations.

NOTE

1. See Foucault, Michel (ed.), *Herculine Barbin*, Harvester Press, London 1980.

Index

 Haworth
DOCUMENT DELIVERY
SERVICE

This valuable service provides a single-article order form for any article from a Haworth journal.

- *Time Saving:* No running around from library to library to find a specific article.
- *Cost Effective:* All costs are kept down to a minimum.
- *Fast Delivery:* Choose from several options, including same-day FAX.
- *No Copyright Hassles:* You will be supplied by the original publisher.
- *Easy Payment:* Choose from several easy payment methods.

Open Accounts Welcome for ...
- Library Interlibrary Loan Departments
- Library Network/Consortia Wishing to Provide Single-Article Services
- Indexing/Abstracting Services with Single Article Provision Services
- Document Provision Brokers and Freelance Information Service Providers

MAIL or *FAX* THIS ENTIRE ORDER FORM TO:

Haworth Document Delivery Service
The Haworth Press, Inc.
10 Alice Street
Binghamton, NY 13904-1580

or FAX: 1-800-895-0582
or CALL: 1-800-429-6784
9am-5pm EST

PLEASE SEND ME PHOTOCOPIES OF THE FOLLOWING SINGLE ARTICLES:

1) Journal Title: _____
 Vol/Issue/Year: _____Starting & Ending Pages: _____
Article Title: _____

2) Journal Title: _____
 Vol/Issue/Year: _____Starting & Ending Pages: _____
Article Title: _____

3) Journal Title: _____
 Vol/Issue/Year: _____Starting & Ending Pages: _____
Article Title: _____

4) Journal Title: _____
 Vol/Issue/Year: _____Starting & Ending Pages: _____
Article Title: _____

(See other side for Costs and Payment Information)

COSTS: Please figure your cost to order quality copies of an article.

1. Set-up charge per article: $8.00
 ($8.00 × number of separate articles) _____
2. Photocopying charge for each article:
 1-10 pages: $1.00 _____
 11-19 pages: $3.00 _____
 20-29 pages: $5.00 _____
 30+ pages: $2.00/10 pages _____
3. Flexicover (optional): $2.00/article _____
4. Postage & Handling: US: $1.00 for the first article/
 $.50 each additional article _____
 Federal Express: $25.00 _____
 Outside US: $2.00 for first article/
 $.50 each additional article _____
5. Same-day FAX service: $.50 per page _____

GRAND TOTAL: _____

METHOD OF PAYMENT: (please check one)
❏ Check enclosed ❏ Please ship and bill. PO # _____
(sorry we can ship and bill to bookstores only! All others must pre-pay)
❏ Charge to my credit card: ❏ Visa; ❏ MasterCard; ❏ Discover;
❏ American Express;

Account Number: _____ Expiration date: _____

Signature: **X** _____

Name: _____ Institution: _____

Address: _____

City: _____ State: _____ Zip: _____

Phone Number: _____ FAX Number: _____

MAIL or *FAX* THIS ENTIRE ORDER FORM TO:

Haworth Document Delivery Service or FAX: 1-800-895-0582
The Haworth Press, Inc. or CALL: 1-800-429-6784
10 Alice Street (9am-5pm EST)
Binghamton, NY 13904-1580

www.ingramcontent.com/pod-product-compliance
Ingram Content Group UK Ltd.
Pitfield, Milton Keynes, MK11 3LW, UK
UKHW041839280225
455677UK00005B/35